DATE DUE

Unless Recalled Earlier

Judith Rothschild

AN ARTIST'S SEARCH

Judith Rothschild

AN ARTIST'S SEARCH

by Jack Flam

HUDSON HILLS PRESS

New York

FIRST EDITION

Text © 1998 by Jack Flam

Illustrations © 1998 by The Judith Rothschild Foundation

All rights reserved under International and Pan-American
Copyright Conventions.

Published in the United States by Hudson Hills Press, Inc.,
122 East 25th Street, 5th Floor, New York, NY 10010-2936.

Distributed in the United States, its territories and
possessions, and Canada by National Book Network.

Distributed in the United Kingdom, Eire, and Europe by Art
Books International Ltd.

Exclusive representation in China by Cassidy
and Associates, Inc.

Editor and Publisher: Paul Anbinder

Assistant Editor: Faye Chiu

Copy Editor: Fronia W. Simpson

Indexer: Karla J. Knight

Designer: Betty Binns

Composition: Angela Taormina

MANUFACTURED IN JAPAN BY DAI NIPPON PRINTING COMPANY

Library of Congress Cataloguing-in-Publication Data

Flam, Jack D.
 Judith Rothschild : an artist's search / by Jack Flam.
 p. cm.
 Includes bibliographical references and index.
 ISBN: 1-55595-150-3 (cloth : alk. paper).
1. Rothschild, Judith. 2. Painters—United States—
Biography.
 I. Rothschild, Judith. II. Title.
ND237.R7254F63 1998
759.13—dc21
[B] 98-4695
 CIP

Contents

Preface and Acknowledgments

This book accompanies a retrospective exhibition of Judith Rothschild's work, which for the first time includes paintings from the beginning to the end of her career. Although she had two partial retrospectives during her lifetime, they included paintings only from the latter part of her career, after 1970. Since this book is thus the first comprehensive study of her career, it is both biographical and art historical, meant to familiarize the reader not only with her art but also with the relationships between her work and the circumstances of her life.

In my research for the book I was given access to Rothschild's journals, letters, and private papers and permission to quote freely from them. This has allowed me to see her in a more unguarded way than one usually gets to know the subject of such a study. To allow her own voice to come through as much as possible I have included a fair number of quotations from her journals and letters. Since these documents were not written for publication, and since in the journals especially she often used a system of shorthand, quoting from them has posed certain problems in presentation. For example, to save time when she was writing, Rothschild often abbreviated words—such as, *paer* for "painter," *thru* for "through," *thot* for "thought," and *pic* for "picture." She also frequently omitted obvious punctuation, such as the period at the end of *etc.* and commas in places where they would normally be used. To make direct quotations from journals and letters easier to read, and to avoid the excessive use of square brackets, I have spelled out obvious abbreviations and misspellings and have added missing punctuation where necessary to clarify what she was writing. In cases where abbreviations were not absolutely clear, or in the rare cases where I have had to add a word to make her meaning clear, I

have indicated these added words or letters by enclosing them in square brackets. To convey some of the informal quality of her writing, however, I have retained her extensive use of the ampersand.

In the course of writing this book I have benefited from the help and consideration of a number of people. I would like in particular to thank William S. Lieberman, Jacques and Natasha Gelman Chairman of the Department of 20th-Century Art at the Metropolitan Museum of Art, and Nan Rosenthal, Consultant in that department, for their valuable feedback in the planning stages.

I would also like to thank Guillermo Alonso for his help with archival materials and information on specific works; Steven West for help with viewing paintings that were in storage; and Susan L'Engel for her careful preparation of copies of Rothschild's journals and letters. Special thanks also go to Rhea Anastas for her extensive contributions toward research and documentation.

I would like to express my deep thanks to Denyse Montegut for her assistance with all phases of the research and writing of this book and with the preparation of the manuscript.

Finally, I want to acknowledge my debt to Harvey S. Shipley Miller, trustee of The Judith Rothschild Foundation, for making available to me the full range of archival documentation held by the foundation. In addition, I want to extend my warmest thanks to him for his unflagging help in clarifying numerous points of fact and for his deeply appreciated moral support throughout the duration of this project.

All works reproduced in this book, unless otherwise credited, are in the collection of The Judith Rothschild Foundation.

In 1990 Judith Rothschild invited me to visit her studio to see the paintings she was planning to include in her upcoming exhibition in Moscow. We had been introduced about eight years earlier by mutual friends, and I had always looked forward to our occasional social meetings. I enjoyed her alert intelligence, her dry humor, and her analytic turn of mind.

I had seen her work at the Iolas-Jackson and Gimpel & Weitzenhoffer galleries in New York and had admired it. But aside from her recent work, I knew nothing about her history as an artist, other than that she had studied with Hans Hofmann in the early 1940s and that she had spent several years away from New York City, in California and upstate. What I did not know at the time was that many of her close friends had also not seen her earlier work.

At the time of my visit to her studio I was actively working as an art critic, and as often happens when a critic visits an artist's studio, we began to discuss which of her paintings were most successful and which least, and why. At one point in our conversation, I remarked that *Death of Patroklos* (Colorplate 40) was an exceptionally beautiful and moving painting and seemed like one of the directions that she should explore further. Her reaction to my remark surprised me. She nodded in appreciation and said, "But I can already do that, it's too easy." I pointed out that although she might feel that it was easy for *her*, it was nonetheless an exceptional painting and no one else was doing anything quite like it. As we talked about this further we almost got into an argument, she insisting that she wanted to do things that she could not yet do and I taking the position that sometimes it is better to lead to your strength rather than being preoccupied with working on your weaknesses. "Well," she said, "I don't want to be like Mendelssohn." The apparent non sequitur of her remark ended that discussion and we went on to other subjects, among them the possibility of my contributing an essay to a catalogue for a planned exhibition of her work. This I was unable to do because of prior commitments, but we parted with the understanding that perhaps I would be able to write something about her work in the future.

Death of Patroklos stayed in my mind. It was a moving and sonorous work, and I was especially intrigued by the quasi-narrative quality that it shared with a number of her other works from that period. What I mean here is not simply the allusion in the title to the death of Achilles' friend in the *Iliad*, but rather the structure of the painting: the way the arabesque of black forms seems to suggest a progression in time as it unrolls against the measured beat of the background; the way the dark forms themselves seem almost to verge on figuration and to suggest a specific action—such as a warrior dragged by a horse, or a group of mourners—without actually denoting any actual figures or describing any specific action.

Our conversation about the painting and her odd remark about Mendelssohn also stayed with me. It came to mind whenever I saw her socially, and it was the first thing I thought of when I learned of her sudden death in 1993. There was something cryptic about the comment, as if she used it as a private code for a complex aspect of her own psychology. And even the polite but firm stubbornness with which she had expressed it was memorable.

A couple of years after her death, when I started the research for this book, I began to get to know Judith Rothschild on a more personal level. Not only was I able to see the considerable body of work that she had produced before 1970, but I was also given access to her journals, notebooks, interviews, and correspondence, and so I was able to learn a great deal about the intimate details of her earlier life. I discovered that in effect she had had two rather different lives and careers, and that the turning point between them had been the breakup of her marriage in 1970. This is not to say, of course, that there were not important continuities between these two lives; but nonetheless the contrasts are dramatic.

Much of what I found surprised me. I had known, for example, that she was a dedicated amateur pianist; but I was surprised to learn that as a child she had aspired to be a concert pianist, and that as late as 1992 she had enrolled in master classes with Vladimir Feltsman in New Paltz, New York. Her journal entries and letters to

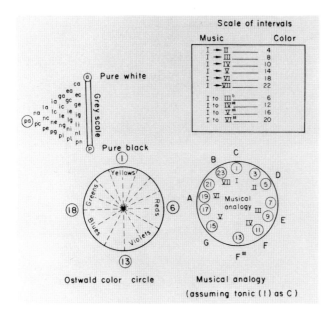

Scale of intervals

Figure 1

Ostwald color diagrams from Judith Rothschild's article in Leonardo, *1970, comparing Ostwald's color scale and a proposed musical analogy based on the twelve-tone scale.*

her parents make clear what an important, even central, role music also played in her painting.

I did not realize how much the idea of a color-music analogy informed her early thinking until I read her 1970 essay, "On the Use of a Color-Music Analogy and on Chance in Paintings," in which she discusses the possibility of developing systematic relationships between painting and music. The system of color annotation she used in that essay was based on the one developed by the German chemist Wilhelm Ostwald (1853–1932). In it, colors are divided into a kind of three-dimensional version of a color wheel—conceived as a globe whose equator is divided into 24 basic hues and whose north and south poles are, respectively, white and black (Figure 1). This division into 24 parts allowed for direct parallels to be made with the harmonic system of octaves in music. Using the Ostwald system it is possible to designate, through a complex but surprisingly accurate notational shorthand, not only the hue but also the tonal value and intensity of some 943 colors, all of which can be actually mixed with pigments and could even be referred to by a standardized set of paint chips.[1]

Rothschild was a well-read and literate person; this was evident not only in the themes of her paintings but in conversation with her. As I learned from her journals and letters, as a young woman she had nurtured ambitions as a writer. References to ideas for novels, stories, and at least one play are sprinkled throughout her notebooks. Sometimes these are framed as possible ideas for her husband, the novelist Anton Myrer. But she herself wrote a great deal. While she was still an undergraduate at Wellesley College she had completed a substantial portion of a novel, entitled *Concerto Grosso.* And throughout her life she kept extensive diaries and maintained a voluminous correspondence with a number of people, most especially her parents. Even more surprising to me was the discovery that between 1959 and 1963 she and Myrer had collaborated on *Faubion*, a novel about a painter that was based on an idea Rothschild had begun to develop as early as 1953.[2] In it, they evoke the struggles of an aspiring artist in the face of the corruption and self-interest of friends and colleagues, the indifference of the public, and conflicts with family. As notes in Rothschild's own hand make clear, much of this material was autobiographical.

Rothschild's parents were both strong-willed, highly cultivated, and highly motivated people who instilled a deep sense of ethical values and of striving for excellence in their three children. The family remained extremely close even after all the children had married, and this focus on family was to become extremely problematic to Rothschild as she sought to establish a life independent of her parents. To her, their attention often seemed akin to what T. S. Eliot calls "The absolute paternal care / That will not leave us, but prevents us everywhere."

Although her father's family had originally come to America in the early nineteenth century from a town near Frankfurt, the home city of the banking Rothschilds, the relationship between the two families is unclear. Her father, Herbert M. Rothschild (1891–1976), was a very American kind of self-made man, who had gained considerable wealth in the furniture business. Her mother, Nannette (née Friend) Rothschild (1897–1979), also of German-Jewish origin, was a teacher who came from a comfortable family. Although she stopped teaching to raise her children, she remained intensely involved in their education and was an active parent at the Ethical Culture and Fieldston schools, which all three of them attended.

Herbert Rothschild and Nannette Friend were married in 1917, and Judith's brother, Robert, was born the following year. Judith was born on September 4, 1921, and her sister, Barbara, was born three years later. Herbert Rothschild founded the John Stuart furniture showroom in 1934 and later became director of the John Widdicomb furniture factory. The John Stuart firm was an early importer of Danish and English furniture, and it featured work by such well-known designers as Finn Juhl, Robin Day, and T. H. Robsjohn-Gibbings. The Rothschilds began to collect art in a somewhat casual way during the late 1930s but became major collectors of modern art only during the 1950s, often asking their artist-daughter, Judith, for advice. Their passion for art was reflected in company advertisements, in which rooms filled with John Stuart furniture were photographed with modern paintings on the wall, with the copy line: "Picture *yourself* with John Stuart Architective Furniture—at home, at business." Sometimes the paintings shown were by their daughter, which was a source of some embarrassment to her.

Although Herbert and Nannette Rothschild remained cognizant of their Jewish roots, they were thoroughly assimilated and by 1920 were deeply involved with the Society for Ethical Culture, which provided an important formative influence on Judith and her siblings. The Rothschilds conceived of Ethical Culture as what Nannette Rothschild once described as a way of managing "somehow to do the best for everyone . . . in such a way that that person can best realize his own potential."[3]

The Rothschilds applied similar principles to raising their family. They were very supportive of their children, but also very demanding. Nannette Rothschild, in particular, frequently observed the ways in which she found people "wanting." Judith seems to have been very much affected by her mother's need for her to excel in all things, and she seems to have suffered from the constant judgment by self and family that was very much part of daily life as she grew up. This, I believe, drove her to feel constantly that she could, and ought, to do better— no matter how well she was indeed doing.

Her parents were also extremely close. Whenever possible, they did things together and traveled together. They were, in effect, each other's best friend and confidant, and they both assumed the very traditional roles of leader and follower that most men and women of their generation took for granted. This, too, set an implicit example for Judith of what a marriage should be, and what the respective roles of the two partners should be.

Throughout the first half of her adult life, Judith struggled to come to terms with the contradictions that this imposed on her own marriage and on her life as an artist.

Moreover, whereas she considered her father to be an understanding and benevolent presence in her life, from an early age she felt that she had an adversarial relationship with her mother. As I read through her notebooks, I was struck by how frequently she remarked on what she perceived to be her mother's antagonism toward her. After her mother's death she reflected bitterly on the fact that her mother had saved none of her early reviews, press clippings, or exhibition announcements (many of which she had sent to her for safekeeping)—a discovery that was made all the more painful by her mother's having saved reviews and articles about all of Anton Myrer's books. Rothschild concluded from this that her mother "could not swallow the idea of a woman doing something, but she loved the idea of any woman brilliantly adding to her husband's glory as she had done. In this role she appreciated me & was happy to lionize my husband."[4]

What she perceived as her mother's uneasiness with her was reinforced with the discovery that when she was quite young her mother had taken her for a psychiatric evaluation because of what she took to be her daughter's unusual behavior. Among her mother's papers was a drawing of "circles & spirals leading into circles," with a note in her mother's hand that read: "J's earliest drawings: the sun from Gramp's window at 2501. Age about 2½." With the drawing there was "a neatly folded typed letter from a psychiatrist" reporting on "the psychological tests privately given to one Judith Rothschild," which assured the mother that her daughter had an extremely high measured intelligence and "in no way was abnormal or deranged." In her 1985 notebook entry about this incident, Judith concluded that her mother assumed it was bad for a girl to be so intelligent.[5] And yet, another explanation for this psychological test is found in Nannette Rothschild's unpublished reminiscences. There she mentions that Judith, like she herself and her mother and grandmother before her, was left-handed, and that, following the practice of the time, which had also been imposed on her, she had tried to force Judith to use her right hand. But since "Judith, from infancy, always had a pencil in her hand and was always drawing or making pictures of one kind or another," she had solidified her left-handedness at an extremely early age, and she had reacted with unexpected intensity, by stuttering and other behavioral problems, to the attempts to

make her right-handed. The project was eventually abandoned and she remained left-handed.[6] That tensions existed between mother and daughter is undeniable, and one suspects that Nannette Rothschild to some degree may have envied her adult daughter's freedom and independence. But what Judith perceived as her mother's antagonism toward her was no doubt also partly the result of her own exaggerated need to defend herself from her mother's love as well as from her hostility.

One of the biggest surprises I encountered in getting to know Judith Rothschild through her writings had to do with the history of her work. I had always thought of her as an abstract painter. But as I began to study her early output, I slowly realized that in fact a good deal of figuration runs through most of her art—sometimes obliquely, sometimes directly. As I read her notebooks I saw that in the course of her career she struggled valiantly with the implications of figuration versus abstraction, which for several years she characterized as a conflict between the humanistic and the impersonal. As a result, artists about whom I had always thought she was unequivocally positive were in fact at various times quite problematic for her. Chief among these was Piet Mondrian. For although she had been deeply affected by Mondrian in the mid-1940s, and although she had encouraged her parents to purchase a number of significant Mondrians for their collection—and with which she herself later lived for some twenty years—it turned out that over the course of her life she had harbored mixed feelings about Mondrian's painting and all that it stood for. During the mid-1950s, for example, she reflected on the possibility that Mondrian was probably "the last 'big' artist of all the Europeans whom we can be sure of—in the sense that we're *sure* of his sincerity. . . . In actuality both his work & his philosophy were vast mistaken hindrances" because of the way he removed his art from direct contact "with the real complexities of life through elimination of the human." This "evasiveness," she felt, had allowed his followers to be able to "paint without any *human* commitment" and to achieve a "destruction of all image, symbol or any other visual connective between the idea & the human situation or problem." This led her to ask, how could art "say anything meaningful about life when it avoids all traces of life as corporeally experienced? And for what other *serious* purpose is art?"[7] At that time she preferred Mondrian's earlier works, such as the 1912 *Flowering Trees* that her parents later owned (see Figure 22). It

was not until some years later that she was able *as an artist* (rather than as a viewer) to come to terms again with the Dutch master's achievement, which in the last analysis she considered to be greatest in precisely those works that she had undervalued while struggling with the problem of figuration. In 1980, for example, she wrote of his later work as having a luminosity, clarity, tension, and beauty that surpass those qualities in his early work. Then she saw his early work as a prelude, when he was "beginning to penetrate a new facet of the crystalline core of nature," but "not yet luminous & clear." Moreover, she later came to think that Mondrian's late work was actually "just as close to nature as [in] 1913—only the forms are more understood—tensions distilled."[8]

When I knew her, Rothschild was very close to a number of artists who were associated with Abstract Expressionism. She was, for instance, friendly with Robert Motherwell and other artists who belonged to the Long Point Gallery in Provincetown, Massachusetts, who were clearly working within the abstract-expressionist tradition. I was therefore surprised to discover that during the 1950s, and even later, Rothschild had had strong misgivings about Abstract Expressionism. These misgivings had to do precisely with the same dichotomy between the humanistic and the impersonal that troubled her in relation to Mondrian. And these issues went to the heart of her own undertaking as an artist. As soon as she began to work with Hans Hofmann in the fall of 1943, she became a passionate advocate of abstract painting, a partisan for what might loosely be termed modernism, at a time when the question of the validity of modernist art in America was still the subject of lively debate. After 1943, when she was only twenty-two years old, Rothschild never doubted which side of this debate she was on. But within the modernist camp she was frequently drawn to a more conservative position—one that would allow for, and in fact insist on, some element of figuration or "humanistic" subject matter in her work. In this, she was for several years allied with Karl Knaths (1891–1971), an influential teacher and painter who became her mentor and had an especially strong effect on her art during the 1950s and early 1960s.

In her 1970 article on color and music, Rothschild mentions that she had first become aware of the Ostwald color system through Knaths; but her reference to him, though respectful, is cool. And since Knaths's name was not even mentioned in any of the publications I had read about Rothschild, it was surprising to discover what a

large role he played in her development as an artist. Not only was he her mentor for many years, but he also acted as a kind of artistic father figure to her (he was in fact born the same year as her father).[9] It is apparent from her notebooks that Knaths's version of the Ostwald color system provided her with two things that for several years were very important to her: an intellectual frame of reference for her work and a source of self-confidence. As she mentions in her 1970 article, the Ostwald system as interpreted by Knaths gave her an underlying mathematical basis for pictorial structure and thereby a sense that she was somehow dealing with "objective truth." Having cut her teeth as a painter under the aegis of Mondrian, she started out with the assumption that an artist had to aspire to finding a higher truth that could be expressed in purely pictorial terms. Like other artists of her generation, she mistrusted surface realism and believed that one had to go beyond surfaces to find a deeper reality. The color system supplied her with a touchstone for such a deeper realism, a philosophical scaffolding to which she could attach her own subjective experiences.

Some of the most psychologically revealing episodes in her journals are the accounts of the critiques she received from Knaths from the mid-1950s to the early 1960s. She and Knaths discussed the structure of paintings with the same kind of technical terminology that one might bring to the analysis of a musical composition. But at one point during the summer of 1960 she remarks in her journal that she is troubled by the nagging realization that he is pulling her down. She reflects that by Wednesday of each week she is "full of elan & hope for my work" and has a sense of "direction & purpose & vigor & energy," but that on Thursdays, the day she meets with Knaths for her weekly critique, she repeatedly feels deflated and enervated.[10] Even though she was able to draw a connection between the two, she was not quite able to pull herself away from Knaths's influence—any more than she was able for a long time to become independent of the influence of two other male authority figures: her father and her husband.

Her relationship with her parents, and especially her father, is revealing in this respect. Even after she married and went to live in California—in part so she and her husband could be away from the East Coast artistic and literary establishment, but also in part to be away from her parents—she wrote to them with extraordinary frequency and in great detail. The subjects covered in their letters ranged from personal impressions of peo-ple and events to politics and ethical issues. In 1948, for example, there is a lively and witty account of Rothschild's chance meeting with the photographer Edward Weston, a neighbor in Monterey. And that same year, there is an explosive exchange of letters between Rothschild and Myer on the one side, and her father on the other, over the ethical issues raised by an article written by Lawrence Frank, who was being considered for a leadership position in the Ethical Culture society. So strong were the underlying feelings this disagreement brought to the surface that it almost resulted—with Myer's urging—in Rothschild's breaking completely with her parents.

As I read through her journals, the crucial role that her marriage to Anton Myer played in shaping both her artistic career and her personal life became painfully clear. Myer had gone to Boston Latin School and then to Phillips Exeter Academy and Harvard, and his family lived on Louisburg Square in Boston. His father, Raymond Myer, was a financier. His mother, Angele, who became a Christian Scientist, was a painter who had a studio in Provincetown.[11] In fact, it was through Angie Myer and in Provincetown that Judith Rothschild (Figure 2) and Anton Myer first met. He was a strikingly handsome man, and Rothschild, who was a rather plain young woman, had been overjoyed to have been chosen by a good-looking, well-bred young man. As she herself later remarked, he was the sort of man whom she thought she would never be able to get, and whose love she lived in constant fear of losing. Myer was about a year younger than she was. He had enlisted in the Marines during World War II and had seen action in the Pacific, where he was wounded on Guam. Since his education had been interrupted by the war, he was just finishing his last year of college during their courtship, and he graduated only a few months before they were married in 1947.

At the time Rothschild married, she had only recently begun to exhibit her work. During the previous year she had been given two one-person shows in New York City and had begun to attract the notice of critics and collectors. But because Myer hated New York and what he perceived as its corrupting influence, he insisted that they go to California, where he believed they could live a productive life writing and painting in isolation, devoted to the "timeless" values of art. She was moved to do so not only by her love for him but also because it provided her with a way of rebelling against what she came to regard as her parents' materialism and philistinism.

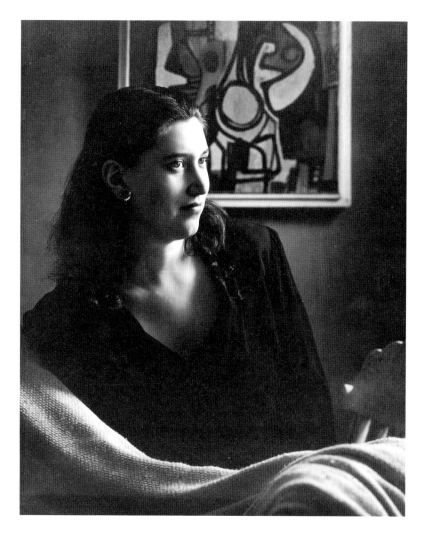

Figure 2
Photograph of Judith Rothschild, 1946.

For the next twenty years or so, Rothschild adjusted her living and working conditions to the exigencies of Myrer's career and work habits, and to his ego. Since Myrer felt that he needed to work in seclusion, she willingly lived with him in isolated circumstances, often in houses that lacked modern conveniences, as if a kind of physical asceticism would naturally foster spiritual growth. She not only loved him deeply but also had enormous confidence in his judgment and opinions—in both practical and aesthetic matters. Thus, although she continued to work productively on her paintings and collages during the twenty-odd years of their marriage, she gave less attention to her own needs as an artist and to her intellectual and emotional independence than perhaps she ought to have. Shortly after they set up house in California, it became apparent that Myrer could not tolerate her contradicting him in public. One evening, for instance, they became involved in a discussion with a

friend about Virginia Woolf's work, and Rothschild voiced an opinion that differed from Myrer's. He told her afterward that it was all well and good to argue about such things in private, but that "in public we are in agreement . . . in public we are to be a unified team."[12] So in a sense, as she later recounted, although she never "overtly promised to follow this edict," she realized that she would have to trim her sails a bit "or Tony would be miserable." She came to realize only much later that gradually "I accepted more and more constraints, always telling myself 'it was worth it.' . . . I gave away more and more pieces of myself, and still felt that I was happy. What is happiness if it is not thinking that one is happy?"[13]

Although part of her bristled against these restrictions, she also tried desperately to rationalize them. In 1959, for example, she wrote of the necessity for "all sorts of reassessments about the 'natural' creative aptitude of my kind of woman," and of a growing resent-

ment at the nuisance that her painting represented to her life with her husband, and thus of her "growing inner conviction . . . that in many ways the traditional view of dominant husband is, even for us, the most satisfactory." She spoke of her determination to curb her ego accordingly, "and most of all *here* not to get T. needlessly upset & off his work schedule for painting reasons."[14] (To Myrer's credit, he paid lip service to her independence and by her own account argued against such views when she expressed them. If their marriage developed for her into a kind of cult, she was a willing participant in it.) "A show by me," she noted at the time of one of her own New York exhibitions, "takes a disproportionate amount out of Tony's time & if I am to continue to show at all I must do it more alone—& he *must* agree to let me do it so."[15] Her relationship with Myrer, like that with her father, and later with Karl Knaths, indicates how susceptible she then was to the claims of authoritative men.

Anton Myrer was by most accounts a rigid person—controlling and demanding, by turns emotionally cool and explosive. For all of his surface polish, he was unsure of himself and dogged by a puritanical aversion to intimate emotional or physical contact. (His mother's religious conversion seems to have encouraged these attitudes.) Possibly because of his own fear of failure, he was very critical of his contemporaries. In Rothschild's notebooks there are numerous references to Myrer's aggressively negative opinions about writers such as Norman Mailer, William Styron, John Fowles, and even Vladimir Nabokov. Their very success seems to have attracted his scorn. He also considered New York a hotbed of artistic corruption and dangerous worldliness, and he convinced Rothschild, who had grown up in a cosmopolitan environment, that there was something debased about both that environment and the wealth of her parents. Rothschild, like almost any young artist, was quite ready to believe her parents to be philistines, and their own conventionality and traditional values, especially their emphasis on family unity and family loyalty, gave her ample reason to do so. The situation was exacerbated by the fact that Rothschild had been very close to her father, whom she adored; and in the early days of the marriage, the impecunious Myrer apparently resented having to compete with his rich and high-minded father-in-law for his wife's affections and loyalty.

Myrer had strong views about what constituted good writing and good art, and how artists ought to behave and live to remain on the high road of "durability" and "timelessness"—and here his word was law. For example, he felt that it was important to live without children, and he imposed this condition as one of the prerequisites of their marriage. "I never fought him about having children," she later remarked, "because before we were married I know I felt that just to be loved by Tony was such a miracle I 'should' not ask for anything else."[16] But this was one decision that Rothschild came to resent terribly. While they were still married, she sometimes mentioned this as a point of contention, and afterward she was openly bitter about it. In 1962, for instance, she equated having a child with forcing Myrer to give up writing.[17]

Myrer seems also to have affected her art in a fairly direct way, in that his own aesthetic ideas were strongly held and rather conservative. Although his first novel contains some Joycean flourishes, most of his books are straightforward narratives in the popular style of the time. He seems to have mistrusted exactly the sort of abstract art that Rothschild was doing at the time they met, and he appears to have exerted a modifying influence on her own aesthetic. In 1955, when Rothschild was having misgivings about Mondrian and abstraction, Myrer stoked the fire and told her he felt that Mondrian was "to blame" for many of the shortcomings of contemporary art.[18] The following year, according to Nannette Rothschild, when the Rothschilds bought a great 1924–25 lozenge-shaped painting by Mondrian, Myrer was repulsed by it: "When her husband Tony first saw it in our entrance hall, he covered his eyes and retreated, saying, 'Oh no, not that!' It was too big, too brash, too overpowering for him—he couldn't see it because of its size and power."[19] And indeed, as Rothschild noted only a few years later, at a particularly rocky moment in their marriage: "Tony fears & resents the N.Y. in me—the relativistic—the love of the new, the jangling and the heat. I fear his over moralistic over conservatism—his being out of step & not examining but condemning whole hog."[20]

It is not mere coincidence that Rothschild's career entered a new and vital phase after 1970, the year that she and Myrer were divorced. The breakup was made especially painful for her by the fact that Myrer left her for a woman whom Rothschild had considered a friend and by the way that Myrer soon began to write her out of his life story, emphasizing in interviews his nourishing relationship with his new wife and acting as if

Rothschild—whose income had largely supported them for the first decade of their marriage—had not even existed. But it was at this disruptive time that she began to produce her most original work and to establish her reputation as an artist.

What emerged from my reading of Judith Rothschild's notebooks and journals was a vivid sense of her often anguished search for personal independence, for an original voice, and for a personal style. Not until she had achieved the first was she able to find the others.

And Mendelssohn?

Mendelssohn, I discovered, had become a symbol for her of someone with whom she in many ways identified but whose limitations she wanted to be able to overcome. She identified with both his Jewishness and his denial of it, as well as with his precociousness and his family situation. In 1959, after reading a biography of the composer, she noted that she had learned a good deal that was meaningful to her. She felt that she shared with him what she considered a Jewish need to succeed—an internal pressure that was "part of almost *all* Jewish families I've known. Forces one toward public acclaim—*irregardless. . . . But little* fulfillment of his *higher* potentials."[21]

Mendelssohn, for her, also represented an important aesthetic shortcoming: "He never learned to vary the rhythmic units as some of his much less talented peers did—even learned to do mechanically as part of the craft." This she characterized as a "kind of unconscious narcissistic primitivism," which prevented Mendelssohn from achieving the kind of complexity that she admired in Haydn, for example. Listening to Haydn's op. 76, no. 2, string quartet, she was "awed by that naturalness of power—not yet made rhetorical (as in Beethoven) or even delectable (as in Mozart) but with such a masculine austerity & yet exactly with that native sense that Mendelssohn lacked—of the exact moment to vary—to expand & contract the rhythms . . . the marvelous rich *organic* structure. . . . Perhaps because its logic is so *felt*, so unforced, & so supra-rational. To paint one canvas like that! Oh my."[22]

This, too, was part of what Judith Rothschild sought, and what she sometimes found—especially, despite her misgivings, in paintings like *Death of Patroklos*.

Judith Rothschild appeared on the New York art scene in the winter of 1945, when she had her first one-person exhibition at the Jane Street Gallery and was subsequently elected a member of the American Abstract Artists (AAA). At the time, the Jane Street Gallery, an artists' cooperative, was a center for painters associated with the ideals of the American Abstract Artists, an avant-garde group that had been formed in 1936, the same year that Alfred H. Barr, Jr.'s, "Cubism and Abstract Art" exhibition was mounted at The Museum of Modern Art.

The annual exhibitions of the AAA soon became a focal point for artists who worked in an abstract geometric style. Among the artists who originally exhibited with the group were Josef Albers, Ilya Bolotowsky, Byron Browne, Burgoyne Diller, Balcomb Greene and Gertrude Greene, Carl Holty, Harry Holtzman, Alice Mason, and George L. K. Morris. Artists such as Lee Krasner, Willem de Kooning, Arshile Gorky, and David Smith were also associated with the group in its early days, but only briefly. Right from the beginning, American abstract artists were divided into two groups, those who worked nonrepresentationally, favored cool paint application, and found their models in European artists such as Jean Hélion and Mondrian, and those who favored freer brushwork, retained references to representational subject matter, and allied themselves with the tradition of Picasso and the French cubists.

Furthermore, even among the "pure" abstractionists, there was a further division between the materialist-rationalist tendencies of the AAA artists and the more overtly metaphysical aspirations of other backers of abstract art. When the formation of what would become the Solomon R. Guggenheim was announced in 1937, the mystical leanings of its director, Baroness Hilla von Rebay, made her unsympathetic to the rationalist objectivity espoused by most of the AAA artists. They in turn were irritated by her insistence on using the term *non-objective* instead of *abstract* and by what they considered her pretentious spirituality. A group of AAA members responded to Rebay's espousal of art that had an "absolute" structural basis and strong mystical connotations with a letter to the *New York Times.* "It is our very definite belief," they asserted, "that abstract art forms are not separated from life, but on the contrary are great realities, manifestations of a search into the world . . . made by artists who walk the earth, who see colors (which are reality), squares (which are realities, not some spiritual mystery), tactile surfaces, resistant materials, movement."[1]

But whatever the divisions within the AAA group or between various factions of avant-garde artists, they stood in direct contrast to American Scene painting and social realism, and to what they perceived as the superficiality and provincialism of most recent American painting.[2] These were some of the issues that were being argued during the time that the young Judith Rothschild was developing as an artist. It was a transitional moment during which American painting was coming of age and on the verge of becoming a powerful international force. American art was being given a fresh impetus by the European artists who had recently been driven from Europe, first by political persecution, then by the war. Many of the questions raised at this time directly affected Rothschild's development for the rest of her life. For example, throughout her career, Rothschild would have very mixed feelings about the conflicting claims of "pure" abstraction and painting with a "humanistic" subject matter. She also alternated between a rationalist approach to art—which was no doubt reinforced by the Ethical Culture values of her upbringing—and her spiritual aspirations. And perhaps most important, arguments about the role that subject matter should have in painting would have far-reaching consequences for her. Throughout her life she tried to reconcile the myriad details of lived experience with an aspiration to deal with "tragic and timeless" subject matter. As a result, unlike many of her contemporaries, she did not work toward developing and perfecting a single image. Instead, she sought to find formal structures that could act as metaphors for her underlying sense of order and at the same time to devise a pictorial language supple enough to allow those structures to be adapted to include a broad range of subjects. As a result, she shifted back and forth

between abstraction and figuration for most of her career.

This polarity was the subject of her first published text, a 1944 essay in which she discussed her ideas about the differences between "abstract" and "non-objective" art. Behind Hilla Rebay's notion of "non-objectivity," Rothschild saw "a negation of the world, a denial of the importance of the eye, or the material world, as a sound basis for artistic experience." Rothschild, by contrast, felt that the work of "abstract" artists—such as Joan Miró, Paul Klee, and Hofmann—was "touched with a breath of life more vibrant than appears in the work of most non-objective paintings."[3] In an essay published the following year, just a few months before the opening of her Jane Street show, she discussed the way "the impersonal quality" of Mondrian's technique was the result and embodiment of his "total philosophy." This, she asserted, was an extraordinary accomplishment, but one that could not easily be used by contemporary artists, who risked merely imitating his "forms and technique" while missing the underlying philosophy that had produced them.[4] As is evident in these essays, Rothschild was acutely aware of the expressive and philosophical implications of the painter's technical means. She speaks of the conscious way in which the "objective mechanical type of brush stroke" employed by Mondrian, and by Hans Arp, was part of a conscious attempt to achieve an impersonal spirituality, as opposed to the more painterly and "human" approach of Miró and Picasso.[5]

This duality was also evident at her Jane Street Gallery exhibition. The paintings she showed were a mixture of geometric abstractions, modest in scale but tightly composed, such as *Untitled Composition* of 1944 (see Figure 6), and works that employed an abstracted pictorial language but retained clearly figurative subject matter, such as *Mechanical Personnages* of 1945 (Colorplate 3). At her second one-person show, at the Joseph Luyber Galleries the following fall, Rothschild showed a similar range of work. This second exhibition included beautifully balanced abstractions such as *Grey Tangent* of 1945 (Colorplate 2) along with clearly figurative paintings such as *Figure and Objects* of 1946 (see Figure 7). The latter evokes the interior of a room, a human figure, a still life on a table, and a window with a cubist-derived vocabulary of forms that is basically similar to that of *Grey Tangent* but set in a clearly representational framework. Although the presences of Mondrian, later Fernand Léger, and Picasso are strongly felt in

both of these paintings, they have their own voice and are surprisingly mature for an artist who was only twenty-five years old when she did them.

Rothschild's development at this time is all the more remarkable when one considers that she had begun to work abstractly only a couple of years earlier, in the winter of 1943–44. Up until that time, she had been painting figuratively and had taken American Scene and realist painting as her models.

Her early interest in art and her early traditionalism are not surprising for someone brought up as she was. Both of her parents were deeply interested in the arts, and Nannette Rothschild even attended Metropolitan Museum of Art Saturday classes with her children in the early 1930s, where Judith gained a deep familiarity with Egyptian, Greek, and medieval art. Judith had begun to sketch regularly at an early age, while she was a pupil at the Fieldston School, and she later recalled traveling around New York by subway, looking for subjects—a typical activity of realist and socially engaged artists at the time.[6] She had also begun to paint in oil quite precociously, when she was only about twelve. From then on she painted steadily. The art program at Fieldston was run by Victor D'Amico, who was among the most progressive art educators in the country and who later ran the education program at The Museum of Modern Art, where Rothschild also took his courses. Since the museum heavily emphasized School of Paris modernism, she became particularly enthusiastic about modern French art.

In 1937, after several months of negotiation, she persuaded her parents to allow her to go to see French art firsthand by spending the summer in Europe. She and her brother, Robert, joined a youth group that went to southern England, Holland, Belgium, and traveled extensively in France. Rothschild's tastes at the time were remarkably mature for a girl of sixteen. In her journals she made energetic notes about the art in museums and churches and spent a good deal of time sketching—not only at picturesque historic monuments such as Carcassonne but also in the disreputable quarters of Marseilles, where she and one of her friends scandalized the others by going to see a "blue" movie.[7]

Her artistic taste at the time was still grounded in the more conservative aspects of early-twentieth-century modernism. While in Paris, she was enthralled by the paintings of André Derain, especially his portraits and landscapes.[8] Derain's influence was felt in a number of

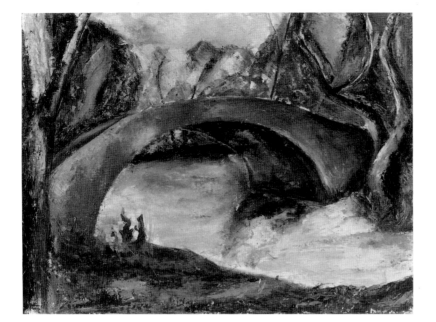

the works she did during the next few years, as can be seen in the small *Untitled Landscape with a Bridge* of 1942 (Figure 3).

Her parents encouraged her to attend a liberal-arts college rather than a school more directly oriented toward art, such as Bennington, and Rothschild reluctantly decided to study at Wellesley, which did not offer a major in studio art. Although she felt that she received an excellent education there, majoring in art history, she also complained about a pervasive atmosphere of constraint and conformity, from which she later had to struggle to free herself. Some idea of her state of mind then can be seen in a striking picture she painted of a nude woman standing before an easel and painting (Figure 4). In this self-portrait, the woman and the objects around her are evocatively suggested by heavy black lines, which are set against an amorphous red and violet background that creates the chromatic equivalent of a stifled cry. For all its sketchiness, it is an intense and affecting image that conveys a deep sense of anguish and psychological isolation.

Despite what Rothschild saw as the disadvantages of Wellesley, the school provided her with the opportunity

to do a fair amount of painting.[9] It was there that she began to experiment, somewhat tentatively, with a cubist-inspired manner, although most of her paintings from this period remained naturalistic. This naturalistic bent, along with her admiration for Derain, was reinforced by her summer studies: with Herman Maril at the Cummington School, in Cummington, Massachusetts,

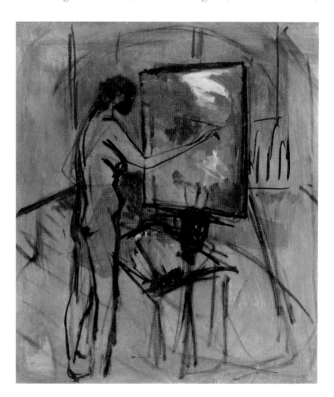

Figure 4

Untitled Self-Portrait at the Easel, *ca. 1940.*

Oil on canvas, 34 x 30 inches.

during the summer of 1940; with Maurice Sterne during the summer of 1941; and most especially with Zoltan Sepeshey at the Cranbrook Academy of Art in Bloomfield Hills, Michigan, during the summer of 1942. It was under Sepeshey's tutelage that she began to understand the nature of the commitment that would be necessary to be an artist.[10]

After graduation from Wellesley and on her own in New York during the summer of 1943, she first decided to study at the Art Students League, where she worked briefly under Reginald Marsh. An extensive number of pencil and charcoal sketches done at Coney Island and around New York City at that time attest to her growing technical ability and her commitment to hard work. But she still had not found a direction that engaged her whole being. She felt that what her parents, especially her mother, wanted most from her was for her to fulfill *their* expectations and marry and raise a family. Despite her parents' longtime interest in art and the fact that they were beginning to collect on a modest scale, being an artist was not something they considered a desirable goal for a daughter. This conflict between her desires and her parents' weighed heavily on her at this time. Her concerns are reflected in an uncompleted autobiographical novel, *Concerto Grosso*, which she began that summer and continued to work on into the fall. Not surprisingly, its main character is an aspiring young woman artist locked in a battle of wills with her family.[11]

Given her musical background and her intense interest in contemporary music (she was, for example, an early admirer of Shostakovich), Rothschild was particularly well disposed toward grasping the abstract, musical possibilities offered by modern painting and its philosophical implications. Her longing to work in a freer way led her to Hans Hofmann's studio, which was a magnet for aspiring women painters at the time. It was from her study with Hofmann, which began in the fall of 1943, that she began to become seriously engaged with the potentials of abstract painting—and with the expressive and structural possibilities of painting in general. Her experiences with Hofmann were also a liberation from the aesthetic and emotional constraints that she had felt at Wellesley. "Well it has happened at last!" she wrote shortly after she began to work with Hofmann. "I was beginning to fear it never could! I refer of course to that wonderful *feeling*, which dates back to the days of Fieldston & Cummington & which Wellesley so ardently squelched."[12] It was at this time that her lifelong search to seek a personal voice seriously began.

Hofmann's teaching centered not so much on a particular style as on a way of conceiving and constructing pictorial space in terms of dynamic tensions, created mainly through assertive color and vigorous brushwork—all of which were component elements of the famous "push and pull" principles that he advocated. His stress on the creation of space by color, independent of modeling, was based largely on his understanding of Matisse, and of Matisse's understanding of Cézanne. Hofmann's own background was somewhat eclectic, as was his manner of working, which between 1902 and 1943 ran through virtually the entire repertoire of modernist styles. Although Hofmann had not established a significant reputation in Europe, in the United States he was seen as a kind of living embodiment of European High Modernism. He was known to have been acquainted with a number of the early European modernists, such as Matisse and Kandinsky, and he spoke very highly and with deep understanding of Picasso, Mondrian, and Klee. At the time that Rothschild began to study with him, Hofmann had not yet shown his work in New York and was known mainly as an inspired teacher rather than as an important artist. (His first New York exhibition took place at Peggy Guggenheim's Art of This Century gallery in March 1944.) The generally held attitude toward him at the time is reflected in Rothschild's remarks about his significance for her that fall: "H. is still a symbol to me of *THE* attitude towards work that I feel every artist should (must) try to develop—even if he can't be Vladimir Horowitz."[13] Hofmann's emphasis on the formal qualities of painting made him notoriously indifferent—even antagonistic—to Surrealism, which he regarded as a reactionary attempt to restore "outside" subject matter to painting.[14]

While Rothschild was working with him, she experimented with several different ways of painting, all of which involved a new freedom in the use of the medium itself. The paintings that she did in his studio range from broadly brushed to quite linear, but they all have in common a clear emphasis on spontaneous paint handling and fairly loose drawing. In some of the studies she did there, such as *Pure Line XI* (Figure 5), her first truly abstract painting, amorphous painterly areas dominate. In other works, such as *Abingdon Square* (Colorplate 1), which was particularly admired by Hofmann, geometric forms assert themselves against a thinly painted ground, in a way that recalls both Miró and Arp. Shortly after she finished *Pure Line XI*, she saw it as a sign that

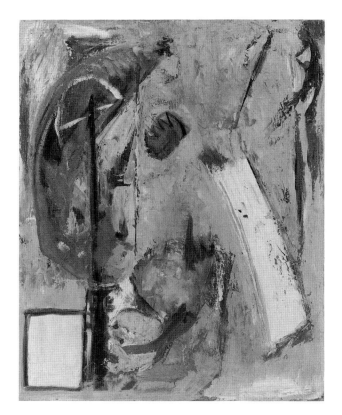

Figure 5
Pure Line XI, *1943. Oil on canvas, 24 × 20 inches.*

she could indeed cast off the "binding training" that she associated with Wellesley.[15]

Hofmann gave Rothschild the kind of encouragement that helped build her self-confidence. Near the beginning of her time in his studio, he singled her work out in a way that gave her enormous satisfaction and hope for the future:

> The other day h.h. said he could see I have *courage.*
> I half felt he was damning with faint praise. But today
> he explained . . . what he means by *courage:* The power
> & *will* to act & act as I feel things should be no matter
> what the consequences. . . . I brought my abstraction
> on a blue background *[Pure Line XI]* over for criticism.
> He said: "Is this yours." in tone of wonder & applause.
> Then, "Its good. I like it." And placed it before the
> class. . . . He turned to the class & said—"This is a
> painter of *great* promise." . . . I am beginning to stop
> worrying about whether or not I *ought* to paint. And
> to feel I really have some ability worth paying atten-
> tion to.[16]

Even after she had stopped studying with Hofmann, she was gratified by the interest that he continued to take in her work, and she was particularly touched by the encouragement he gave her at the time of her 1946 exhibition at the Luyber Galleries.[17] As late as the sum-

mer of 1947, she still occasionally took paintings to him for criticism.

Moreover, her contact with Hofmann put her closer in touch with what might be called the "painting culture" of European artists—the conversations, interviews, and theoretical essays in which they expressed their ideas. At the time, very few of these now-familiar documents had been translated, and beginning in 1945 Rothschild began to do partial translations of statements by artists such as Arp, Max Ernst, Georges Braque, Picasso, Miró, and especially Mondrian. Most of these were simply for her own use or to be shared with artist friends. But in 1945 she made a little booklet for her parents of diary notes by Arp that had recently been published in *Cahiers d'Art*, as if to encourage their own growing interest in modern art. And in the brochure that accompanied her Jane Street show she quoted passages from these notes by Arp that reflected her own goals as an artist:

> (I) do not wish to copy nature. (I) . . . do not wish to
> reproduce but to produce . . . to produce as a plant
> which produces a fruit and is unable to reproduce
> a still life . . . to produce directly, not thru an inter-
> preter . . . to reproduce is to imitate . . . art, however, is
> reality, and the reality of all should triumph over the
> particular . . . these works are constructed with lines,
> surfaces, shapes and colors, they seek to reach beyond
> human values and attain the infinite.

The notion of reaching beyond human values and attaining the infinite was at that time associated especially with Mondrian, who had come to New York in 1940 and died there in 1944. Even Hofmann—although his own work was at the opposite pole from the severe geometry of Mondrian's paintings—had deep regard for the Dutch painter's achievement and spoke of him with great emotion. At this time, Rothschild, like many of the other young artists she was meeting, was deeply impressed by that achievement and by the challenges that it presented. Mondrian's reputation, thanks in part to the dedicated advocacy of Harry Holtzman, was steadily growing—especially among artists. (At the time, Mondrian's paintings were still virtually unsalable, and

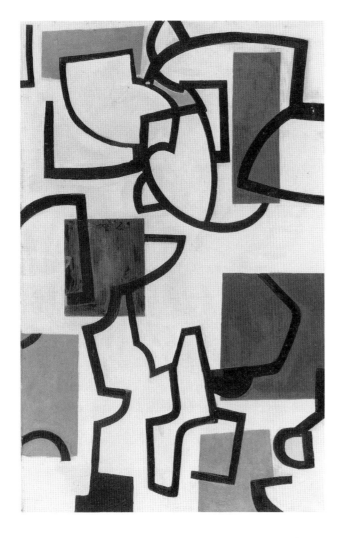

Figure 6
Untitled Composition, *1944. Oil on canvas,
28¼ × 18⅛ inches.*

when they did sell they brought rather low prices.) The extreme position that Mondrian represented offered an enormous challenge to the artists of Rothschild's generation. She herself remained very much involved with Mondrian's work throughout her life—both as something to aspire toward and something to struggle against.

Around this time, "Mondrianism" served as a model for a certain purity of form and for radical abstraction. Unlike the abstract and semi-abstract paintings of Kandinsky and Klee, which were also highly valued at the time, Mondrian's mature paintings did not relate even metaphorically to specific subject matter. For Rothschild—as for her friend Nell Blaine, who was working in a similar manner—Mondrian's presence can be seen in the simplicity and austerity of her color, in smooth and carefully controlled paint application, and in the cool purity of the use of white. In *Grey Tangent* of 1945 (Colorplate 2), although the forms themselves do not recall Mondrian, the effect of color and light and the

way in which the black lines relate to the white ground clearly evoke the Dutch painter. The forms in *Grey Tangent*, however, appear to have been derived indirectly from still-life objects, and although none of the objects is clearly discernible, one does intuit their underlying presence. What Rothschild seems to have aimed at here was the development of imagery in which a generalized subject matter could linger as a kind of overtone, even though the composition itself is basically abstract. The *idea* of objects was used to help determine the forms, but without the objects themselves being overtly represented.

Because the writings of most of the European artists in whom Rothschild and her contemporaries were interested had not yet been published in English, the methods of those artists, she recalled, "had to some degree to be reformulated intuitively, without specific reference to their actual working procedures." Rothschild remembered particularly the excitement created by the translations of Juan Gris's statements on art in the 1947 English edition of D. H. Kahnweiler's *Juan Gris—His Life and Work*, especially Gris's statement, "I compose with abstractions (colours) and make my adjustments when these colours have assumed the form of objects."[18] In *Grey Tangent*, a similar balancing of abstract form with explicit subject matter was involved—but going in the opposite direction. Rothschild's goal was to weight the balance toward maintaining abstraction despite the implied presence of subject matter, as opposed to Gris's method of maintaining the description of subject matter despite the constant presence of abstract structural elements. Between 1944 and 1947 Rothschild did a number of paintings in the manner of *Grey Tangent*, in which the purity of Mondrian is balanced with the animation and liveliness characteristic of Léger's recent paintings. Several of these works were included in her first solo exhibitions.

During Rothschild's early years as a professional artist, she was in close contact with a number of other women artists who were working toward similar goals, including Lee Krasner (1908–1984), Grace Hartigan (b. 1922),

and Nell Blaine (1922–1996). Both Krasner and Blaine had also studied with Hofmann, Krasner between 1937 and 1940 and Blaine between 1942 and 1944. The work of all three artists shows certain shared characteristics from around 1944 to 1946, in part because they had all studied with Hofmann, and in part because they were interested in the work of many of the same early European modernists. For example, all three artists had done sets of large, freely rendered charcoal drawings in Hofmann's studio, which provided motifs for related near-abstract paintings.[19] In the winter of 1943–44, while in Hofmann's studio, Rothschild did a suite of charcoal drawings that are like a series of variations on the pictorial motifs in *Abingdon Square*, and she has left behind dozens of sheets covered with studies of quasi-figurative abstract forms. Moreover, the sources on which Rothschild and her colleagues drew were very much in the air at the time: Mondrian, Miró, Arp, and also— though with caution, because of the strength of both his artistic personality and his legend—Picasso.

Even at her second solo exhibition, in 1946, Rothschild attempted to associate herself not with a single style but rather with a general approach to painting that could be roughly described as avant-garde or modernist. Along with *Grey Tangent* and related abstract-purist works, she also showed *Mechanical Personnages* of 1945 (Colorplate 3), which depicts the interior of a room with two figures in the foreground, the one on the left composed mostly of curves and the one on the right much more rectilinear. The abstracted figure style of this work is related to surrealist painting and contains echoes of Picasso's works of the late 1920s and 1930s. (This aspect of Picasso's work was also influential among the abstract expressionist painters, many of whom were using Picassoid pictographic forms in their work around this time.)

The overt figurative element in paintings like *Mechanical Personnages* can be seen as part of Rothschild's desire to retain a "humanistic" subject in her paintings. In fact, the "mechanical personnages" concept seems to have had specific significance for her, in relation to the social and economic exploitation of people during the postwar period.[20] She continued to work with this theme into 1947, when she finished one of her most striking and ambitious works in this style, *Mechanical Personnages III* (Colorplate 4), which she showed in another exhibition at the Luyber Galleries in the spring of 1947. In *Mechanical Personnages III*, the figures are more difficult to read than in *Mechanical Personnages*, and the composition and brushwork are more confident. Particularly impressive is the sweeping way that painterly effects are played against the cooler geometric aspects, and the way the heavily worked surface is contrasted with the delicacy of the color. Here, too, the curvilinear forms of the figure on the left are set against the angularity of the figure on the right—as if to suggest a male/female contrast. The curves are expansive and energetic and reinforce the liveliness of the surface at the same time that they connect specific forms to the surrounding space. This painting sums up the various tendencies within Rothschild's work at this time, and it has a remarkable energy and self-confidence for so young a painter. It synthesizes her concerns with abstraction and representation, with the hard-edged and the painterly, and between the purist and the humanistic. In fact, its strength comes in large measure precisely from the way it balances abstraction and figuration. By contrast, in related pictures done about the same time, such as *Figure and Objects* of 1946 (Figure 7), a more pre-

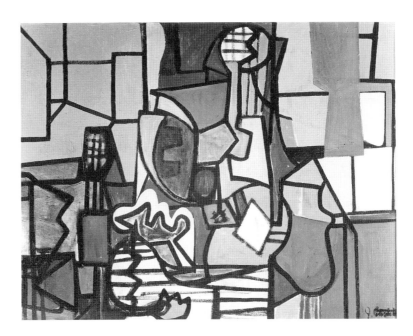

Figure 7
Figure and Objects, *1946. Oil on canvas, 38 x 48 inches. Collection Museum of American Art of the Pennsylvania Academy of the Fine Arts, Philadelphia.*

dictable, cubist-inspired grid is used. Although this painting is intricately and thoughtfully composed, it does not have the ease and sweep, or the originality, of *Mechanical Personnages III*. In part this is because it lacks the tension produced by the dichotomy between figuration and abstraction.

Rothschild's early exhibitions attracted notice not only from other artists but also from critics. Among the reviews of the Jane Street exhibition was a particularly glowing one by the artist and critic Ben Wolf, who called Rothschild "a remarkable young talent" with a "sureness and maturity that belies her age" and a "sense of rhythm and instinct" that made her "a genuine find."[21]

The exhibition also resulted in some significant sales. The art dealer Karl Nierendorf bought a painting (now in the collection of the Solomon R. Guggenheim Museum). Jere Abbot, the director of the Smith College Museum of Art, bought a collage, as did Agnes Mongan for the Fogg Art Museum at Harvard University. And directly after the exhibition, Rothschild was elected to membership in the American Abstract Artists, which entitled her to show at their next annual exhibition, in the spring of 1946.[22] Around this time she was also introduced to the dealer Rose Fried by Marcel Duchamp, who had been favorably impressed by the Jane Street exhibition, and she began to meet a number of older artists. She got to know Charmion von Wiegand and Burgoyne Diller, who were among the leading abstract artists in New York, and through the composer Edgar Varèse she met Fernand Léger.[23] Around this time she also made a pilgrimage to the studio of the recently deceased Mondrian, which still had his last unfinished works in it.

Rothschild's 1946 exhibition at the Luyber Galleries drew even wider notice. In a sympathetic review, Carlyle Burrows referred to her "nicely painted abstractions" as evidence that "her style continues to grow larger and richer in feeling."[24] Edward Alden Jewell, the often difficult critic of the *New York Times*, noted that Rothschild was continuing to develop and was pointed toward a promising future.[25] Jewell's enthusiasm for her work was such that he named her as his selection in a Critics' Choice exhibition at the Grand Central Art Galleries that December. (The following January, her painting *Mechanical Objects* was included in the Pennsylvania Academy of the Fine Arts's 142d annual exhibition of painting and sculpture, as well as in the American Abstract Artists' annual exhibition.)

At this time Rothschild was exhibiting both small works in gouache and collage and the distinctly larger oils. Some critics felt that the smaller gouache paintings and collages worked better than the oils. René Arb, for example, noted that Rothschild had

> sharpened her vision, heightened her color, and improved her technique since last year. She is still at her best in gouache, and the small pure abstractions and collages are well-knit, fortuitous, varied compositions of line, shape, and color. Their charm and clarity is somewhat lost in some of the large oils, derivative of Picasso. *Room with Landscape*, however, predicts that this young artist may soon master the latter medium as well.[26]

Ben Wolf also noted that Rothschild's work had developed since her exhibition at the Jane Street Gallery: "Since that time, color has become more integrated and line better controlled. Add to this a growing understanding of composition and a feeling for pigment and you have a promising brush in the arena of young American hopefuls." Among the paintings Wolf singled out was *Grey Tangent*, which he felt "adroitly balanced yellows and greys in relation to linear movement."[27]

That fall, Rothschild's personal life also began to undergo a dramatic change. During the summer of 1946 she went for the first time to Provincetown, the center of artistic activity on Cape Cod, and there she met two men who in different ways were to have an enormous effect on her future: the painter Karl Knaths and an aspiring young novelist named Anton Myrer.

Rothschild had met Knaths briefly the previous winter, when he saw her show at the Jane Street Gallery. But it was not until she was reintroduced to him by the painter Angele Myrer in Provincetown that summer that their friendship began. Knaths, a tall, dignified, and forceful man who was thirty years older than Rothschild, had had a long and influential career as a teacher as well as an artist. He had taught painting at Bennington College and also at the Phillips Collection in Washington since 1938 and had recently taken up year-round residence in Provincetown. He was passionately devoted to music and had developed a method for creating color and spatial structures in his paintings that had a mathematical basis which he compared to music. Knaths's color system was based on the one perfected by Wilhelm Ostwald, which was fairly widely used at the time; in fact, Winsor & Newton had created a color chart coordinated to the Ostwald system, complete with hand-painted removable paint chips. Knaths instructed

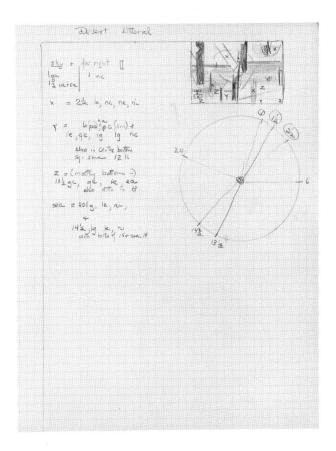

Figure 8
Notebook page with Ostwald color analysis of Desert Littoral,
1955. Pencil on paper, 10¼ × 8 inches.

Rothschild in the use of this method, and throughout much of her life she used her own version of the Knaths-Ostwald system to make compositional sketches for paintings and also to analyze finished paintings by herself and others (Figure 8). Part of this method's appeal for Rothschild was that it allowed for a direct parallel to be made with octaves and therefore "was perfect for... working with a system related to musical harmony."[28]

When Rothschild met him, Knaths was painting in a manner derived from early Cubism, in which he submitted clearly legible subjects to a cubist-inspired simplification. Knaths would have responded most strongly to the aspect of Rothschild's work embodied by *Mechanical Personnages*, or to the cubist grid of *Figure and Objects*, rather than to her "pure" abstractions. And although during the next few years Rothschild returned intermittently to the purist sort of abstraction embodied by *Grey Tangent*, her subsequent work, probably in response to prodding by Knaths, began to move in a different direction.

The second, and even more fateful, acquaintance Rothschild made that summer was with Angele Myrer's son, Anton, whom she would marry the following year.

At the time they met, Myrer had recently returned from service in the Marines and was about to begin his senior year at Harvard, where he was studying history and literature and planning to become a writer. At the end of the summer, Rothschild went back to New York and Myrer returned to Cambridge. Over the course of the fall and winter they corresponded ardently and journeyed to see each other whenever they could. Within a short time, Myrer occupied a large part of Rothschild's inner life, and they began to talk about marriage. On the evidence of his letters to her, Myrer seems to have been somewhat hesitant about committing himself definitively to one person so early in his life.

After an awkward period of hesitation, they made plans to visit Europe but then decided against it for the sake of their careers, mainly his. Although Rothschild very much wanted to renew her contact with Europe and European art, she was even more eager to marry; she was at an age when remaining single implied a failure of sorts, and her family surely expected her to marry. She was also sensitive to the fact that her own career as an artist was far in advance of her future husband's, and that he needed time in which to develop. By the summer of 1947 she had already had two one-person exhibitions in New York and her work was beginning to be included in prestigious group shows and to enter important collections. Myrer, by contrast, was just starting out. He had written only some short fiction and had as yet published nothing.

"*I* am at something of a jumping-off-place in my work—& Tony is at a jumping-*in*-place," Rothschild wrote to her parents that summer. "What we both really *need* & want is a chance for uninterrupted work & to be together. We decided it is too hazardous to go into a situation [Europe] with so many complicated unknowns when we had not even had a chance to establish a pattern of living together.... Tony did some heavy reevaluating etc., between the end of school & now...he has gotten things better understood & now feels there is no reason why we should not be married as soon as all the practical things can be worked out."[29]

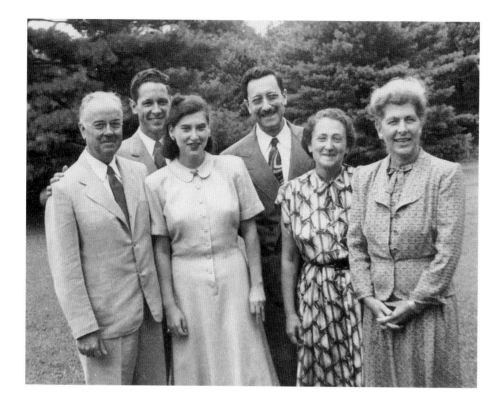

Figure 9
Wedding photograph, August 17,
1947. From left: Raymond Myrer,
Anton Myrer, Judith Rothschild,
Herbert Rothschild, Nannette
Rothschild, Angele Myrer.

They were married on August 17, 1947, at Old Dam Farm, the Rothschilds' country home near Ossining, New York (Figure 9). Shortly afterward they rented a house in Provincetown, planning to divide their time between Cape Cod and Judith's studio on Twelfth Street in New York. But Myrer, who was planning his first novel, felt that New York would have a corrupting influence on their artistic ambitions, and within a short time they decided to pick up stakes and leave for California. It was the first of many times that the circumstances of Rothschild's life would in large measure be determined by Myrer's perception of what he needed for his own work. And it was the first of many times that she would willingly follow him wherever it was he determined that his needs could best be met.

A New Life, 1947–1950

Two months after their wedding, Rothschild and Myrer drove to California. Taking the southern route, they passed through the deserts of Arizona and New Mexico, whose vastness and colors made a deep impression on her. She would use them as subjects numerous times in succeeding years, in paintings called *Southwest* (see Colorplates 10 and 36) and in other works that emphasized the subtle gradations of yellow ochers and the dry glare of the desert landscape.

Although they had planned to settle in Los Angeles, they were put off by the crassness of the film capital and decided to drive up the coast looking for a place to live. Eventually they settled on a small house in Carmel Highlands, a short walk from the sea. They had gone to California seeking an ideal of simplicity, and they relished the run-down, primitive feel of the place. After a brief settling-in period, they established a work routine and began the first of the extensive reading programs that they would share in the coming years. That winter of 1947–48 they became involved in reading the French surrealists, and this led to lively discussions about what they were reading and about their own aspirations as artists. The hermetic, creative life that they had set for themselves began to take shape.

Characteristically, Rothschild became involved with the landscape and local plant life as well as with the house itself. "Our place turned out to be a cottage up a hill, just off the main road," she wrote her parents.

> It is a strange little, haphazard sort of structure but actually just exactly what we were hoping for. The living room is large enough, very bright, and easily divided into studio and living room. . . . Around the house is quite a little garden with a couple of beautiful trees, all sorts of sedum plants, begonias in bloom, rose bushes, nasturtiums, acacia and a lot we have yet to discover and more whose names I forget. It is overgrown and needs a lot of doing . . . as does the house itself. . . . Every ceiling slopes a different way, and sometimes three or four different ways . . . which we like. . . . And we can see a piece of the sea from the house.[1]

A few months later they were forced to move, and in the spring of 1948 they set up housekeeping in a studio-barn in Monterey, where they were particularly enthralled by their new landlord, a larger-than-life local character named Jean Varda. This ramshackle structure, which had the literary interest of being just a few blocks from John Steinbeck's Cannery Row, had been built by Varda himself. Rothschild was taken by the quality of the light and space there, and by the rough-hewn white painted furniture that Varda had made for it.[2] Varda was himself an artist and it was he who had painted the shacks and shanties on Fisherman's Wharf in the bright colors that had made them a local attraction. He also knew a number of well-known writers, including William Saroyan and Henry Miller, and was supposed to have served as the model for Henri in Steinbeck's *Cannery Row*. He seems to have embodied for Rothschild and Myrer a kind of quintessential West Coast bohemianism. Rothschild was impressed by his "gusty elan" and ready wit, which combined "a kind of social, aesthetic awareness with a brilliant and satirical humour. . . . He attacks everything with tremendous force and originality and with great appeal."[3]

During those first months in California Rothschild's career seemed to be maintaining its momentum. She was included in a show at the Boris Mirski Gallery in Boston. She participated in "Abstract and Surrealist Art," the fifty-eighth annual exhibition of American paintings and sculpture, which opened in November at the Art Institute of Chicago, where she is listed in the catalogue between Mark Rothko and Alfred Russell. And some of her paintings were being shown in the back room of Rose Fried's Pinacotheca Gallery, one of the most prestigious venues in New York for abstract painting.[4] But at the same time, her distance from New York limited her ability to follow up on fortuitous opportunities. That December, for example, Marcel Duchamp and Katherine Dreier saw Rothschild's work at Fried's gallery and were enthusiastic about it. Fried wrote Rothschild that they wanted to see more of her work and then possibly buy. Rothschild was excited by this prospect and

told her parents that she would send things from California as soon as she did them.[5] But the delay proved fatal, for Duchamp and Dreier lost interest. Although Fried continued to keep some of Rothschild's paintings in stock, it would be nearly ten years before she mounted a proper exhibition of it.

Gradually, Rothschild began to place more psychological emphasis on Myrer's career than on her own. Myrer was working hard on his first novel, and the couple led an austere life that centered on creating art rather than promoting it. Under Myrer's direction, they developed the attitude that they ought to remain above the fray and avoid self-promotion as well as fleeting literary and artistic fashions. Their goal instead was to live in a "timeless" way and pursue a timeless art that would transcend the contingencies of its historical moment. To them, as to many other artists of their generation, the question of whether or not such a goal was actually possible did not come under doubt.

Rothschild's descriptions of their life together give a good sense of their dedication: "We finish breakfast and are at work by eight thirty. We take between one and two hours out for supper and dishes, and then go back to work until eleven thirty or twelve. I think we are both beginning to look as though we have spent our lives living under a rock, but it is worth it in terms of the joy and discovery in our work."[6] Such descriptions, of course, were meant to reassure her parents, who were providing them with financial as well as moral support. In 1947 the Rothschilds had set up irrevocable trusts for all three of their children, but only Judith was actually living on the income generated by hers. This sum was a relatively modest one, and she and Myrer were the recipients of various kinds of "Care" packages from home, whose contents ranged from cigarettes and food to flower bulbs and sheet music. She was also the only one of her siblings who was living so far from home. (Her brother and her sister's husband had joined the family business.) Her letters to her parents were therefore to some degree meant to allay their fears about both her well-being and her seriousness as an artist.

And in fact, both she and Myrer *were* working very hard. So hard that they became somewhat intoxicated by their own quest for purity and apartness. When her parents visited them in the fall of 1948, the four of them frequently discussed philosophical and ethical issues, and the elder couple came away from the encounter feeling somewhat disturbed. It was as if Rothschild and Myrer had formed a kind of private cult, with a membership of two. This is apparent in a letter Rothschild sent her parents a few months after their visit:

This sense we have come to have, that we are living a life (as completely as we are able) which embodies and fulfills our conviction of what man is, and what we believe we should do in the world, as a force for good, has made this beginning in our marriage a time of great and unending joy. The sense that what we are doing is right for us to do, has given us a greater certainty in all our relations, as well as in our work. It has inspired us and humbled us. And most of all, I think it has affected us both so deeply that we feel convinced we have found the way for us to live, and that we will follow this road faithfully and joyfully because we have found a bliss in the dedication of all our efforts towards the big things we believe in. For us this I am convinced is the only way we could ever live....

I think this sense of urgent dedication has led us gradually to discard many considerations of "things." ... I don't suppose I will ever get to the point where I would *hope* to live in a place without hot water, or where we *have* to walk across the back yard to the john we share with Virginia Varda. But I think I have come to care less about such annoyances, and to see for its true worth many of the material considerations which had become increasingly dominant parts of my thinking before we were married.... And I think this schedule we usually stick to, which allows at least 12 hours a day (except for Sundays when we usually sleep late) for our work is about as intensive a schedule as we can sustain, at least at this time in our lives.

We both feel we have accomplished a good deal. Most of my work has been very divers. But I have never had such a sure sense of what I want to say, and what are the problems I face in the saying of it. Everything I have attempted has not been successful, I know. But I have gained greatly in power and understanding by the failures, and there are beginning to be encouraging signs.[7]

Ironically, her parents were anything but assured by the "purity" with which she and Myrer practiced their respective arts. The Rothschilds feared that this kind of behavior would produce an unhealthy distance from the realities of everyday life. They also feared that their daughter was becoming increasingly alienated from their own values, which were centered on family and social responsibility. A somewhat tense dialogue developed in their correspondence, in which Rothschild and Myrer would try to explain and justify the course they had

Figure 10
Surreal Landscape, *1948.*
Oil on canvas, 23⅛ × 28⅛ inches.

taken, while Herbert and Nannette Rothschild expressed concerns that Myrer in particular found more and more irritating. He felt that their implied criticisms were yet another manifestation of what he considered to be their bourgeois mediocrity, materialism, and philistinism.

Because of Rothschild and Myrer's relative isolation (they had no telephone and received phone messages at a neighbor's), they greatly relished the contacts they did make—mostly local artists and writers, such as the Vardas, Barbara and Ellwood Graham, Henry and Paul Rink, and David and Elaine Duncan. Rothschild frequently described their friends and the events of their daily lives in the regular letters that she sent to her parents.[8] But when friends of her parents stopped by for an unannounced visit, she could not refrain from writing her parents an acerbic letter asking them please *not* to give their address to friends who were vacationing in California, even though she knew she risked making her parents think that she and Myrer were "getting too sensitive for our own good."[9]

During her first months in California Rothschild continued to paint in the abstract geometrical mode that she had been working in back East. Soon, however, the Monterey landscape began to make itself felt in her paintings, and she began to work with motifs that were based on the commanding presence of the sea. This is evident in *Surreal Landscape* of 1948 (Figure 10), where the horizontal sweep of the shoreline is suspended, as it were, from the vertical forms on the left that anchor to the picture plane the suggestions of deep space. Played against the rather naturalistic view of the shoreline, these verticals introduce a strong note of ambiguity and contradiction. In a general way they suggest piers or columns. But at the same time, because they are neither thoroughly described nor really fixed in space, they function as signs for architecture. And by implication we also read them as signposts of our own near-vertical presence within the landscape. This is a compositional format that she would develop further in a number of pictures during the next decade, such as *Antelopes* (Colorplate 8) and *Byzantium* (Colorplate 9).

The byplay between naturalistic description and imagined forms in *Surreal Landscape* is one of the early instances of a new kind of direct contradiction in Rothschild's work. Up until now she had been painting either fairly naturalistically or quite abstractly, but she had not combined these basically opposed modes in such a distinct or disjunctive way. The title *Surreal Landscape* is not coincidental. It reflects Rothschild's reading of surrealist texts at this time. "As a result of our concern with the Surrealists," she wrote at the end of

1947, "we began to feel a quality in their *method* which neither of us ever had employed much, and which we feel . . . well, at least is worthy of investigation as a possible tool."[10]

At the same time, Rothschild still continued to work in, and generally favor, her earlier, more abstract manner. This can be seen in works such as the sensuously biomorphic *Narcissus* (Figure 11) and in the starkly geometric *Tenement* (Figure 12), which is noteworthy for the taut surface tension of its flat, rhythmic forms.

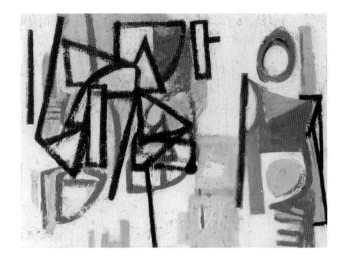

Figure 13
Weirs, *1949. Oil and sand on canvas, 18 × 24 inches.*

That Rothschild still set high store by this sort of work is evident in the fact that she showed *Tenement* at the "Forum 49" exhibition in Provincetown in 1949, where it was shown alongside works by Jackson Pollock, Karl Knaths, Weldon Kees, and Fritz Bultman (see Figure 15), and at the 1950 "Réalités Nouvelles" exhibition in Paris, the first showing of her work in Europe.

A number of the paintings she did that spring in Monterey combine abstract forms with a metaphorical subject. In *Weirs* of 1949 (Figure 13), for example, the byplay between the open network of forms on the left and the more solidly anchored ones on the right functions pictorially on a completely abstract level. But the title invites us to read the linear forms on the left as nets and the forms on the right as a figure. The tangibility of the forms is enhanced in this case by the addition of sand to the paint, providing a rough texture that gives the abstract shapes a certain concreteness. A similar division of the canvas into left- and right-hand areas, with

Figure 11
Narcissus, *1948. Oil and sand on canvas, 34¼ × 30 inches.*

Figure 12
Tenement, *1948. Oil on canvas, 30 × 36 inches.*

Figure 14
Eidolon, *1949. Oil on canvas, 40 x 27⅞ inches.*

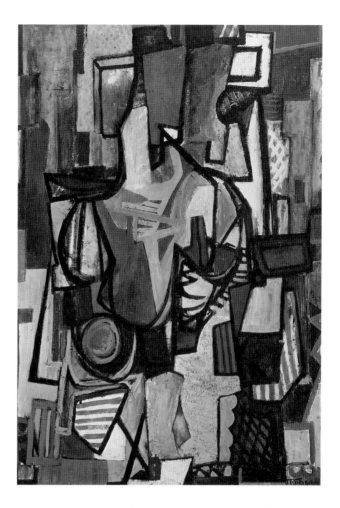

elements of figural overtones enhanced by the roughness of the surface, is also seen in *Untitled Composition* of late 1947 (Colorplate 5).[11] Here the texture is provided by the rough burlap on which the picture is painted. Once again the painting reads primarily as an abstract composition with overtones of figuration.

The figural element is more explicit in *Eidolon* of 1949 (Figure 14), which is densely worked with a variety of paint textures. Within the fragmentary, cubistic network of forms we can discern parts of a figure in a room and even note such details as a framed picture and perhaps a mirror in the background. The forms of the figure tend to merge with the space that surrounds them, forcing us to read the picture in a fragmentary way, making out a hand here and head forms there. Although we are never quite able to combine the forms into a continuous figure, the conventions of Cubism allow us to read them quite readily. The title, *Eidolon* (Greek for "phantom"), suggests the dynamics of the style itself, which gives us glimpses at an apparition or ghostlike presence. In this painting and in a number of related works the subject matter acts as a kind of spectral inspiration that the artist uses to generate a structure of abstract forms. The eidolon image, like several images and themes that Rothschild developed at this time, would appear in a very different way in her later work (see Colorplates 41 and 42).

Since the couple had arrived in California, Myrer had been working on his first novel, which was set in a Cape Cod town that resembles Provincetown and whose main character was modeled on Hans Hofmann. He finished the book in June 1949, and the 428-page manuscript, which was then entitled "One Bread, One Body," was a matter of no small pride both to Myrer and to Rothschild, who had given him a good deal of support as he wrote it.[12] Rothschild considered it to be a "tremendous work," and they both had high hopes for its successful reception—which would not only allow them a certain financial independence but would also help justify their existence to both their families. (In this regard, Myrer's standing was more tenuous than Rothschild's, for while a woman was not usually expected to be self-

supporting, a man who sat around writing all day and produced no results might appear to be a freeloader.)

This need was exacerbated by the growing tension between the Myrers and the Rothschilds. Although the Rothschilds admired Judith's intentions, they were increasingly uneasy about the kind of life that their daughter was living and clearly sensed Anton Myrer's thinly veiled antagonism. The situation came to a head over an article by Lawrence Frank, a leading figure in the Ethical Culture society, which Herbert Rothschild had sent them. Frank believed that "cultural renewal" could be achieved only through "scientific knowledge of nature and man," and in his article Frank asserted that the function of the arts was to communicate the new insights gained by scientific understanding.

Rothschild and Myrer were so enraged by what they considered the smugness of Frank's ideas and the pomposity of his means of expressing them that each responded to Herbert Rothschild in a detailed, separate letter. Judith, in a five-page, single-spaced, typewritten missive, attacked Frank's article point by point and was

especially hard on what she felt was his platitudinous language and self-righteousness.[13] Shortly afterward, Herbert Rothschild replied with a five-page letter, defending Frank and remarking that he thought the young couple's vehemence and "bitterness" were an expression of an "unrealized insecurity" as well as their youth.

Even more hurtful was Herbert Rothschild's concluding salvo to the childless couple: "If Frank (I'm back to him) were pressed to name some of the enduring values, I'm sure he'd include family life. There, if anywhere, in every culture, is communion." He then described Thanksgiving dinner with Rothschild's brother and sister and their children, and the unity and togetherness they all had felt.[14]

The debate was continued in subsequent letters, with sharp rebukes on both sides. Along the way, Rothschild and Myrer had typed out and sent Herbert Rothschild a copy of Albert Camus's essay "Neither Victims nor Executioners."[15] This, they felt, offered an implicit refutation of Frank's views and a much more realistic appraisal of the postwar political and moral situation than he had made. In a joint letter, Rothschild and Myrer also sent a rejoinder to the accusation about their being bitter and vehement: "That you found bitterness, where vehemence alone had been felt or meant by us, might be considered as diagnostic of you as you found it of us."[16] At this point the exasperated Herbert Rothschild decided to withdraw from the argument, pleading lack of time and the need to discuss these issues face to face.[17]

One of the things that became clear during this exchange was that Judith's values had become very different from those of her family. This was of course part of the normal process of growing up and becoming independent, but the rift was made even deeper by Myrer's high-minded notion that the Rothschilds were excessively materialistic and were in a sense the enemies of art and artists. Matters were made even worse when the couple returned east the following spring. During a visit to Old Dam Farm, Myrer and Herbert Rothschild exchanged heated words and Myrer called his father-in-law a philistine right to his face.

What made this situation even more charged is that Rothschild and Myrer were living almost entirely on money that was coming from her family. And as feelings ran higher, they felt some pressure to act on their ideals. At one point, apparently at Myrer's insistence, Rothschild tried to have her father dissolve the trust that he had set up for her, and whose income was covering their living expenses. The trust, however, was an irrevocable one

and could not be broken—thus allowing her and Myrer the luxury of standing on principle while retaining the income. Rothschild did, however, persuade her father to sell a number of securities that were held in her name.

This conflict turned out to be a bruising one for both sides, and the wounds would not heal for a few years— during which time the two couples treated each other with a certain amount of formality and coolness. Even long afterward, the pain inflicted on both sides was not forgotten.

While in California, Rothschild had put greater emphasis on larger oil paintings in preference to the small gouaches and collages that had sold so well at her New York shows. But in the middle of 1948 she reached what she felt was a "hiatus" with her painting and became unsure of which direction to pursue. She had received feelers about two solo exhibitions—one with the Jane Street Group in New York, which was contemplating taking space uptown on Madison Avenue, and the other in California. She was uncertain, however, about whether she wanted to show at all, given what she considered to be the experimental nature of her recent work. By her own account she was trying to fuse "the best in [the] surrealist symbolic tradition within the abstract idiom," and she was aware that she had been working in several different directions at once.[18]

By the spring of 1949 she and Myrer began to think seriously about returning east. Their initial plan had been to go to California for a single year to have uninterrupted time to work, and it had been implicitly understood that they would go back east at the end of that time. And although they felt they had both profited enormously from their sojourn in California, Rothschild wrote to her brother early that year that

we are beginning to think joyfully of our return. As I see it now our decision to come out here originally was, for me, (at least) terrifically apt. New York, with all its endless stream of stimuli & ideas, can be a wonderful force—& it was for me, I think, when I got out of the cloistered halls of Wellesley. But it can also be a terrific in-coiling whirl-pool. And the young—beginning artist is, I think in great danger of being sucked into its vortex without finding his own way. This time here, I feel, saved me, for the moment at least, from that. And I'm glad we decided to stay this long because I needed these extra months to reinforce & explore the direction I've found in my work. Now I feel that I (may) have enough strength & direction to be able to find the things the

East has to offer & not get hopelessly enmeshed in the sheer wealth of intellectual opportunity that exists there.[19]

Although she did not say so, Myrer was having difficulty finding a publisher for his novel, and they felt that being closer to New York might also help on that front.

That May they drove back east and spent the summer in Provincetown, where they had the use of Angie Myrer's house and studio. They were both full of energy, and Rothschild's optimism about her future was reinforced by her inclusion in the Denver Art Museum's annual exhibition of contemporary art. As she wrote excitedly to her parents at the time, "there were 1,390 entries of which they were able to accept 142! They took my gouache 'Retrospection' which I did in Monterey."[20]

That summer in Provincetown was a very important one for her. Both she and Myrer became deeply involved with the Forum 49 group, which was formed largely through the efforts of the poet and painter Weldon Kees, who brought together a diverse group of artists that included William Baziotes, Fritz Bultman, Adolph Gottlieb, Hans Hofmann, Karl Knaths, and Robert Motherwell. Rothschild helped organize an exhibition of paintings (Figure 15), along with Hofmann and Knaths, and prominent writers such as Dwight MacDonald came to lecture. The mood of the Forum events was at once serious and festive, and the suave but hard-driving Kees, who came across as an incongruous mixture of a 1930s

Figure 15

*Photo of "Forum 49" exhibition, Provincetown, Mass., summer of 1949. From left: Judith Rothschild, Fritz Bultman, Weldon Kees. The paintings on the wall are by Bultman, Jackson Pollock, Kees, and Rothschild (*Tenement, *1949, see Figure 12).*

Hollywood tough guy and a Proustian aristocrat, threw himself into the proceedings with gusto. "With an admission fee of only sixty cents, attendance had broken records even on hot and sultry nights. . . . Even the most celebrated speakers were paid only with a bottle of Scotch, but they were put up for the night by the artists and by their close friends. An added attraction was that the forums were always followed by lively parties . . . with Weldon Kees dancing until all hours."21

Rothschild and Myrer's friendship with Weldon and Ann Kees was very important to all four of them. Kees was an extremely dynamic and persuasive person who had a knack for bringing people together and generating enthusiasm. He was seven years older than Rothschild, and at the time they met he seemed infinitely more worldly than either she or Myrer. Moreover, Kees was a writer and a painter, and so both Rothschild and Myrer were able to sustain professional dialogues with him. The two couples became so close that in the fall Kees and his wife would live in the same building in New York as the Myrers; and the following year, when the Myrers went back to California, the Keeses followed them west.

By 1949 Kees had already published about forty short stories and a volume of poetry, and he was preparing to publish a second book of verse. He had also worked in film, as a jazz musician and jazz chronicler, and was a painter who actively exhibited his paintings. In addition, he wrote art criticism, and in the fall of 1949 he would serve a brief turn as art critic for the *Nation*. "Weldon was one of the last great romantics," Anton Myrer later remembered. "He genuinely believed that sensibility and talent would receive due recognition with time, that beautiful and important moving pictures would still be made in Hollywood . . . that open-handed generosity of spirit was a vital necessity in a world of gentility and merit."22

When they met, the Myrers were flattered that Kees and his wife, who had been an editor at *Antiques* magazine, were willing to pay any attention to them—not realizing the degree to which Kees himself was in desperate need of the respect and admiration of younger artists. "We have been spending a lot of time with the Keeses," Rothschild wrote to her parents,

> who are not only good company, but are, we think, very much the kind of friends we really need. Weldon is good looking (Nebraskan) in his mid thirties who has accomplished a tremendous amount for his years.

He knows everyone *we* have merely been reading, or reading about, or conjecturing over, from Whittaker Chambers, Alfred Kazin and Bruce Bliven, to Francis Biddle and Edmund Wilson. (He got Biddle to speak here last night at the Forum.) He and Ann both are very witty conversationalists. And they also know a lot of the younger unknown writers and painters. Weldon seems to have a very clear critical judgement, and a good sense of the total scene in the arts today—plus an attitude which is neither ivory towered, nor the usual foil for that . . . [the] aggressively, partisanly political. We've probably been overly wary about seeing them because they are "big boys" around here, and it seemed silly that they should see us when they could be seeing Edmund Wilson (who is in Wellfleet for the summer). But they keep coming over and asking us out, so we have been very glad to be with them.23

As the summer wore on, however, they began to become aware of Kees's vulnerabilities. Rothschild saw the Keeses as people "who seem to have come to accept a lot of the sad facts about the general condition in the arts today. . . . And Weldon seems to have a pretty mature attitude about himself—he seems to be one of the few artists whom we know who is able and willing to recognize his own inadequacies, and the fact that he is not going to become, and has not the talent to become, the Joyce of his generation, and who has not been thrown into the depths of despair by the realization."24

Because both Rothschild and Myrer were aware of the limitations evident in what Kees actually produced, he acted as a kind of cautionary figure as well as an inspiration. They realized that his spectacular range of activity involved a reckless dispersion of creative energy, and that his total dedication to art was as dangerous as it was appealing. So while they admired his fluency and sophistication, they also both feared precisely the kind of artistic failure to which Kees seemed doomed.

Less dramatically, but in the long run much more significantly, Rothschild also renewed her acquaintance with Karl Knaths. She and Knaths exchanged studio visits in Provincetown, where he gave what she considered to be probing critiques of her work, and he began to assume the role of mentor. The next February (1950), in New York, he gave her a critique that she said had the effect of "a brick bat." He criticized the way she was using "intervals," the term he used to designate rhythm, and "achieving a relationship through significant similitudes (of shapes) vs. dissimilitude." He also criticized

the difficult legibility of her pictures, which resulted from her fragmentary dispersal of forms, and he told her that she needed to create stronger rhythmic patterns. Although she realized that Knaths was himself still very much in the "grip" of the cubists, which limited his critical perspective, he nonetheless persuaded her to reconsider her direction.

"I can see his point & it has led me to see my own weaknesses *much more clearly*," she wrote. The degree to which Knaths seems to have taken over the role of her father at this time, and to have directed her attention to her shortcomings rather than her strengths, is remarkable. "I think I have not yet enough spatial certainty throughout all of my canvases," she wrote, echoing Knaths, shortly after one of his critiques. "Certain areas I seem not to have lived through sufficiently to have related them unambiguously to the whole." Instinctively, she realized that Knaths's approach to form was more literal than her own, and she observed immediately afterward that "generally speaking, Karl's leaning [toward] Gris makes him unlikely to like my attempts to evolve a structure like Mondrian's . . . i.e., where every area *can* be the focus."[25] But nonetheless, her confidence in her own judgment was shaken, and the time that she spent in close proximity to Knaths during the summer of 1950 drew her inexorably closer to the older artist's own aesthetic.

At this moment of uncertainty about her direction as a painter, she felt that Knaths's ideas about composition and his advocacy of the Ostwald color system might offer a stable intellectual framework for her art. Knaths was also a prod to her doubts about the claims of pure abstraction as exemplified by Mondrian—whom Knaths also greatly admired but remained wary of as an influence. In particular, Rothschild began to doubt whether extreme abstractions could include deep human feeling. "It now seems as though the whole sum of the plastic redirections which abstract art as I knew and practiced it, . . . led to . . . the effacement of a deep aesthetic (katharsis) participation," she wrote in her journal that December.

It is hard to pull out of because it is so pleasant the old way. And because also there is the surprising force of habit. And the reassurance of pictorial success (at least relatively certain). Uptown I look long and hard at the pictures . . . and the only emotion given off by the contact is at best, technical admiration. In both the Mondrian show at Janis and the Braque show the paintings that moved me were the *pre cubist* ones . . . and

I know I am not alone in this reaction. Sometimes I get to think the whole Mondrian fervor is really just a case of the Emperor's new clothes. Only no one yet is sure enough to speak and say how thin the emotional aesthetic involvement is even for the most ardent spectator.[26]

These doubts and her concern about them became almost obsessive, and she continued to write about Mondrian over a period of several days.

As for the "transcendent" which Karl talks of—more & more I feel that it must come (should say "*may* come") through the struggle with the human situation (& the plastic one *also*—but not solely—) in the canvas. Be aware of it. Cultivate it. Know it when you get it. . . . But Mondrian was wrong in trying to *isolate* it. One must not expect to achieve transcendental quality by simply trying to paint it, anymore than one can achieve saintliness by simply concentrating on martyrdom. The quality of "goodness," for instance, has impact on us only when it comes to us through a human situation. (Or at least it has most force then.) Suffering as a *concept* is not likely to be as terrifying as an experience with it. . . .

Still working on this question of the Purist direction in art. Seems to me now that its limitations cripple its aesthetic potentialities—i.e., It ignores "man's problem." . . . Mondrian eliminates this whole struggle from his work. He pretends that no such problem exists. His work (whatever his writing may say) deals only with this sublime finality.[27]

Rothschild was very much preoccupied by the possibility of achieving a new synthesis in her art, but at the same time she noted, "It will take great original power to revive the human dignity of connotative symbols in our time," and she wondered about her capacity to do so, but she focused on the challenge of trying.

Rothschild was encouraged in this direction not only by her discussions with Knaths but also by Romare Bearden, whom she met through the Keeses in mid-December 1949, when the two families lived in the same building on the Lower East Side. She was heartened by Bearden's positive reaction to *Tenement* (see Figure 12) and impressed by his keen awareness of technical matters. "The main thing I got technically," she noted the next day in her journal, "was the thing he said about 'cutting planes.' Spoke of Gris' doing this continually & the problem of the *edges* (which I have become aware of lately especially) being consequently too broken.

Spoke of a Bronzino nude, & how the canvas always flattens towards the edges. And of the increased power of the color in Titian & Tintoretto by their use of *empty* spaces." She was also impressed by Bearden's sympathy for her "preoccupation with the human as well as the plastic," and by his profound understanding of the old masters.[28]

But at the same time, she still saw Mondrian as a kind of touchstone, and when she was asked for a statement for the *Réalités Nouvelles* catalogue a few months later, she began her statement with a quotation from Mondrian, which she interpreted to allow for the reintroduction of explicit subject matter in painting, by emphasizing the possibility of moving away from "pure" abstraction toward paintings that might synthesize "humanistic" content within the context of apparently "abstract" imagery:

> Mondrian wrote: "Today the great simplification of plastic means is accomplished. The young artist has but to choose." He foresaw that it would no longer be necessary for us to rivet our attention solely on further investigations of plastic means, but rather that we could be free to expand our use of the means already uncovered by his generation—first, to find new expression of the transcendent aesthetic vision; and secondly, to evolve forms and images which evocatively embody our most intense human aspirations. I believe abstract art permits a manifold expression of Idea. It need not necessitate constriction of concern to plastic structure alone. It can be a forceful and completely exciting vinculum between the plastic and the human—the formal and the spiritual. In a world assaulted by fear and materialism, abstract art which affirms man's effort toward a transcendent vision is an exigent necessity.[29]

Her ambition was to synthesize these opposing ideas in her paintings. It now remained to see if it could really be done.

Way Out West, 1951–1957

Although the time Rothschild and Myrer spent on the East Coast was intense and stimulating, over the course of 1950 they began to yearn for the simplicity of their life in California. That December they returned and rented a house at Big Sur. There Rothschild found the landscape "generous" and majestic, and she embarked on an extended series of paintings in which landscape figured as a major element.

It was during this period that the influence of Karl Knaths began to be strongly felt. It was evident first in her more lively brushwork and her increasing tendency to stylize her forms from naturalistic motifs; eventually it extended to her Knaths-like use of a network of angular contours that derived from Cézanne and Cubism. In contrast to Knaths, however, Rothschild's imagery generally remained more abstract and difficult to read. While the level of representational legibility in Knaths's pictures tended to remain fairly consistent (see Figure 46), Rothschild continued to favor more ambiguous imagery and to mix abstract and descriptive imagery in the same picture.

Later Rothschild remarked that Knaths was able to have his abstract scaffoldings subsume his intuitive process, so that he had the freedom to move instinctively through the rigorously worked-out structures he had devised. Rothschild greatly admired this aspect of Knaths's creative thinking, and her later remarks about his method could well be related to her own work during the early 1950s: "One thinks of James' insistence that the true artist has to be able to hold at least two dichotomous things in his mind at the same time. Knaths' way of working required that he master an enormous group of rather rigorous relationships, very much as a musical composer does and then be able still, to give his creative imagination free reign."[1]

Around this time Rothschild also invested a good deal of energy in literary themes, a direct result of the extensive reading program she had embarked on with her husband. Myrer's first novel was published by Random House in the fall of 1951, under the title *Evil under the Sun*, but it received little critical attention and did not sell well. He then began to work on a war novel that he hoped would have epic proportions and would establish him as a writer. The two of them spent many evenings together reading, and sometimes they read whole books aloud to each other, including *Moby-Dick*. After Charles Baudelaire and Stéphane Mallarmé, the authors who most appealed to them at this time included Herman Melville, Gustave Flaubert, Ford Madox Ford, and William Butler Yeats.

The large picture called *Herodiade*, 1952–53 (Figure 16), seems to have been inspired by Rothschild's reading of both Mallarmé's poem by the same name and Flaubert's story "Herodias." Within the cubistic architectural scaffolding of the painting, which is reminiscent of Jacques Villon's graphic imagery, we are able to discern a female figure holding in her large right hand what appears to be a lighted candle. At the upper left, a series of colorful fragmented forms suggests a garland of flowers, and at the lower right there appears to be a stringed instrument, possibly a lute. The color is somber but opulent, evoking the dark yet sensuous atmosphere of Mallarmé's poem as well as some of its specific imagery, such as the snuffed candle and "a bunch of flowers unfaithful to the moon / (by the dead candle it still sheds its petals)."

Using a symbolist approach to her subject, Rothschild does not so much illustrate the poem as attempt to create an equivalent for its mood, into which are incorporated fragments of its own (fragmentary) imagery. Mallarmé's "bed with vellum pages," for example, seems to be evoked by the book-page-like form to the left of the figure. This mode of metaphorically conveying a subject is also very much in keeping with the kind of symbolism that had been developed by Knaths in his recent paintings, which Rothschild admired as images that "held a complex of symbolic implications."[2]

Rothschild returned to the Herodiade theme in 1955, in a canvas of virtually the same size rendered in a similar color harmony (Figure 17). In the second version, however, the forms are more fragmented and the composition is generally more sumptuous, almost Byzantine in its richness. Here the figure faces us full-front and stares out at us intensely with a steady and

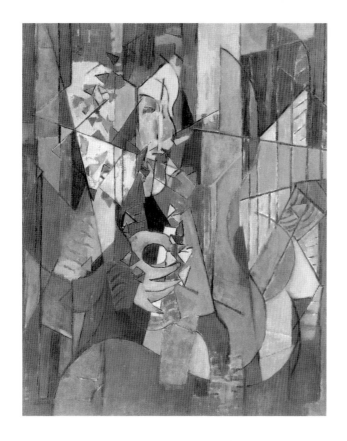

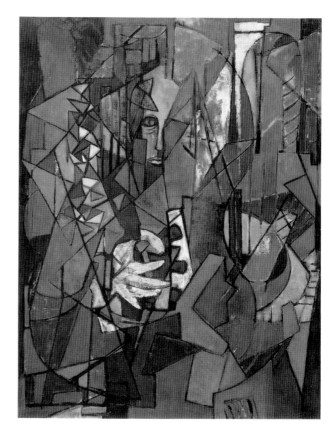

Figure 16
Herodiade, *1952–53. Oil on canvas,*
42 × 33⅞ inches.

Figure 17
Herodiade, *1955. Oil on canvas,*
44 × 34¼ inches.

Figure 18
Persephone, *1954. Oil on canvas,*
42 × 33¾ inches.

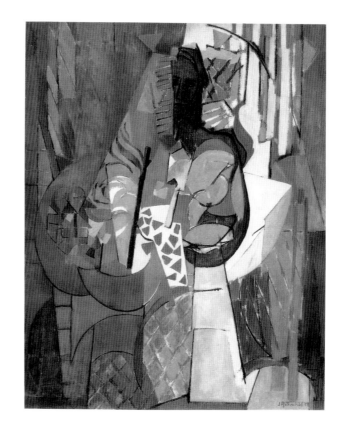

Figure 19
Wide Arcs, *1954. Oil on canvas, 35⅞ × 43¾ inches.*

Figure 20
Lemon and Limes, *1953. Oil on canvas, 24 × 32 inches.*

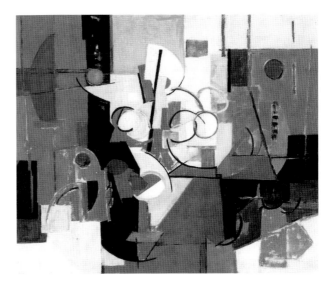

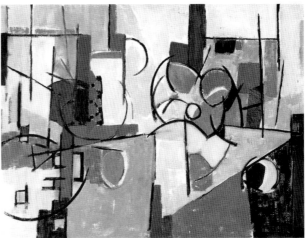

unsettlingly asymmetrical gaze ("Herodias with the lucid diamond look"). The garland of flowers is rendered in a more rhythmic and continuous way, but the object that the woman holds in her hand is more difficult to read. To the right, the forms of a stringed instrument can once again be discerned, but above them we now see the generalized form of another figure, whose head and shoulders are set against the rectangular shape of a window, from which a beam of moonlight emerges and falls on Herodias herself, conveying some of the spectral atmosphere of Mallarmé's poem.

Around the same time, Rothschild addressed another literary theme. Persephone (Figure 18), on a canvas about the same size and in a similar color key—centered on what she would have referred to in her new Knaths-Ostwald terminology as the "tonic in 13" (blue-violet). Into the abstracted spatial construction, which is very much like that of a still life in an interior, is inserted a naturalistically rendered dark figure at the center. In this symbolic still life, the dark figure of Persephone acts like a benevolent deity presiding over the bursting floral forms around her. According to the Greek myth, Persephone was held captive in the underworld for four months of the year, as a result of her having been tricked into eating a pomegranate (the food of the dead) after she had been abducted by Pluto. In the myth—which is concerned with the annual cycle of death and rebirth in nature, and with the immortality of the soul—when Persephone left the surface of the earth, everything died; when she returned, all of nature blossomed and thrived. In Rothschild's painting, the dark figure of Persephone suggests her association with the underworld, but her presence seems to inject life into the floral and fruitlike forms around her.

At the same time, Rothschild was also working on a number of intensely abstracted still-life compositions, some quite small and done in gouache, others oils of more substantial size. An excellent example of this manner of working is seen in *Untitled Composition* of 1952

(Colorplate 6), which is composed of a series of circular and arcing forms arrayed against an abstract white background. Although the angular form at the lower center of the painting seems to suggest the edge of a table, the composition as a whole remains basically abstract, as does that of *Wide Arcs*, done in the first half of 1954 (Figure 19).[3] The fine line that exists between abstraction and representation in these works can be seen by comparing *Wide Arcs* to *Lemon and Limes* of 1953 (Figure 20), in which the title suggests a representational subject even though the composition itself hardly seems to suggest objects.

The titles of many of these works play an important role in how we perceive what they actually represent. In *Prisms and Pavannes* of 1955 (Colorplate 7), for example, the abstractness of a similar vocabulary of forms is emphasized by the title, which stresses visual sensations and music—referring to light in the *prisms* and

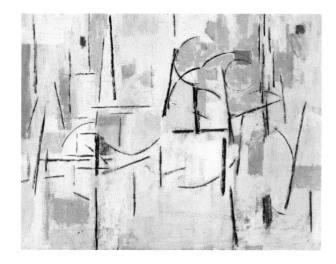

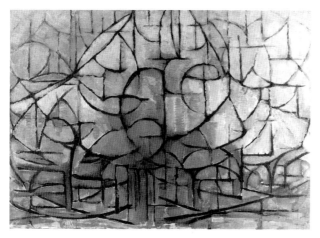

Figure 21
Hommage à Mondrian, *1953. Oil on canvas,*
28 x 36 inches.

Figure 22
Piet Mondrian, Flowering Trees. *1912. Oil on canvas,*
23⅝ x 33½ inches.

Hommage à Mondrian is thus both an homage and a critique, a declaration of allegiance and an equally strong declaration of independence.

Not coincidentally, it was at this time that Rothschild distanced herself from the American Abstract Artists group. Although in previous years she had been unhappy with both the internal politics of the group and the uneven quality of the work in their exhibitions, she had continued to show with them. But after the 1952 annual exhibition she stopped doing so, although it is uncertain as to whether she actually resigned from the group (as she later remembered) or whether she simply let her membership lapse. In any case, as her work became more overtly figurative she felt that her own goals and those of the AAA had become so divergent that she could no longer exhibit with them in good conscience.

At the end of 1952, the Myrers had moved to their fifth California address, 212 Soledad Drive in Monterey (Figures 23 and 24). This is the California house where they lived the longest and that they would both remember with the greatest affection—and the only one where it was possible to have a piano, an old Baldwin upright on which Rothschild practiced regularly and first began to play Hindemith. And it was here that Weldon Kees brought his tape recorder (at that time still a fairly uncommon machine), so that Rothschild could make a tape of herself playing and thereby improve weaknesses in her technique.

The Keeses and the Myrers had become very close. During the summer of 1950, back East, Kees had helped Myrer revise his first novel, and before publication both he and his wife "went through it several times, finally checking its punctuation, spelling, and sentence structure in galley proof."[5] Like the Myrers, the Keeses had also quit the East Coast in the fall of 1950 for San Francisco, Kees leaving behind his multiple roles as "poet, painter, critic, cultural middleman, and jack-of-

to the cadences of a stately Renaissance dance in the *pavannes*.[4] Here the title leads us away from whatever representational elements might linger and makes us conscious instead of the qualities of light and of abstract musical intervals. In combining images of light and music, this painting well reflects two of Rothschild's most long-standing preoccupations.

Rothschild's continued engagement with Mondrian at this time is reflected in a 1953 composition that she called *Hommage à Mondrian* (Figure 21). Here she both acknowledges the Dutch master and declares her separation from him. For while the ubiquitous whiteness of the background is played against the squares of bright color in a way that alludes to Mondrian's late style, the paint handling and irregular lines embody the opposite of that style—and in fact allude to his pre-abstract period, typified by paintings like the 1912 *Trees in Bloom* that Rothschild's parents later acquired (Figure 22).

Figure 23
Photograph of Anton Myrer and Judith Rothschild taken
for a newspaper feature of her work at the time of her second
Blair Studios exhibition, 1952.

all-artistic trades" for an unknown future. He was fed
up with the big city and "viewed his departure from
New York as fleeing a stricken city . . . 'a dark and dread-
ful place.'"[6] This view, of course, was shared by Myrer.
In California, the two couples saw each other with some
frequency, and Myrer and Weldon Kees maintained a
lively correspondence. They gave each other consider-
able moral support, exchanged views on literature, and
shared problems they both had with publishers. Kees
was particularly supportive of Myrer, who would dedi-
cate his next novel to him.

In San Francisco, however, Kees's fortunes took a turn
for the worse. He did some collages and published some
poetry, but for most of the fall and winter of 1952–53
he was paralyzed by depression. He then turned his
attention to writing song lyrics and worked closely with
Bob Helm, a first-rate musician who later remembered
their association as one of the highlights of his life.[7] But
once again, Kees fell just short of success, and his songs
never caught on. For a while he had his own radio show
on a small listener-sponsored station, but he remained,
in Helm's words, "a man on the horizon," who never
quite arrived. Like most of the Keeses' friends, the
Myrers had remarked on Ann Kees's gradual withdrawal
into herself, but they were surprised by the sudden vio-
lence of the nervous breakdown that she suffered dur-
ing the summer of 1954, and they were deeply upset by
the couple's subsequent separation and divorce.

As if to keep his personal anguish at bay, Kees became
involved in a feverish round of activity: he offered to
review books and write articles and essays; he worked
on promoting a book of his poetry; he became involved
in freelance film and jazz recording projects, and he
even wrote sketches and music for a local revue called
The Seven Deadly Arts. But the more he tried to lose
himself in a frenetic schedule of work, the more desper-
ate he became. Anton Myrer, who had a tendency to
drop people suddenly when for some reason or other

they disappointed or angered him, distanced himself from Kees, and Rothschild reluctantly followed suit. During the summer of 1955 Kees began to speak of going to live in Mexico and asked a number of his friends to come with him. His avowed plans to leave became more feverish, and he phoned, or tried to phone, a number of friends—including the Myrers, who had gone back to Provincetown for the summer—to urge them to accompany him. On July 18, 1955, almost exactly a year after his separation from his wife, Kees made his last phone call. Two days later, his abandoned automobile was found in a parking lot on the Marin County side of the Golden Gate Bridge. Although it was assumed that he committed suicide, many of his friends remained disbelieving. It took some time for Rothschild and Myrer to admit to themselves that Kees might indeed have killed himself, and it was not until years later that Rothschild was finally able to come to grips with the fact that Kees was actually dead.

Kees's distress, moreover, was all too understandable to Rothschild and Myrer, who in 1955 also felt overlooked and left out. As they got older, they began to understand that the possibilities of life were finite and that good intentions and high ideals did not in themselves guarantee artistic success. They could see Kees's problems as directly related to their own. "It is too much to require everyone to have the disposition of a Cézanne merely to *survive*," Rothschild wrote shortly after she learned of the Keeses' divorce.

> We've seen a number of people get caught (and no one is *completely* above it) in this problem, and most recently and more poignantly for us, Weldon Kees. Admittedly he is no Auden (but on the other hand, Auden is no Shakespeare either, . . .) But his poems are probably at least as good, for instance, as Randall Jarrell's, and there seems to be no logical reason why they could not be published with equal merit. But (and this I think has been the great blow to Weldon) his volume of poems has been rejected by house after house, and he finally has decided to get a friend with a hand press to publish them for him.
>
> . . . But for Weldon, who always had a certain pull towards fame and fortune *for its own sake*, a la Hollywood, etc the whole thing evidently became intolerable and led to a sort of desperate frenetic search for success in all manner of projects and schemes. Which has been saddening to see. . . .
>
> . . . It has been important to me because for years I've looked at certain people (usually people over 45 or so) in the arts who seem to have such a jaundiced attitude towards both other artists and the art they themselves practice (or, more often *criticize)* and I have always been somewhat at a loss to really understand how they got that way.
>
> Part of growing up, I suppose. But no less saddening for all that.[8]

Rothschild took Kees's situation to be typical and even paradigmatic of the general situation of the serious artist in America, rejected by the large public and barely able to survive. It was at this time that she compared American artists to snails, "totally unwanted, and even reviled . . . emitting a kind of excremental trail behind us wherever we go."[9]

During the mid-1950s Rothschild focused on oil paintings and did fewer small gouaches and collages. In part this was due to her enthusiasm for Lefevre-Foinet paints, which her mother had first sent her from Paris in the spring of 1953, and whose intense but richly nuanced colors had put her into "a state of high excitement."[10] And since she was particularly sensitive to the specific qualities of light, she also liked to take advantage of the daylight to work on oils, which she now felt better suited her artistic ambitions.[11]

During the mid-1950s, as her work became more representational, Rothschild based her imagery increasingly on the surrounding landscape—both in Monterey and on Cape Cod, where she and Myrer continued to return for awhile almost every summer. A number of works done at this time are of harbor scenes, often given the title *Boatworks*. One of the earliest of these is the *Boatworks* done in Monterey in 1953 (Figure 25) in which a harbor scene is rendered in a stylized manner in deep blues. Although the subject is a panoramic landscape, Rothschild has kept the space fairly flat and emphasized its symbolic character. She has also mixed straightforward description on the left with abstract curvilinear forms on the right. The large Braque-like bird that hovers at the upper left adds a note of specificity to the scene and at the same time reinforces the symbolic reading of the forms.

During the next few years, Rothschild developed an increasingly naturalistic view of landscape, often using a similar compositional format. In the small 1954 collage called *Monterey Boatworks* (Figure 26), for example, the drawing is quite descriptive despite its simplification and despite the intrusion of such discordant elements as the stylized cloud motif at the upper right. One of the works that she struggled with most at this time was *Deadmen* of 1954 (Figure 27), which evokes a broad,

Figure 25
Boatworks, *1953. Oil on canvas, 19 x 29 inches.*

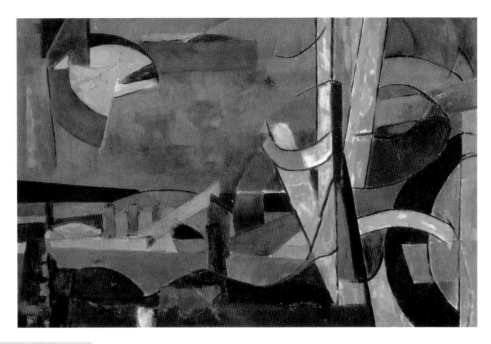

Figure 26
Monterey Boatworks, *1954. Casein with ink and collage on board, 9½ x 14⅜ inches.*

Figure 27
Deadmen, *1954. Oil on canvas, 24 x 36 inches.*

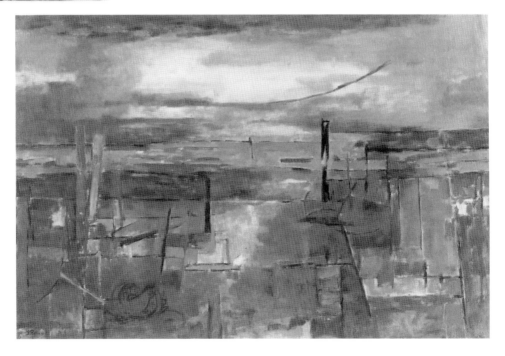

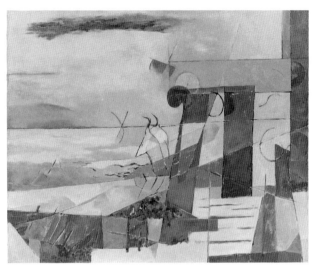

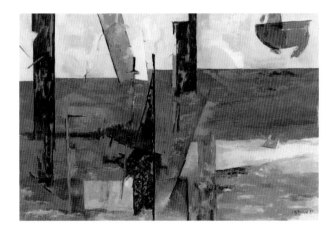

Figure 28
Snow Scene #2, *1955–56. Oil on canvas, 24 × 40 inches. Collection Mr. and Mrs. Roger A. Michaels, New York.*

Figure 29
Way Out West, *1955. Oil on canvas, 35¾ × 43⅞ inches.*

Figure 30
Evening Littoral, *1955. Oil on canvas, 24¼ × 35⅞ inches.*

expansive space and employs a handling of form that self-consciously recalls Cézanne. Although many of the paintings she did around this time, such as *Snow Scene #2* of 1955–56 (Figure 28), are obviously done under the inspiration of Cézanne—and not infrequently Cézanne as seen through the eyes of Karl Knaths—the mood in almost all of them is wistful and melancholy. The best of them are imbued with a haunting kind of poetry, while the weakest border on sentimentality.

This period in Rothschild's work came to fruition in a series of panoramic seascapes she did in 1955–56, in which she was able to control the mood more carefully. At the time that she was working on these paintings, she was very much aware of the danger of her moonlit reveries becoming too sentimental, and she struggled hard to replace that incipient emotionality with a sense of grandeur. This led her to develop the theme of the sea played against architectural elements in a number of pictures—a motif that had its seed in her 1948 *Surreal Landscape* (see Figure 10). In *Way Out West* of 1955 (Figure 29), Ionic columns are played against the flat horizon, and ghostlike images of animals seem to ride the waves. Different versions of such columns appear in a number of paintings done at this time, such as *Evening Littoral* (Figure 30), *Antelopes* (Colorplate 8), and *Byzantium* (Colorplate 9). The underlying metaphor seems to be that of nature opposed to the man-made, evinced in the interplay between architectural ruins and the corrosive action of the sea that they are buttressed against. Although the ruins frequently look like industrial ruins—enormous piers or loading cranes—they are usually rendered in a generalized way that disassociates them from a specific sense of place. While the space in these pictures is atmospheric, it is frequently inhabited by abstract, signlike forms.

In *Byzantium*, for example, the overall impression is of a panoramic coastline, and at first one reads the small triangular forms that seem to flitter around the piers as birds hovering around the coastline. But at the same time, those geometric forms also take on a life of their own, as in the large pale triangle that overlaps and cuts into the tallest vertical pier. A form like this comes, so to speak, from the abstract world of paintings like *Prisms and Pavannes* rather than from nature; and this mixture of abstract and naturalistic elements reinforces the resonance of the image as a whole.

The source of inspiration for *Byzantium* was William Butler Yeats's poem of the same title, which Rothschild copied out in a notebook in the fall of 1955. Although the painting does not directly illustrate the poem, and in fact does not incorporate much of its physical imagery—neither the palace pavement nor the image of a "starlit or a moonlit dome" is depicted—nonetheless the painting attempts to evoke the melancholy fury of Yeats's poem. The nocturnal ambiance and the rather abstract imagery of the poem (such as "bitter furies of complexity") are evoked by the general mood of the painting. "Where blood-begotten spirits come/And all complexities of fury leave."

The mixture of abstract and naturalistic elements in this painting evokes an image of the ancient city of Byzantium hovering in ruins above the sea, and it also seems to suggest the metaphysical overtones given even to physical things in Yeats's poem:

> At midnight on the Emperor's pavement flit
> Flames that no faggot feeds, nor steel has lit,
> Nor storm disturbs,
> Flames begotten of flame . . .

Rothschild struggled a great deal with these paintings and was very self-critical about them. In July 1955, shortly after she went to Provincetown, she wrote in her notebook that she was looking at *Way Out West*, which she had brought east, with the "most unfriendly gaze possible. And one advantage of travel is it becomes easier to conjure up the mentality of others' visions . . . & especially of unfriendly ones (aesthetically). There *is* something coy . . . feminine—in this picture which is bad, & evasive plastically—but I only just see that now—when it's really finished. Also it's too pretty."[12] (These comments probably reflect Knaths's reaction to the painting.) While in Provincetown, she reworked *Way Out West* and began another landscape, which eventually evolved into *Antelopes* (Colorplate 8).[13] Less mono-

chromatic than *Byzantium*, *Antelopes* has an almost surrealistic combination of actuality and fantasy. In *Byzantium* the *subject* of the painting is the missing text of Yeats's poem, which hovers in a ghostlike fashion around the image as we look at it. In *Antelopes*, as in *Way Out West*, the "ghosts" are within the painting itself, in the animal forms that seem to float above the sea. On the right-hand side of the painting the animals are merely hinted at by the curving forms that denote their horns, but further to the left, especially in the yellow band that seems to suggest the setting sun, an animal's body is clearly delineated. The overall picture space is treated three-dimensionally, but at the same time its surface is literally treated like a wall onto which imagery can be inscribed. In fact, the linear rendering of the animals is reminiscent of those inscribed and painted on the walls of prehistoric caves. *Antelopes* also anticipates the greater chromatic differentiation that Rothschild was to seek in many of the paintings that followed.

The theme of the ghostlike animals riding the waves is an intriguing one. Although it has a strong literary flavor, it is difficult to fix it to a specific source. One thinks of Rothschild's description of watching whales spouting offshore when she lived at Big Sur and Monterey. And it is possible that a number of quite different lived and literary experiences are conflated in this painting, as well as in *Way Out West*, in which similar antelope forms can be clearly discerned. On a study sheet for *Way Out West* (Figure 31) Rothschild wrote the words, "Evil Landscape," "Ahab," and *"the sea."* This leads one to think of the opening paragraphs of the eighty-sixth chapter of *Moby-Dick*, which begins with the mention of antelopes and then describes the sperm whale's tail.

And given Rothschild's involvement with Yeats at this time, one also thinks immediately of the poet's haunting image in "Cuchulain's Fight with the Sea":

> . . . "Cuchulain will dwell there and brood
> For three days more in dreadful quietude,
> And then arise, and raving slay us all.
> Chaunt in his ear delusions magical,
> That he may fight the horses of the sea."

Added to this, of course, there is the experience that Rothschild frequently had at Big Sur of seeing deer come down to the sea. One such instance is recorded in a letter written in 1951: "There are a tremendous number of deer . . . more than the terrain can support. In particular they come down lower and lower in the hills for

Emil Landscape
Ahab
Hosea

Figure 31
Studies for Way Out West, *1955. Ink on paper, 11 × 8½ inches.*

water . . . it always gives me a great thrill to come upon three or four of them right near our place or beside the road. We can sometimes watch them wend their way down the hillside towards the water. We actually passed four of them . . . out, way past where we used to live, past the lighthouse, fairly near the sea."[14]

That fall, when Rothschild returned to Monterey, she was still at work on *Antelopes*, which she felt needed more work in the lower right corner. It was there that she also finished *Byzantium*—which she at first thought might be too melodramatic in its abrupt transitions. But she nonetheless felt it had come off well enough for her to allow her parents to acquire it for their growing collection of modern art.[15] And nine years later, when it was shown at the Rhode Island School of Design as part of an exhibition of the family collection, she noted that although it did not have much color, it had held up pretty well.[16]

As she completed this series of sea paintings, Rothschild began to focus on color. Although she continued to work with landscape motifs, she began to treat them more abstractly, giving the interaction between the various areas of the canvas clear precedence over description. This can be well seen in *Winter Solstice*, finished early in 1956 (Figure 32), in which the architectural motifs that appeared on the right side of paintings like *Byzantium* and *Antelopes* are transformed into a series of rhythmic, arcing curves. As in *Byzantium*, the color is predominantly in the violet to red-violet range, and although the color is pushed somewhat higher, it nonetheless operates tonally as much as chromatically. It was not until the following year that Rothschild began consistently to give more emphasis to chromatic interaction for its own sake. This can be seen in *Points of Light* (Figure 33) and in *Southwest* (Colorplate 10), both of 1957. *Southwest* is one of a series of paintings that evoke the southwestern desert—a motif that allowed her to work in a completely different part of the color spectrum. While the seascapes had mostly been in a blue-violet tonality, in *Southwest* the dominant tones are various shades of yellow. And while the seascapes were inherently dramatic and full of movement, the southwestern landscapes lent themselves to a greater emotional coolness—one might say a greater distancing. Because of the disembodied quality that is projected by the desert landscape itself—vast empty spaces saturated with light and color—the motif allowed Rothschild to reincorporate more overtly abstract forms into her work, while at the same time not being arbitrarily distant from her subject. This polarity—between the dramatic and deeply atmospheric seascapes and the flat geometric forms of paintings like *Southwest*—reflects a marked division in Rothschild's thinking at this time.

Although she remained firmly in the modernist camp, Rothschild's doubts about pure abstraction were becoming stronger—reinforced by Anton Myrer's views and by her close contact with Karl Knaths. In raising these doubts, she was aware that she was swimming against the current, and she was not unaware of the irony of her situation. "I think we are entering a curious time," she wrote in 1955, as she was developing the semi-abstract and ambiguously figurative imagery that she would work with for the next ten years or so.

It now is the unsophisticated neophyte to modern art who accepts totally the abstraction, the idea that one must not "look for the rabbit." He now knows there

Figure 32
Winter Solstice, *1956. Oil on canvas,*
26 x 42 inches.

Figure 33
Points of Light, *1957. Oil on canvas,*
24 x 40 inches.

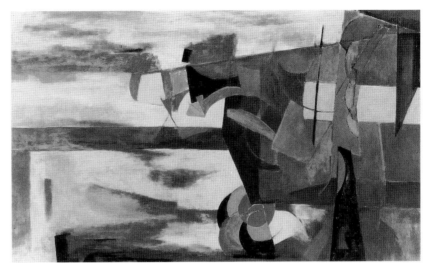

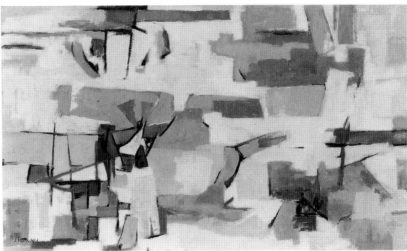

just won't *be* any rabbit—in modern art. He is at home with Mondrian and Glarner, of course. But it all gets complicated when artists now are beginning to put the rabbits back in (as I have done). It is now required that one both know better than to look for the rabbit— that is, that one never see the rabbits in pictures—& at the same time *if* the rabbit's shadow is there, one must be able to see it—though not of course in the old pre-cubist way.[17]

Rothschild's doubts about abstraction took two different forms. On the one hand, she was profoundly disturbed by the lack of "humanistic" content that she perceived in geometric abstraction, especially in the followers of Mondrian, with whom she had previously been allied. This was something that she returned to again and again in her notebooks—partly because, despite her doubts, Mondrian nonetheless remained so important to her. He was like a remote parent, and in a way she struggled against him all the more vehemently precisely because he did exert such an enormous authority in her artistic sensibility—a classic case of "anxiety of influence," in which she was engaged in furious combat with her artistic father.

On the other hand, she became increasingly antagonistic toward the abstract expressionists. To a large degree this was because, following Knaths, she saw them as undisciplined and raw, the embodiment of Whitman's "barbaric yawp." Rather than seeing them as extending the possibilities of high art, she saw them as bringing down artistic standards. If this reveals a certain European bias in Rothschild's sensibility, it also reveals her mistrust and perhaps even fear—very likely reinforced by Myrer—of the undisciplined energy that the abstract expressionists embodied, and which ran so

strongly counter to her own need to find an underlying system of order. She associated their violence with the violence that she saw in the later works of Picasso, and with the dynamically tense and spontaneous sort of painting that was taught by Hofmann, whom she had come to see as a vulgarizer of Picasso's ideas. "I think the most insidious influence on my generation," she wrote in 1955, "is still that old Picasso-via-Hofmann legacy...that somehow painting is all thrills, quite quickly achieved...and it's a mistake to try to find out too much about the process itself."[18] For her, the "process" involved distilling visual phenomena into a systematic formal equivalent, into a kind of pictorial metaphor. She was not yet willing to make the imaginative leap that was necessary to see that the abstract expressionists were involved in creating a new sense of both "process" and "order," and that along the way they were inventing a new pictorial language.

Furthermore, at the distance that she kept from New York, where abstract-expressionist painting was centered, she came to resent the way in which the painters associated with the movement began to dominate serious critical discourse—especially as embodied by writers such as Clement Greenberg and Harold Rosenberg. And also, no doubt, she envied their rise to prominence. Here, the isolation that she and Myrer had so carefully cultivated surely worked against her. For while they were living in self-imposed exile in Monterey, and Rothschild had only tenuous contact with the work of vital California artists such as Richard Diebenkorn and David Park, a real revolution was being effected in American painting.[19] And it was happening back in New York—her native city—which Myrer encouraged her to detest with such vehemence.

Although she acceded to Myrer's need for seclusion, and although she even persuaded herself of its value for her own work, defiantly deluding herself into believing that it was actually helping her to develop independently even as she was coming more and more under the influence of Karl Knaths, she was by no means free of doubts about this. In 1953 she could write, "I know it may not have helped 'my career' to be away from N.Y. so long— but I am positive it has helped my work. While you're *there* I think (witness almost every painter my age you can think of) it's almost impossible to avoid being swallowed up in the vortex of the current enthusiasms (if not fashion) of 'the crowd' of artists around you, or if you *do* avoid it it is only by a very exaggerated pose of independence."[20] But only a few years later, she would come to realize that being out of New York cut her off both from the vital stimulation of other artists her own age and from practical opportunities to further her public career.

For at the same time that Rothschild was wary of abstraction, she also understood that abstract painting still remained the means by which the most ambitious sort of painting could most readily be achieved. For years she and Myrer had discussed their desire to create "timeless" art. And she understood that if abstract painting had any validity whatsoever, as she believed it did, then it might well be the best means available to her to achieve her goal.

As Rothschild pondered these problems with increasing intensity, she came to see that "the battle in painting" seemed to be drawn between two lines. The first comprised "those who believe pictures should be self-sufficient works of art—i.e. non-metaphorical, non-symbolic," and the second of "those who believe pictures must be expandable—at least metaphorically, towards a world beyond the entity of the pictorial alone...i.e. The world of the living problem(s) of man." For her, this second category did "not necessarily negate the emphasis on style.... the talents of my generation won't see that we don't have to reject the tools of the previous generation. To use them *expansively* is itself a hell of a problem."[21]

This was the problem she continued to wrestle with.

During the previous ten years Rothschild had exhibited in a number of regional group exhibitions, and she had been given three one-person shows at the Blair Gallery in Monterey between 1951 and 1953. (Starting about 1952, she often used the name Judith Myrer when she showed, and she also signed her paintings with that name.) But she had not had a solo show in New York since 1947. During this period, Rose Fried had kept some of her works in the back room of her gallery, so in a technical sense Rothschild could be considered one of the gallery's artists. At the beginning of 1956 Fried invited Rothschild to participate in a collage exhibition, and the possibility was raised of her having a one-person show in New York. Her parents, in particular, felt that if she were going to have a career as an artist she ought to show more regularly. To which she replied: "I am glad to show. I think perhaps you have mistaken my sense of there being no immediate time pressure about showing for a reluctance to show.... I know you have often felt I go too far in [the] 'timeless sense.' But I am convinced [that] of the two paths mine is by far the sounder...that is, assuming one is interested in ART."[22] What remained

unspoken was that Anton Myrer had not published a book for the past five years and that Rothschild was very likely under the constraint of not upstaging him at this particularly crucial time in his career. The following year, when Myrer's new novel was about to come out, Rose Fried finally scheduled her for a solo exhibition.

In the meantime, Rothschild and Myrer were becoming impatient with what they began to consider the cultural thinness of life in California, and they were especially eager to go to Europe to see the places where their artistic heroes had worked.[23] They returned east at the end of 1956, and the following spring they went to Provincetown, where Rothschild worked hard on paintings for her show. In the interim, Myrer had finished his new novel, *The Big War*, which was based on his experiences in the Marines, and it had been accepted for publication by Appleton-Century-Crofts. The book (which was dedicated to Weldon Kees, "a casualty") was being considered as a selection by the Book-of-the-Month Club and had attracted film interest. Thus, as Rothschild and Myrer began to reestablish themselves on the East Coast, they were full of optimism about their new situation. As it turned out, *The Big War* sold very well and gained Myrer a good deal of recognition. The movie rights were

purchased, and for the first time the couple began to have a substantial, independently generated income.

The paintings that Rothschild showed at the Rose Fried exhibition were all recent works that indicated the range of her new imagery. Among them were *Southwest* (Colorplate 10), *Canyon #1* (Figure 34), and *Baroque Still Life* (Figure 35). *Southwest* represented the most abstract mode that Rothschild was working in at this time. Although a horizon line and other specific landscape elements are evident, the painting is based on a dialogue between the sense of an actual landscape space and the contrapuntal deployment of disembodied and brightly colored geometric forms. Moreover, despite the presence of a horizon line, the abstract forms float as if independent of the force of gravity, thus creating an ambiguous world that lies somewhere between a mental conception and a physical reality. In *Canyon #1* the imagery is somewhat more descriptive. The tree forms and the contrasts between objects and empty spaces are more literally delineated than in *Southwest*, and the landscape motif is not only more specific but is also given a greater sense of tangibility. In *Baroque Still Life*, Rothschild demonstrated what she could do with virtuosic paint application and a more fluid pictorial space. The handling of

Figure 34
Canyon #1, *1957. Oil on canvas, 40 × 50 inches.*

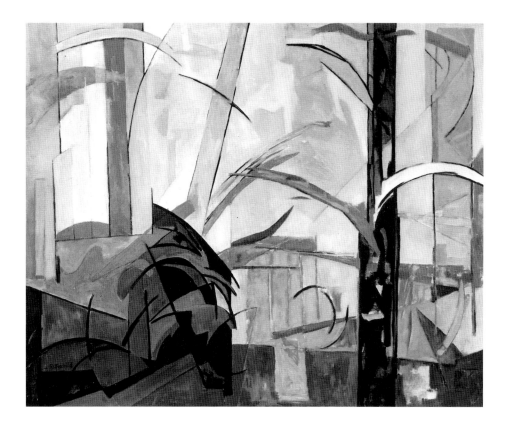

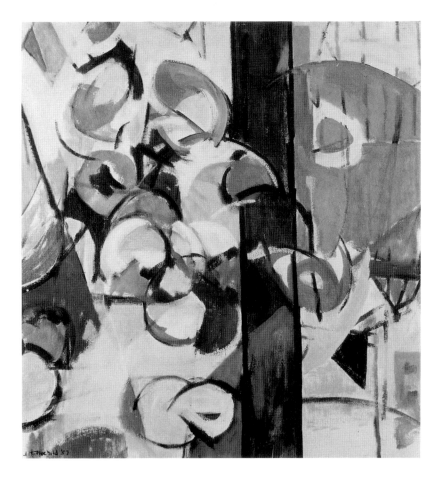

the paint is positively exuberant and the picture space has an ambiguity and a suggestiveness that anticipate the works that she would do during the next few years.

For the exhibition, the gallery printed a brochure that included three quotations chosen by Rothschild—from Flaubert, Randall Jarrell, and Poussin—and a short statement about her own work.[24] All the quotations touch in one way or another on the conflict between abstraction and representation, as does Rothschild's own statement, which directly addressed the contradictory problems that she had been involved with in recent years:

> If painting is to avoid Flaubert's gloomy foreboding it must face up to the duality between the non-metaphoric, pure, plastic world and the world of visual appearance—of human concerns. We must risk inconsistency—as Giotto and Gris did. We must risk it in order to move, however painfully, toward that compelling distillation, an expansion of the specific *through* structured form. For it is this we are all seeking—whether in terms of the intricate splendor

of Uccello's battle scenes or Cézanne's majestic Mont Sainte-Victoire.

> In these terms the expression of subjective emotions alone cannot suffice, still less mere concrete specifics—nor even a succession of sensitively wrought areas of paint on canvas. The idea is *in* the mountain: in the mountain rendered eloquently, structured, expanded, which recalls us to our own humanity, our own individual importance—and unimportance . . . the ultimate power of Poussin's silent art.

Although Rothschild's exhibition did not have the same kind of life-changing success as her husband's novel, it was nonetheless widely noticed and reasonably well received. Moreover, most reviewers were aware of at least part of her history and were attuned to her intentions. Martica Sawin recalled that although "formerly an adherent of the strictest Neo-Plasticism, Judith Rothschild has recently based her painting more directly on a foundation in nature, namely landscape. While the discipline of a purist is still fundamental in her work,

the arrangement of forms and colors has an evocative quality which cannot be interpreted in abstract terms alone, but which involves echoes of a response to the structures of the natural world and the sensation of their physical presence." Sawin also praised her for her color and her lyricism, and for her "independence of inherited forms and her serious intention of charting her own purposeful course of discovery."[25]

Lawrence Campbell recalled Rothschild's history with the Jane Street group and saw her return to New York as "a return to nature." He lauded her "restraint, clarity and structure" and noted that "with her, feeling and thinking do not come apart.... There is intimacy and the mark of a strong personality."[26] Emily Genauer also wrote of Rothschild's "free and spirited use of cubist-abstract form and color," and noted that despite her titles and the presence of real subjects, her painting was "in essence abstract and reflects only the feeling of things depicted."[27]

Stuart Preston, however, felt that although Rothschild's "semi-abstract paintings" were elaborately composed, they embodied a "feeling toward nature that is too ambiguously expressed to be satisfactory. On the one hand, the artist does not want to make a break with the visual world. On the other, she translates its phenomena into a language of visual telegraphese that is a good deal from being clear."[28]

By far the most probing review was by Eugene Goossen, who a year earlier had written a thoughtful article about her work in Monterey. Then Goossen had praised the seriousness of her paintings and her desire "to know what she is doing and how she does it." Although Goossen had felt that her approach did not always produce successful results, he had been positive about the level of her ambition and her independence from Abstract Expressionism. "By far the most interesting aspect of Myrer's present work," he had noted, was "her bold juxtaposition of the realistic and the abstract." In doing this, he wrote, she was trying "to break through into an area which has been too little explored," and he was generally supportive of her effort, her patience, and her skill.[29]

This time, however, Goossen was more critical. He began by discussing the catalogue statements at some length and misinterpreted them as aggressive attacks on her contemporaries. In particular, Goossen noted that Rothschild seemed to feel that she and her abstract-expressionist contemporaries were in their different ways seeking the same thing: "'an expansion of the specific through structured form.'" This he rightly took issue with, pointing out that not all painting "must derive from the kind of organically unified forms presented grossly to our eye by nature whose structure we can easily divine and analogize." Similarly, he felt that the Cézanne analogy was no longer appropriate: "That Cézanne had to have a mountain to paint in order to paint is an undeniable fact. What has that got to do with painters now living who don't want to paint mountains but prefer to paint their 'subjective emotions'? Does this really preclude their making art? Isn't Miss Rothschild gloomily trapping herself somewhere between algebra and Calvinism at an age when she should be embracing possibility with all the joie de vivre she can muster?"

Then, in a critique that went right to the heart of the aesthetic position that Rothschild and Myrer had so carefully been constructing during the past decade, Goossen declared that "personally, I like to see young people kicking their 'subjective' emotions around for awhile, just as if they were 'objective' emotions. I even like to see them rebel: not so much against their contemporaries, however, as against Cézanne, for example, rather than against the enthusiasms of their times. We can grow old too soon."

Goossen came out squarely in favor of the paintings that were the most abstract (and the most free of Knaths's influence), such as *Points of Light* (see Figure 33) and *Southwest* (Colorplate 10): "I have long wished Miss Rothschild would abandon the stark outlining of her forms and replace the sensationalism they create with something more like what Hans Hofmann would call the 'push and pull' of color. In two small, very recent pictures in her show, she seems to be making a major move in that direction. The looser, more confident and more powerful effect of 'Points of Light' kept me really looking. 'Southwest,' a charming little color poem, has plenty of the quality but none of the dryness of the term 'structured form.' It was, I think, the best in the show."[30]

Although Rothschild initially dismissed Goossen's criticisms, she did not forget them. But several years would go by before she began directly to address some of the issues they raised.

An Unsettled Time, 1957–1964

A month after her 1957 exhibition at the Rose Fried Gallery closed, Rothschild and Myrer left for Europe. They had high hopes for their trip, expecting to find there the spirit of the artists and writers they most admired. But at the beginning they were bitterly disappointed. They started out in Paris, and although they were impressed by the beauty of the city, they found the people hostile. Although at the time Paris was still considered the artistic capital of Europe, Rothschild was learning firsthand that there was much more energy and far better contemporary art to be seen in New York. Even the artists about whom she had been most enthusiastic, such as Serge Poliakoff, seemed somewhat disappointing. Only her high regard for the recently deceased Nicolas de Staël, who had also tried to balance an abstract formal vocabulary with representational subject matter, remained unabated.

For the most part, her enthusiasm was limited to older artists such as Jacques Villon, whom she saw briefly at an exhibition of his work, and Sonia Delaunay. While in Paris she also sought out the legendary music teacher Nadia Boulanger and met Marc Chagall at a dinner given by her parents' friend, the art dealer Claire Guilbert. Rothschild was seated next to Chagall and came away from the experience saddened by the feeling that he was very much aware that his best work was far behind him. Throughout their time in Paris, Anton Myrer felt extremely alienated. He was not comfortable with the language and as a result felt vulnerable and defensive; and he was full of resentment at what he saw as the "pride and contempt" of the French.

It was not until they left Paris that they began to relax and to feel that the trip was worthwhile. In Burgundy, Rothschild was particularly interested in the color of the stained-glass windows, which she tried to relate to her own color theories, and she marveled at the churches of Vézelay and Autun.[1] As they went south through Provence, on their way to the Mediterranean coast, they stopped at Aix, where they visited Cézanne's studio and made a pilgrimage to a number of the sites he had painted. Cézanne meant a great deal to both of them:

for Rothschild he was the paradigm of modern painting; for Myrer he embodied the supreme virtues of humility and durability—the purity of motive and timelessness that he himself spoke of with such fervor.

In late December they found an apartment in Cannes, where they would each be able to get some work done. Although the place was not initially to Rothschild's liking, Myrer loved it. Trying to put the best possible light on their choice, she wrote an upbeat appraisal in her journal: "Light. With view of water. . . . Will be a light studio if not a huge one. Chief thing will be to get started—Tony very happy over it I think. And I less so, but relieved to have it & expecting to work well there anyway—once I get acclimated."[2] But a few days later she revealed some of the tensions that had underlain their choice: "It is one of the new stucco buildings on La Croissette—which I disdained. . . . In American dollars it's not expensive. And it was enormously to Tony's liking. He has done a great deal this trip that is *not* (& a lot of it for my sake) so it is a joy to be where he is truly enthusiastic. Initially, as T. knew, I was not."[3]

Despite the constant little tensions and conflicts generated by traveling, which are perhaps inevitable when two people make a long journey together, on the last day of the year Rothschild reflected on her good fortune: "Hated to see this year go," she wrote in her journal. "It certainly brought us a vast number of good fortunes. Unbelievable change. From Centre St. to Cannes. Tony unpublished to 3 (maybe 4) different editions at least of the novel—and me from being shut out utterly to having Rose [Fried] solidly behind me."[4] But that night, on New Year's Eve, a small symbolic incident occurred that shook them both. Finding themselves in a strange town where they knew no one was depressing, and at midnight they were still in their apartment, arguing about how to spend the rest of the evening. In the midst of the argument, almost exactly at the stroke of midnight, Rothschild's watch stopped. The next day they treated their superstitious reactions to this incident with some irony. But they both noted the event in their journals and they both saw it as a bad omen.[5]

Figure 36
Outdoor Market at Cannes, *1958. Ink on paper,*
9½ × 13 inches.

Figure 37
Two Figures in an Outdoor Market, *1958.*
Ink on cardboard, 8½ × 14 inches.

During the trip from Paris, Rothschild had done numerous drawings of the French countryside, some of which she would later use as the basis for paintings. She also did a number of sketches of the outdoor markets in Antibes and Cannes, where she was fascinated by the people, the bustle, and the abundance of color (Figures 36 and 37).[6] The sojourn in Cannes not only gave her a chance to do some painting: it also allowed her to think over a number of ideas and impressions, including her relation to the past, which she felt was particularly important: "In a time when no one in this world can have much of a sense of the future perhaps we as Americans with almost no *mature* sense of a cultural past need this European contact very badly. But the opposite is effected by seeing most of the contemporary shows here. . . . the French painters seem to be in a kind of doldrums."[7]

She was also struck by the extraordinary preeminence Picasso seemed to have among French artists. "And overall—unbelievably," she noted, "—still reigns Picasso —a kind of Louis XIV of painting—whom *no one* criticizes ever."[8] On their visit to the Picasso museum at the Château Grimaldi at Antibes, however, both she and Myrer remained unconvinced by Picasso's recent work. At a time when Picasso was still considered a controversial painter, Myrer was vehemently against him, and he spent a certain amount of energy trying to bring Rothschild around to his way of thinking. Contrary to their usual habit, they had gone through the museum separately and had not talked about what they had seen. The day after their visit Rothschild noted, "Tony said nothing . . . still haven't discussed it since he knows I feel he is unfairly unfair to P. And he didn't want to seem to bludgeon me with his powerful arguments."[9]

While at a distance from New York, Rothschild also tried to take stock of what she saw as the general state of contemporary European painting, and what she saw troubled her. For it seemed to her that in Europe, too,

Abstract Expressionism had become "*the* historical direction." And yet, she noted, "the more I see the less I'm convinced. Though it *is* all around us—the only thing being done with any conviction of any sort. Great question is—though—isn't this just a period of reaction like the 16th C. in Italy. Aren't we just a bunch of mannerists?"[10] Only her visit to Matisse's chapel at Vence, which had been finished just a few years before, seemed to give her the sense she sought of the continuity between contemporary art and the historical past.

The five weeks they subsequently spent in Italy reinforced this feeling. For in Italy there seemed to be no contemporary art scene at all, and the past seemed to be especially present. The days Rothschild spent going through the museums and churches of Florence and Rome were a particularly exhilarating experience, and she filled page after page with sketches and color notes. But she found it hard to relate what she saw to her own work, except in the most general way: it buttressed her belief that painting should retain some sort of "referential connective" to its subject matter.

While in Europe, she and Myrer decided that when they returned to the United States they would remain on

the East Coast. The trip abroad confirmed her thinking that gaining any sort of recognition for either her or Myrer would be nearly impossible outside New York— that once one was out of sight one was forgotten. For *The Big War*, which had been refused by three publishers before it was accepted by Appleton-Century-Crofts, Myrer had benefited from the help of Patricia Schartle, the Appleton editor who worked with him on the manuscript and who later joined the firm of McIntosh and Otis and became his literary agent. The success of this book underlined for Rothschild the importance of having some sort of support system, even though she and Myrer had convinced themselves that they should remain above such concerns. "T. should be back East NOW when Pat is full of fire & *wants* to introduce him to everyone in the city," she wrote. "I should be there to keep the pressure on Rose & see if she can or will do anything for me. . . . God knows neither of us ever really is able to act in any sustained manner for such considerations—but there are moments I bitterly wish we could." And then, indicating a crack in the facade: "It is hard to maintain a timeless sense in the face of it."[11]

The couple's financial situation had changed substantially as a result of the success of *The Big War*. The book not only became a best-seller but was also being made into a film, *In Love and War*, starring Robert Wagner and France Nuyen. Possiby because of Myrer's growing reputation and what seemed like the virtual certainty that he would become a well-known author, at this time Rothschild began once again to sign her paintings with her maiden name rather than Judith Myrer, or Judith R. Myrer, as she frequently had since about 1952.[12]

Although Rothschild did little painting in Europe, she had done a number of sketches that she could use for future works, and she returned to New York in April 1958 optimistic about her future work and her prospects with Rose Fried. She saw her marriage in particular as creating a rich and supportive environment, though not without its problems—specifically how she could retain her autonomy while being helpful to Myrer.

"Something T. & I must *not forget*," she wrote in January 1959, "how—despite all logic—& our own constant trepidations, the good, even the pure, can survive in a human being in the midst of total foulness & chaos & even without any model to show what Love (or love) can be like." But she also wanted to remain closer to her family than Myrer did, and she worried about the kind of balance they had achieved. "I feel our even-Steven-

ness of relationship has gone much too far. T.'s talent (I know) is much more important than mine—& *must* come first even if he won't agree (he won't) to this." Increasingly, she felt that her exhibitions were a burden to Myrer. While trying to decide whether or not to push for a fall show, she observed,

> For T. it will be a real hardship to be in the city 'til June (which is what a May show would mean.) Therefore, apart from *all* other considerations, I am determined to wait 'til fall. . . . My feeling is that sometimes what T. wants is not good for me. . . . But when we try something that is good only for me in the beginning it always ends up by being bad for us *Both*. Partly this is sheer male dominance—but it's also a lot of other things. And the point is that I'm increasingly sure it is more important to the world & to us that T.'s creative work "go" which is a complex enough resolution to live up to—but all important nonetheless.[13]

Although she tried not to come to grips with it, her marriage was coming under increasing stress. They had lived for the past decade in a state of relative isolation and constant togetherness, and the unrelenting closeness was beginning to wear on both of them. When they were in Rome that winter Rothschild had noted, "Without work, being together *so* steadily is difficult & we find ourselves chaffing each other the wrong way when we really have no reason to."[14] But then the circumstances of traveling and not working seemed to be to blame, rather than anything in the marriage itself.

When they returned home and began to work again, however, the stress continued. By his own later account, Myrer was already beginning to become physically indifferent toward Rothschild. At the same time he was becoming emotionally attached to his editor and literary agent, Patricia Schartle—although almost a full decade would pass before he and Schartle actually became lovers. There was also some friction about where Rothschild and Myrer would live. Initially, they both felt that they ought to be more in touch with the New York artistic and literary worlds, and the summer after they returned from Europe they went to Amagansett, an artists' and writers' enclave on Long Island, instead of to Cape Cod. That winter they remained based in New York, in an apartment on East Ninety-second Street. But Myrer's hatred of New York life made it impossible for him to be there, and the following spring they went to Cape Cod, where they rented a house in Wellfleet. There Rothschild worked on a number of paintings with

European and mythological themes, including two versions of the *Marché* theme (Colorplates 11 and 12) and some paintings with subjects from Greek mythology (Colorplates 13 and 14).

At the end of the summer of 1959, at Myrer's insistence, they decided to stay on Cape Cod for the winter. This enforced isolation increased the tension between them, and Rothschild's journals from this period are full of contradictory references to their situation. On the one hand, she felt that their constant togetherness was bad for them both and wondered whether they should not spend more time apart. On the other, she dreaded being away from him. At the same time that she felt that having to conform to Myrer's preferred living arrangements was bad for her work, she also felt woefully inadequate to help him. Statements like "Plan to separate for periods of time when we both can be doing things that we want to and won't be forcing the other to 'make a sacrifice'" alternate with such statements as, "Sometimes I am filled with not altogether merely neurotic fears that I have diminished his life by my own great limitations."[15]

It was perhaps as an attempt to restore a common goal to their marriage that they began to work together on a novel about a painter named Faubion, which was based on an idea that Rothschild had written down several years earlier. Myrer was still searching for a subject for his next book and Rothschild wanted to do something that would be in unison rather than in conflict with him, so the idea had initially seemed good to both of them. Although they worked on the project, on and off, for well over three years, it was ill fated from the beginning. Myrer understandably came to feel that Rothschild was imposing the subject—and the togetherness—on him.[16] The more they tried to accommodate each other, the worse their situation became.[17]

In the fall of 1959, while they were still based on Cape Cod, they bought a house and property in the High Woods area of Saugerties, New York, near Woodstock, about one hundred miles north of New York City. In the fall of 1961 they also bought a house on the Cape, at Bound Brook Island, an isolated and sparsely populated part of Wellfleet. For the rest of the decade, Rothschild's working year would be divided between the woodlands of Saugerties and the dune and ocean landscapes of Cape Cod.

The paintings that Rothschild embarked on during this period of transition were especially strong and interesting ones. Two of the most striking started as evocations of the outdoor markets she had seen at Cannes and Antibes. Rothschild first began to work with the theme in November 1958, when she did a collage called *Marché*, which she subsequently destroyed. Shortly afterward she began a 40-by-50-inch version in oil, *Marché (I)* (Colorplate 11), for which she also did a series of Ostwald color diagrams.[18] This picture, along with several others started about the same time, would be worked on for a period of several months. In mid-March she noted that she was just "finishing" it, but on July 10 she did an elaborate drawing of it in a notebook with Ostwald notations (Figure 38). And as late as July 14 she was still working on it.[19]

Marché (I) takes the dialogue between abstraction and figuration a step further. At first it seems to be a broadly brushed abstract painting rendered in terms of the linear drawing system that she had been using in her

Figure 38
Study for Marché (I), *from Journal no. 21, July 10, 1959. Ink on paper, 11 × 8½ inches.*

seascapes, but here with a greater sense of freedom and spontaneity. (Without documentary evidence about how long she worked on it, one would think it had been done in a single sitting.) On closer examination, however, we begin to discern elements of figuration: the upper torso and head of a figure at the right, and what seems to be a large exuberant still life at the left. We can also make out the dislocated planes of a table, and then realize that the circular forms that frolic in the air above it suggest flowers, and that there is a large blue squash near the center.

What seemed at first to be an abstract painting turns out to be filled with the representation of specific objects, which were an integral part of the painting right from its conception. In Rothschild's July 10 drawing, the head of the figure is clearly delineated, and a note describes the picture as "40 x 50—Marché w/ fig on right & anemones left." On the same page, along with Ostwald color notations, she notes that the figure on the right is "to be more hieratic sombre" while the other areas are noted as "less imp[ortan]t." The painting works both as an independent, abstract composition and as a kind of poetic equivalent for a lived experience—the animated energy and bustle of a French open market.

As she struggled to finish *Marché (I)*, Rothschild also worked on other versions of the theme, most notably another 40-by-50-inch version that she began in mid-February 1959.[20] In *Marché (II)* (Colorplate 12) we are again initially not aware of the presence of the figures. Here the representational elements are more diffuse than in the earlier painting, and the space as a whole is more dynamic and fluid. Eventually, however, we can make out two figures—one placed at the right in a position similar to that in *Marché (I)*, the other, at first more difficult to read, at the far left. In *Marché (II)* Rothschild introduces bolder color contrasts, playing strong yellows against blues and blue-violets, and uses freer and more disembodied linear drawing. The painting also seems to have had an autobiographical subtext, since it was also for a while given the title *Family Portrait*, which leads us to speculate that the two figures are meant to be Rothschild on the left and Myrer on the right.[21]

At the same time that Rothschild was executing these densely worked pictures, in which linear and painterly elements are played against each other with equal intensity, she was also engaged with a number of related paintings in which the line drawing is more fragmentary in relation to the painterly areas, and in which more emphasis is given to atmospheric effects. Several of these pictures have titles from mythology—a direct result of

her continued reading of the Greek tragedies, and perhaps of her recent trip to the Mediterranean. And not coincidentally, at a time when her marriage was becoming more volatile, several have themes that involve women suffering from the consequences of love.

Alcestis (Colorplate 13) was begun in February 1959, at the same time as *Marché (II)*. It is one of a number of treatments of the theme that Rothschild undertook at this time, inspired by her reading of Euripides' *Alcestis* the previous summer.[22] The abstract-representational dichotomy is especially telling in *Alcestis*, for which she also did a number of drawings and color studies (see Figures 39 and 40). What appears to be an abstracted landscape actually contains the figure of a woman in the lower right-hand corner; the lines that describe her body are so embedded in the landscape forms around her that at first she is barely discernible.

Rothschild's use of the Alcestis theme at this time was especially provocative. In Greek mythology Alcestis was married to Admetus, a man who had once shown great kindness to the god Apollo. After the couple had been married for some time, Admetus fell mortally ill and was destined to die. But Apollo extricated from the Fates the promise that Admetus would be spared if someone could be found to die for him. Neither Admetus's father nor any of his courtiers, however, was willing to do so. Instead, it was his wife, Alcestis, who offered herself in his place; so, as Admetus began to regain his strength, Alcestis fell ill and began to expire. In Euripides' play, which takes place on the day of Alcestis's death, it is apparent that in allowing Alcestis to sacrifice herself, her husband has acted in a cowardly way. And only through the intervention of Heracles, who subdues Death himself and forces him to release her, is Alcestis ultimately restored to life. Alcestis is described in the play as "the noblest of women." But as Richmond Lattimore points out in the introduction to his translation of the play, which Rothschild read, "The theme of the drama is not 'if a wife dies for her husband, how brave and devoted the wife,' so much as 'if a husband lets his wife die for him, what manner of man must that husband be?'"[23] The significance to Rothschild of this particular mythological theme seems clear, especially at this time, when so many of her decisions were being made in deference to her husband's needs and to the detriment of her own. (One does wonder, however, what Anton Myrer thought about her use of this theme.)

Rothschild's picture was conceived as a kind of ecstatic vision, and she described it in terms of a whirl-

Figure 39
Study for Alcestis, *from Journal no. 21, July 2, 1959.*
Ink on paper, 11 × 8½ inches.

Figure 40
Studies for Alcestis, *1959. Ink on paper, 9⅜ × 7⅞ inches.*

ing presence: "Dervish almost landed new 40 x 50 Alcestis paysage drawn in." In a now-lost first version,[24] Rothschild wavered between a color scheme dominated by warm yellows played against violets and another dominated by violets and reds. One she saw as having a "sun-bleached dryness…with the fragmentations & inexorable sun more intense & set vs. 2 dark streaks" that would press out to the "right & bottom of [the] canvas like a terrible crack in the fabric of the world." The other she conceived as "a kind of night walkers' song scale of unreal colors," purples and reds "making a kind of dance in the sky," with "less intense versions of the same colors in the foreground" and a streak running out of the bottom, "possibly black or bright orange—like a shocking wound—& with the only relief the horizontal bar of silvery pale green."[25]

While she was working on this picture, Rothschild made notes in her journal about the need for "Katharsis" in her work, and she wrote specifically about her intentions in *Alcestis:*

> to show the awful hugeness & the frightening fragility of our sense of creating order in our lives. This dependable earth *can* open up at any moment. Or Worse.… The sun has but to set. In the play, the sun becomes like her fate. Another way to do it would be (again) to get the brilliant glaring pristine beauty of (say) a NW day at Amagansett or Cape in the light of the inexorable orb which controls A's life span (in the play).
>
> All this seems beyond me to do. If only someone (a man) would try to do something—& this is *not* a literary but a visual idea, the legend is only the springboard that made me think in such terms of awful fate—It touched me particularly as it is one of the few that is about a happy loving married woman & because when we read it last summer (at Amagansett) I so begrudged the passing of each hour since that time there seemed like life itself & our great last chance before coming back to NYC & its winter jungle.[26]

The feeling of catharsis was especially important to her, in terms of creating a pictorial language that could not only convey her feelings but that could also compete with the mythopoetic ambitions of abstract-expressionist painting. "To avoid painting non-Kathartic pictures," she wrote in her journal, "that's the thing—at the same time that the specific never becomes the constricted. To make people have this sort of deep Katharsis in terms of the space of the picture & in terms of a more exact human connection."[27] At the same time, she was aware that this "human connection" had to be expressed in pictorial terms—in terms of how forms, lines, and colors related to each other spatially rather than in terms of literal representation or direct linear narrative. When she was in Florence she had questioned the way that early Renaissance painters had given priority to direct narrative and had suggested that this aspect of Renaissance art was "merely a prolonged & increasingly decadent digression in which the narrative assumes an 'unlawful' place & chiaroscuro and perspective are too totally employed solely in its service."[28] Despite her feeling that Abstract Expressionism was too visceral, she nonetheless realized that it embodied the best effort yet to understand and articulate contemporary perceptions of space. She even wrote that "*only* Abstract Expressionism has begun to respond to the new spatial preoccup[ations] of man. All its other aspects aside Abstract Expressionism *is* groping in the sphere of space. . . . Our spatial frame of reference is changing. Art is reflecting this before anything else admits it. This is why Abstract Expressionism has a new spatial preoccupation which is its *one* element of validity. The rest, the hedonism, the subjectivism . . . the texture etc., is unimportant."[29]

This adversarial feeling toward Abstract Expressionism was something that she had shared with Knaths. But during the summer of 1959, she sensed that Knaths had begun to be "lured towards" the abstract expressionists—largely, she felt, because he was dissatisfied with his own work. She was disturbed by this, because she had been drawn ever closer to Knaths's position, and she was frustrated by her frequent inability to communicate on an equal basis with the older painter. "If only it were possible to talk w/ KK sans his endless egocentric interruptions," she wrote that summer, "I *think* I could say something of all this to him that might make sense to him & show him a viewpoint worth pursuing himself."[30] Instead, she found herself being both drawn closer to him and struggling against him—a repetition of the same kind of tension that existed between her and Myer. Despite her mixed feelings toward Knaths, he still remained a mentor and most trusted critic. She was especially pleased, for example, when he told her that fall how much he liked *Alcestis*.[31]

A related theme is addressed in *Io* (Colorplate 14), which was begun in June 1959 and finished early the next year. Io is another instance in Greek mythology of a woman who becomes the victim of love—that of the god Zeus, who fell in love with her (and who in Correggio's famous painting makes love to her in the form of a cloud). To protect her from the jealousy of his wife, Hera, Zeus transformed Io into a white heifer. But Hera was not deceived. She claimed ownership of the heifer and sent the many-eyed monster Argus to guard it. When Hermes killed Argus, Hera sent a gadfly to torment Io, and the gadfly chased her across Europe and Asia, until she was allowed to rest in Egypt. There, on the banks of the Nile, Zeus returned her to human form and she bore his child.

Rothschild's depiction of this theme is more ambiguous than her rendition of Alcestis. The picture is more openly painted and the forms that relate to the subject are more difficult to read. At first viewing, we see above the large expanse of landscape the suggestion of a head rendered in pale tones that extend in a broken arc across the hills stretching into the distance. And below this head is a form that could be taken to be that of an animal, rendered in a fragmentary, foreshortened way; this would seem to suggest the figures of Zeus and Io and to make an indirect allusion to Correggio's painting. But after a while, we realize that these forms actually describe the figure's raised hand, which is brought up to her face in a gesture of contemplation, so that the painting is more of a "portrait" than a narrative. This reading is given further weight by the fact that in an inventory of her paintings Rothschild listed a work, probably this one, as "portrait of Io."[32]

The bridgelike compositional structure of *Io* is also employed in one of the most unusual of Rothschild's pictures from this time. *Figure in Space* (Figure 41), which even after extended viewing appears quite abstract. This picture, however, also has a figure in the foreground, placed similarly to the figure in *Alcestis*, but now on the left. The very sparseness of the linear elements seems to anticipate the gradual paring down of the drawing in her paintings during the next decade.

Rothschild set great store by this series of paintings, many of which were shown together in her exhibition at the Knapik Gallery in April 1962 (Figure 42). Although

Figure 41

Figure in Space, *ca. 1960.*
Oil on canvas, 40 × 50 inches.

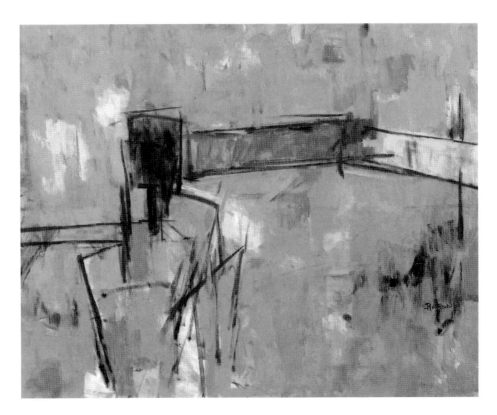

Figure 42
Photograph of Rothschild's exhibition at the Knapik Gallery,
New York, April 1962.

this exhibition represented the best work she had done during the past five years, it received little critical attention. To make matters worse, Myrer's third novel, *The Violent Shore*, which was published around the same time that her show opened, also fell into a kind of void. This double disappointment created a sense of crisis in what was already an unsettled situation between them.

"We are forced to do some heavy reevaluating of ourselves, our work, the whole direction & meaning—if any—of our lives," Rothschild wrote. "It promises to be a tough evaluation too, because in so many ways we seem to be pulling against each other. And because we have come at last to see what we are up against in the world of the arts more clearly than we have previously admitted to. At 40 it is not the same thing to be ignored as at 25."[33]

Rothschild felt disoriented and had difficulty regaining her balance. She was beginning to feel a strong need to free herself from the subordinate position that she had allowed her marriage to place her in. And as she struggled to redefine certain aspects of her relationship with Myrer she also became increasingly aware of the consequences of middle age, especially with regard to having a child.

At Myrer's insistence, she had foregone having a child. At the end of 1960, against Myrer's protests, she had

purchased a saluki puppy, which she named Jezebel. The dog was clearly a substitute for a child; she admitted this and noted that her parents had also remarked on it. She had wanted to breed Jezebel, but Myrer insisted that they have the dog spayed. In the spring of 1961, while the dog was recovering from the surgery, Rothschild remarked that she herself would soon be forty and "beyond the age to have babies." She also noted that seeing Myrer's pleasure with the dog, "which

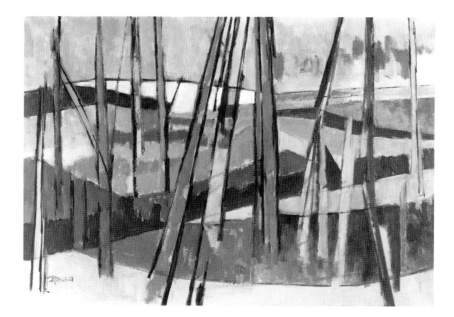

Figure 43
Woodland, *1959. Oil on canvas,
29¾ x 48⅛ inches.*

he resisted so long," had made her think "I should have had a child & he would have been glad in the end."[34]

Now even the notional possibility of having a child was becoming increasingly remote, and she also began to take measure of the diminishing options for her life in general. At moments of crisis, her thoughts often returned to Weldon Kees, whose tragic career she now saw from a different perspective. "Reading Weldon's last poems," she wrote shortly before her fortieth birthday:

> For first time I can believe he is dead. And this is a blow now as it never was. . . . One misses him so. . . . It seems he had placed himself . . . in a life without solace. This is something to remember. Because it was *this* most of all that made him so embattled & lonely & hopeless. . . . That last room in S.F.—what a sad thing—his collecting bits of broken machinery and carting them back. As though the only thing he could embrace were these scraps of rusty, meaningless, now defunct metal—that had once served as parts of the very machines he hated & that were killing him.
>
> I always postpone thinking of my own part in his despair. What a poor role I played: the possessive ambitious American wife full of thoughts of comparative status and competition. . . . I felt W threatened Tony—& in all truth I still think I sensed, correctly, that W wanted to bring a few others down as he fell—at least wanted that intermittently. But the point is that—I was too protective, too conscious of T's (My HUSBAND'S) vulnerabilities to see W's. . . . Sad thing is really simply that at the time I was just too young to understand the depths & complexities of WK's misery & could not believe he would seek such a desperate solution. Now that I am nearly 40 myself I begin to understand—which is why I suddenly can believe he may actually be dead.[35]

As Rothschild divided her time between Saugerties and Cape Cod, the imagery of her paintings also alternated between the kinds of motifs found in each place, as in *Woodland* of 1959 (Figure 43) and *Pink Hills* of 1960 (Figure 44).

The Cape landscapes proved to be the more amenable to what she now wanted to accomplish. Within her depictions of dunes, marshes, and the sea there is a gradual but marked development from rich textures and painterly flourishes to an increasing severity. *Pink Hills*, a Cézannesque depiction of high dunes on Cape Cod, is a good example of the former phase, which is characterized by heavy line drawing and painterly handling of the surface, which is broken into patches of fairly bright color. A few years later, in paintings like *Portuguese I* (see Figure 48), she was beginning to work in a way that recalled the austerity of Mondrian's pre-abstract landscapes. If *Pink Hills* is Cézannesque, it also shows Rothschild's debt to Knaths. At a moment in her development that she later recalled as one of extreme crisis, she was clearly seeking a new approach but was not sure which direction to take. She alternated between allegiance to Cézanne or early Mondrian, and Knaths was the mediating factor between the two and still the

strongest single influence on her work. This is especially clear in *Cape Inlet* of 1962 (Figure 45), one of the most explosive paintings she showed at the Knapik exhibition, and also one of her strongest responses to Knaths.

Since her return east Rothschild had been seeing a good deal of Knaths. When Knaths had paintings on view at Alexander Rosenberg's gallery in New York in October 1958, for example, Rothschild not only went to see them but also did extended analyses of their linear structure and color, complete with Ostwald notations.[36] Knaths also continued to give her detailed critiques of her work.

which she felt were well-intentioned and often right on the mark. She was impressed by the way in which he was able to spot "at once *just* the places I knew were weak & had not 'adjusted' perfectly."[37] She also had extensive discussions with Knaths about other artists, including Mondrian, whom she now was beginning to conceive of as a more beneficent influence. While she was working on the *Marché* paintings, for example, she reflected that "at end of his life (i.e. in Broadway Boogie Woogie) Mondrian was beginning to work on this problem of uniting the 'new' space & color concepts. And he was even sidling up to [the] problem of finding the ref-

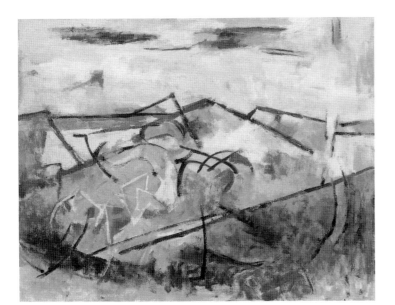

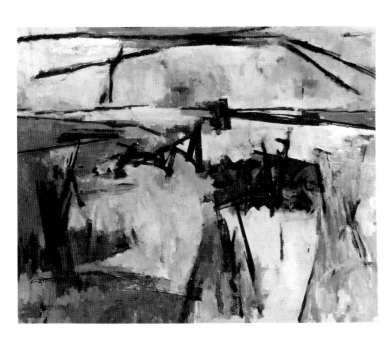

Figure 44
Pink Hills, *1960. Oil on canvas, 28¼ × 36¼ inches.*

Figure 45
Cape Inlet, *1962. Oil on canvas, 36 × 45 inches.*

erential connective—but his own idiom was too rigorous for him to break out of it quickly."[38]

She also planned and worked on specific paintings in relation to Knaths's color system. While she was working on *Io*, for example, she remarked that it was "particularly difficult to see how to achieve a *method* that is feasible, flexible suited to one's *own* talent & yet evocative enough. This is really what I've been battling since Europe." Meanwhile, she noted, she was setting up the composition of *Io* in terms of Knaths's color system.[39] For a while during the late 1950s she became so obsessed with trying to achieve what Knaths called "a balanced color" that it began to dominate her working procedure. She spoke of the way the Ostwald chip colors could "save a lot of time & trial & error" and provide "a sounder method." Her desire, she wrote, was "to get a plangency to the color *yet* keep the movement pressing forward more than K's pictures do, for example." At the same time, she was aware of the danger involved in the fact that the color chips were "not *really* accurate." She had to resist the temptation to rely too much on numerical logic and instead to use the Knaths system "only to strengthen & make accurate my color plan."[40]

Only about 1960 did she gradually begin to question both Knaths's criticisms and his system and to pose a crucial question when she had problems with color: "Is this use of color an actual weakness in my work. . . . Or is this a weakness in KK's system."[41] That summer she began to become seriously troubled by her relationship to Knaths. It was then that it occurred to her that "every Wednesday I am just full of elan & hope for my work," but that after her Thursdays with Knaths she felt enervated.[42]

But try as she might, she could not free herself from Knaths's commanding presence. So deeply was she in his thrall that in February 1961 she wrote to her parents urging them to buy Knaths's *Spearing Eel* of 1960 (Figure 46), calling it "one of the best pictures by an American in the past decade."[43] In fact, Rothschild's paintings of this period owe a good deal to Knaths not only because she was using his system but also because

of the way she based her paint handling and her general treatment of space on his. Yet at the same time she was also resisting him. Even in a painting like *Marché (I)* (Colorplate 11), in which the figure is fairly literal, neither the space nor the action is as straightforward as in Knaths's *Spearing Eel*. Whereas Knaths resisted ambiguity and criticized Rothschild for her use of it, Rothschild insisted on it, and her best paintings of this period are successful precisely because of the way she balances their representational and spatial uncertainties. Around this time, perhaps in reaction to Knaths's influence on her, Rothschild was especially torn between the desire to work in a painterly and expressive way with a marked personal touch and a great deal of linear drawing, and to work in a cooler, more austere way. Throughout the early 1960s she moved back and forth between these modes. And as she started to move away from Knaths's kind of paint handling she became increasingly critical of him, both as an artist and as a man.

One incident in particular upset her greatly. On an afternoon in August 1963 she took some of her paintings to Knaths's studio for a quiet critique. But when she got there she found that Knaths was not alone, as she had expected. With him was a painter named Palone, who instead of leaving began to give Rothschild a critique of his own. In the course of doing so, Palone made a number of aggressive, and to her mind completely irrelevant, comments about the paintings she had brought, concluding with what she characterized as the "old usual bit about 'women painters' & work being pastel, etc."[44] She was stung by Knaths's insensitivity and

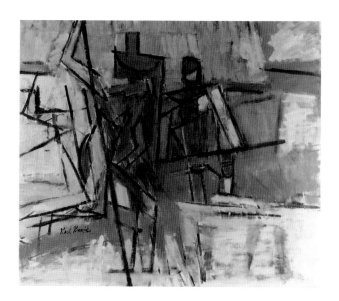

Figure 46
Karl Knaths, Spearing Eel, *1960. Oil on canvas, 36 x 42 inches.*

thoughtlessness in allowing Palone to attack her in that way, and she stayed away from Knaths's studio for some time afterward. "K's actions then have left me oddly bitter toward him," she noted a month later. "Climbing aboard P[alone]'s crits seemed shabby & weak in just the one & only sphere I still expect anything of KK."[45] This incident brought home to her the degree of Knaths's condescension toward her, not only because she was younger than he but also because she was a woman.

A year later, when she began to pull away from Knaths's influence in a definitive way, she became critical not only of Knaths but of his system, noting that "much of KK's actual system seems to me phoney because it is based on spurious, fictitious & inaccurate systems of fake analogies w/ music, math, etc."[46] Around the same time she noted her progress in her own search for a way of working that would satisfy her need for both method and a more intuitive approach to painting, which would allow her to relate to the "metaphor of landscape" without too much verisimilitude but also without relying too much on a dogmatic system.[47]

Another trip to Europe provided a crucial turning point in her progress toward that goal.

A New Austerity, 1964–1970

For the preceding few years, Rothschild and Myrer had wanted to go to Spain and Portugal. Myrer's mother was said to be partly of Portuguese descent, and he was interested in seeking his Portuguese roots; Rothschild was eager for contact with what was still considered a fairly exotic and remote part of the continent. They started their trip in Paris early in September 1964, and they first traveled for a while in eastern France and western Germany before heading southwest to Aix-en-Provence, where they again paid homage to Cézanne before heading west to Spain.

Rothschild had especially high hopes for the visual stimulation she would get from the Spanish landscape. While they were at Toul in eastern France she had written in her notebook: "Keep feeling this is what Spain could be like. Motif of landscape a rich slow arch of hill—endlessly repeated in poplars & sky clouds & accentuated by mode of farming which makes strips of contrasting belts following arch of contour."[1] A couple of weeks later when they finally arrived in Spain, she did a number of sketches (Figure 47) and remarked that these were the first days so far that seemed "really visually exciting" to her. Some of her impressions at this time seem to anticipate specific paintings that were inspired by the trip: "Early views of Pyrenees ... pale and smokey.... Impact of blacks—of the specific mortal being vs the timeless sand colors."[2] She also did sketches of the plains in Estremadura and the Algarve, where she was dazzled by the vibrant colors and intense light.

During this trip she also remarked on a definite coolness and lack of communication that had grown up between herself and Myrer, which she contrasted to her feelings during their first European trip seven years earlier. Over the past year the tensions between them had become worse. The previous fall, they had read aloud Edward Albee's play *Who's Afraid of Virginia Woolf*, a provocative decision in itself, since the play deals so mercilessly with the marital problems of a painfully childless couple. They got into an argument that became so heated that Rothschild began to weep and Myrer suggested they split up for a while: "One of those arguments that unsettles because behind it is both our weaknesses. Both our fears for each other as artists. Tony fears & resents the N.Y. in me—the relativistic—the love of the new, the jangling and the heat. I fear his over moralistic over conservatism—his being out of step & not examining but condemning whole hog."[3]

Throughout their second European trip, Rothschild was dogged by the feeling that Myrer had become indifferent to her, and they argued a good deal over small things.

Figure 47

Page with descriptions and drawings of the Spanish landscape, from Journal no. 30, September 27, 1964. Ink on paper, 11 x 8½ inches.

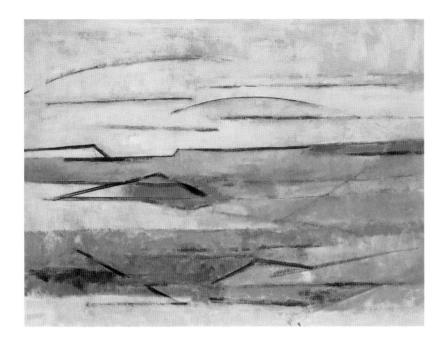

Figure 48
Portuguese I, *ca. 1965. Oil on canvas, 24 x 36 inches.*

Rothschild returned to the United States feeling emotionally dislocated and aesthetically divided. Shortly afterward, when she began to work with a number of motifs inspired by her European trip, she treated them with a new austerity. This is well seen in *Untitled Landscape* (Colorplate 15) and in *Portuguese I* (Figure 48), both probably done in 1965, in which the construction is Mondrian-like, with arcs and angles played against a bright and luminous pictorial field.

The year 1966 was a crucial one for Rothschild's work. It was then that she began to consolidate a number of elements that she had been thinking about for the past few years, especially regarding the use of color to create light. "I want the effect to be of light," she wrote of her landscape paintings, "colored light. Shimmering— sonorous compelling yet subtle & w/ unity through proximate intensities not melodramatic contrasts. . . . There must be form—but . . . I want the impact to come mainly from solidly massed colored forms. Perfect exact adjustments [of] strong colors pitted against each other [without] intervening neutrals (& that includes lines as boundaries [between] colors)."[4]

In *Lieutenant Island* of 1966 (Colorplate 16) the drawing is more descriptive than in *Portuguese I*, though quite simplified in relation to Rothschild's earlier landscapes, and the ensemble creates a wonderfully vivid sense of light.[5] An even more sonorous evocation of light is created in *Sierra de Gredos* of 1966 (Colorplate 17), one of Rothschild's most majestic landscapes, which de-

picts the mountain range that she had seen her first day in Spain.[6] Unlike most of her other landscapes of the period, which are fairly flat, the angular planes here carve out a rocklike three-dimensionality. The more typical flattening of the picture space is especially nuanced in *Algarve II*, also of 1966 (Colorplate 18). Here the evocation of the intense light that Rothschild remembered from Portugal is given special force by the way the deep violets are set against the overall harmony of bright yellows.[7] An even denser and less atmospheric luminosity is achieved in *Estremadura* of 1966 (Colorplate 19), in which the chromatic effects are more closely calibrated. An Ostwald diagram of the painting (Figure 49) shows just how much fine tuning went into it. Here there is very little tonal contrast, so that the articulation of the total space is achieved largely through color, especially by the way the colors interact at adjacent edges.

As Rothschild's pictures became more austere, she was no doubt inspired and encouraged by the rise of minimalist art at the time, and by renewed interest in Josef Albers's ideas about the interaction of colors. She very possibly also reread Ad Reinhardt's 1957 essay, "Twelve Rules for a New Academy," which had been partially reprinted by The Museum of Modern Art in 1963.[8] In his essay Reinhardt had come out against the expression of personal emotion as well as against texture, brushwork, and drawing. Although Rothschild was in no way prepared to subscribe to his proscriptions against color, light, and space, she was undoubtedly affected by the

Figure 49

Color analysis of Estremadura, *1966. From notebook labeled*
"Ostwald." Ink on paper, 10 × 8 inches.

new spareness that was being articulated at the time in
different ways by many different artists.

Not surprisingly, as her painting moved in this new
direction, Knaths became more and more disapproving,
and she in turn grew increasingly disillusioned with him.
When she returned to Bound Brook Island in the spring
of 1966, she noted that she was "fighting a wildly irra-
tional resentment" of Knaths now that she was "free of
him."[9] She saw Knaths's criticism of Nicolas de Staël—
whom she felt represented "a French-version" of her
own motivations—as being "too general," as yet another
sign of Knaths's lack of comprehension about what she
was doing.[10]

She was especially pleased to be free of the Knaths-
inspired drawing and interplay between line and
painterliness that had characterized her work for much
of the past decade. "Mostly because I have shaken off
(in the large ones) most of the encumbering manner-
isms I had got into habitually & I am beginning to get

the sense of color . . . & quiet unruffled surface—of more
impersonality that I am after. Some of that eerie space is
coming through but the problems of keeping each can-
vas all in one idiom keeps dogging me. Mostly because I
am trying to eschew all the habitual solutions & discover
new purer ones."[11]

As she worked in her new, more minimal manner she also
became interested in emphasizing indirect metaphorical
and symbolic meanings. Ever critical, she noted that
sometimes her "color weights" were not intense enough
and that she wanted to free herself from reliance on
"realistic drawing to make transitions credible." She
also wanted to "get the metaphor of landscape in a more
heightened combination of abstractness & credibility."
What she wanted to evoke was a sense not of real place,
"but of its memory—which includes therefore the trans-
positions, fusions, eidetics which happen to the 3rd
dimension in the 4th & 5th . . . color that is intense, unex-
pected, expansive." She felt that the forms in her paint-
ings were still not "crystalline" enough, that they looked
"too impulsive" and "too personal. Not 'cool' enough."[12]

In a conversation with Myrer, who had misgivings
about the path she was embarking on, she enumerated
the reasons why she was eliminating drawn contour lines
and human figures from her pictures. First (echoing
Eugene Goossen's 1957 criticism), she felt that the "lin-
ear black" of the drawn lines had intervened too much
between her colors and precluded the "undiluted power
of color weights" that could be created by pitting colors
directly against each other. Second, she felt that "per-
sonal calligraphy" was just the opposite of what she was
seeking, namely the "impersonality of nature—sense of
'it is there'—not of the artist putting his stamp on it. Not
Rembrandt but Vermeer." And third, she felt that line
had become a crutch that prevented her from "getting
real power out of color." That same sense of touch that
she had set such store by over the past decade, she now
came to dislike. Instead, she asserted, "I want to make
pictures that read flat in shape & color tensions but in
spaces & color relationships read 3 dimensionally. To do
this [one] must not get too specific."[13]

In short, she was returning to an aesthetic that was
closer to Mondrian, closer to where she had started
twenty years earlier. She now spoke of her need "to
adjust color-shapes more exactly" in an abstract sense,
to interlock the edges of the forms, and to create a
"painterly sense of the real scene but always subordinate

to" the abstract sense. She wanted more "noble bigness" and "less effect," to retain some sort of subject matter but not at the "risk of losing abstract elements."[14]

Throughout the later 1960s, Rothschild continued to work toward this kind of austere effect. Her path, however, was not a straight one, and she sometimes fell back on a more painterly approach that included drawn contours. But she now felt a new confidence. Back at High Woods in the fall of 1966, she remarked that her oils now flowed as naturally as her collages used to. She was relieved to have emerged from the "chaotic state" of the past five years and felt that she was beginning to free her own sense of color.[15]

These landscape paintings made up the bulk of her two most important exhibitions during the late 1960s. The first, at the Albany Institute of History & Art, in February and March 1967, was also her first solo museum show. Although it was well received, Albany is some distance from New York City, and, as expected, the show attracted only local notice. A short while before the Albany show opened, however, she was invited to participate in a group exhibition at Helen Serger's La Boétie Gallery, a well-regarded gallery that specialized in European modern masters. After the group show closed, Serger offered her a one-person show at La Boétie the following year. The show in Albany thus served as a kind of "out-of-town" opening for her new landscape paintings.

Rothschild came away from the Albany show with mixed feelings. She thought that a number of the paintings worked very well but that she still needed to create a more unified attack in terms of how she balanced abstraction and representation. "What I want," she wrote shortly after the show closed, "is to flirt dangerously & successfully w/ the ambivalences: mystery & clarity—abstract spacial [sic] serenity & representational overtones. The poetic & the tangible—the specific & the elegantly elegiacally ordered simplification. I want the color to have the impersonal . . . 'it just is' of nature & the poignance of the personal empathetic reaction to the scene." In particular she felt that Estremadura, which was shown at the Boétie group show, was closest to what she should work toward, because of its chromatic intensity and its subtle departures from the strict horizontality that was characteristic of most of the other landscapes she showed.[16]

That summer she worked hard on the paintings that she planned to show at La Boétie the following February.

She was very much preoccupied with what she referred to as a "jarring discrepancy between the drawing and the color," and she pondered long and hard the challenge presented by paintings like Lieutenant Island (Colorplate 16), which had been shown in Albany and which she felt was "drawn more realistically &, in this case, well drawn—& the color is restrained towards that realism."[17] She was wary, however, of letting the shimmering colors of her paintings become too exquisite and disembodied. Hence she wanted them to retain a certain tangibility, so she would not be thought of as a "dreamy lady painter who mistakes vagueness for spirituality." It was her dread of being so categorized that had led her "to want tangibility, specificity in pictures like Lieutenant Island etc. . . . The 1st rate artist—Rembrandt say, drew his figures w/ [a] perfect base in the specific yet perfect relation to the abstract. . . . This is the visual equivalent to Fitzgerald's old rule about writing: The holding of 2 mutually exclusive elements in the mind at once."[18]

As Rothschild prepared for the Boétie exhibition, Myrer was also racing to complete his fifth novel, Once an Eagle, in which he had returned to a military theme—the story of a soldier who has risen through the ranks from private to general and who finds himself locked in a deadly struggle with the military establishment. Although the bulk of the action takes place during World War II, the concluding chapter is set in contemporary Southeast Asia. Coming as it did at the height of the war in Vietnam and at a time of great domestic turmoil, the book touched a nerve and began to attract a good deal of attention. In the spring of 1968 it was selected by the Book-of-the-Month Club, and despite mixed reviews it became a best-seller.

Rothschild's exhibition at La Boétie, by contrast, received relatively little notice and, as with her Knapik Gallery show in 1962, was not covered by the New York Times. Ralph Pomeroy, writing in Art News, recalled her beginnings as a "veteran abstractionist of the Jane Street Group," briefly described the compositional structure of the pictures, and commented on their "glowing color."[19] The notice by Cindy Nemser in Arts Magazine was longer and more substantial. "Simplicity and serenity result from many years of a selfless dialogue with nature," Nemser noted, calling attention to Rothschild's "struggle to discard all that is extraneous from her vision in order to arrive at its very essence." Although Nemser faulted Rothschild's excessive dependence on nature, she

also noted that in her best works Rothschild had achieved "a lyrical synthesis of self and nature, which gives her work a touching, transcendental quality. Simple bands of color create a total statement."[20]

Throughout this time, Rothschild's relationship with Myrer continued to deteriorate. Several times they had discussed the possibility of spending a portion of the year apart so that each would have a greater opportunity to work free of the other's constraints. Then, at the beginning of 1969, Myrer suddenly announced that he was going to go to Morocco and Portugal by himself. Since Rothschild had been very much looking forward to revisiting Portugal, which had provided her with so many motifs for her paintings, she was upset and tried to persuade him to reconsider. Myrer, however, was adamant about traveling without her and left at the end of March.

While he was away, Rothschild came across various papers that indicated he was not traveling alone.[21] Almost immediately she began to suspect that he was with Patricia Schartle. The evidence of this extremely painful betrayal led her to reconsider her whole relationship with Myrer over the past twenty-two years, and especially during the last decade. That she was devastated is apparent from the entries in her diary at the time. It seemed to her that her whole life had been destroyed, and for a while she seriously contemplated suicide. "The thing that has kept me from suicide," she wrote later that spring, "is not ambivalence about now but knowledge that I can stand this.... T's failure of will goes back to *1958*! ... T. wanted me as a mother not wife. Thus resented children.... But I wanted dom[ination] & [the idea of a] team—at once—wanted HMR's dom[inance] & image of a team.... Yeats says: Too long a sacrifice / Can make a stone of a heart. That is the shadow of turning. It became a sacrifice not a delight."[22]

After Myrer returned, she tried to work things out to preserve the marriage and save face with her parents. She also began a long period of recrimination, and self-recrimination, in which she tried to reconcile what had actually happened with her long-held idea of what the nature of her relationship to Myrer had been. She began to question Myrer's probity and artistic integrity and to suspect that he had married her for her money in the first place: "Tony will never see that it was the years of living w/ me & demanding *everything* from me—alienation from my family, friends, origins, (we only came back East for *his The Big War*—not for me) children, N.Y.C.—career etc.—even (pragmatically) for many

years my income while at the same time *pretending* he was doing the same thing—*that this was the great betrayal.*"[23]

During the next several months, as it became clear that the marriage would not last, Rothschild wrote a number of drafts of a long letter to Myrer in which she listed her grievances. He had asked for a divorce and, she felt, had "rewritten" their marriage by emphasizing his longtime attachment to Schartle and by downplaying the twenty-two years they had lived together. "And the deeper part of my anguish," she wrote, "is that I have for so long built every breath around the life we have had—& on the love I have for you & the belief [and] respect I have for you as an artist.... You know for 22 yrs I have really assumed that your wisdom was greater than mine—your needs more necessary of satisfying (if possible), your decisions more likely to be right—it is an incredible habit." Referring to the unusual kind of marriage they had, she asserted,

I'm not saying *our* way was wiser or better. Or blaming us either. Only that I feel now that it involved, for me, an enormous number of areas in which I gave way (or gave up) & forsook natural & normal kinds of fruition.... I was willing to forego a very great deal that I could normally have hoped for—for the sake of your independence of creative spirit & the sort of freedom from city life that you required.

... Now—suddenly—you present me with the need to call a dead halt to *all* that life has been—& the suggestion is made that I have but to work at it a bit & I will be quite happy in some other way of life.

Don't you really see how impossible this is for me.

She concludes the letter by saying that she has learned that "you have very different needs from mine" and "that I have been most wrong not to have insisted on my own more often—at least to have tried to voice them more."[24]

During this difficult time, she also thought about Weldon Kees, and once again she saw his tragic end in a new light:

I keep thinking of Weldon—dreaming of him—worrying about my last phone conversation w/ him. How little it can take to tip the scales just that little bit extra. "You're not angry w/ me are you, Judith"—& then I answered, trying fatally to be the aloof & measured judge that Tony had been.... "Not at all Weld"—A cruel answer because what I *really* said was "You don't mean that much to me that I can level with you"—(he knew that we were annoyed w/ him)—He needed to be needed

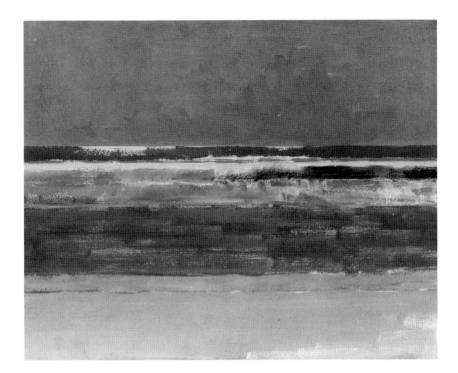

Figure 50
Alcestis III, *1969. Oil on chipboard,
15⅞ x 20 inches.*

then & he knew T would be aloof. He asked to speak to me—& I was just as bad as T.—I understand it all now. But so much too late. Tony should not have turned from him either. Should have spoken frankly but tried to go on from there. By keeping it in T made [a] break inevitable. Made it a matter of loss of respect as well. Of course the sad part was that T. and I were so insecure ourselves & WK had given T. a bad time. I blame myself most. Again an instance of how letting T.'s identity swallow me up made me so much less than myself.[25]

It was toward the end of this period of overwhelming grief and rage that a psychiatrist she had just begun to see asked her why she had previously repressed her anger and why she had ever accepted the idea of not having children, of deemphasizing her career, and of living on her money instead of Myrer's in the first place. And it was while driving back from this session that she came to the realization that "I never fought him about having children because before we were married I know I felt that just to be loved by Tony was such a miracle I 'should' not ask for anything else. Perhaps I have always feared to show anger because doing so runs the risk of arousing anger in the other person, and this in turn runs the risk of revealing the underlying affection or lack of affection that individual has for you. . . . So I acted out of fear with Tony . . . not simply out of 'nobility.'"[26]

This disaster in her personal life was to have a powerful effect on her artistic life. Even while she was in the midst of her most desperate grief, she pushed herself to work.[27] That June, not long after she discovered Myrer's betrayal, she began a series of minimal landscapes with the title *Alcestis* (see Figure 50).[28] These culminated in *Alcestis VI* (Colorplate 20), which is the grandest of the series in both size and emotional impact. *Alcestis VI* is at once lyrical and extremely severe; composed very much in chromatic terms, and yet—in distinction to Rothschild's prior ruminations about reducing the sense of personal touch—painted with a kind of tenderness that creates a depersonalized but deep feeling of sadness.

Alcestis VI was shown at the Wellfleet Art Gallery not long after it was painted but apparently not again. When I first came across this painting in 1995, I thought that a mistake had been made in the title. It was not until two years later that I realized that the title was not only an appropriate one, but that the painting was an excellent embodiment of a statement Rothschild had made a full decade before she had painted it, when she first began to work with the Alcestis theme. At that time, long before she fully understood the further implications of her subject, she had written of wanting to express "the awful hugeness & the frightening fragility of our sense of creating order in our lives," the feeling that "this dependable earth *can* open up at any moment."

Coming Home, 1970–1975

After her divorce from Myrer in April 1970 Rothschild's life underwent a drastic change. When they divided their property he had chosen to keep the house in Saugerties, while she kept the one on Cape Cod, which could be used only as a summer residence. So she decided to make her base in New York City, at the studio she had kept on East Ninetieth Street. The following year, she made a more definite commitment to staying in New York when she bought a house at 1110 Park Avenue, just below Ninetieth Street, where she would live for the rest of her life.

Along with her change in living circumstances, she also began to become involved with a new circle of artists, writers, and friends—and she was welcomed back in the family fold. She also reestablished relationships that had been impossible to maintain because of Myrer's animus toward certain people. She agreed, for example, to participate in a group show at the Rose Fried Gallery even though she and Fried had broken off relations some years before, largely because of Myrer.[1] She also became active in a number of group activities. In January 1970 she was appointed a trustee of the American Federation of the Arts, and not long afterward she renewed her association with the American Abstract Artists.

Around the same time she became involved in looking after the American affairs of the journal *Leonardo*, a new "International Journal of the Contemporary Artist," which was edited by Frank J. Malina, an American who lived in France. *Leonardo*, which was published by the Pergamon Press, attempted to relate art with science and to apply a kind of scientific rigor to writing about artistic issues. In the fall of 1969, the artist "Al" Alcopley had suggested that she write an article about her work for *Leonardo*. Rothschild's article appropriately combined an account of her personal experiences as an "intuitive" artist with a description of some of the theoretical issues that had played a role in her work. The article was written in the fall of 1969 and published the following summer under the title "On the Use of a Color-Music Analogy and on Chance in Paintings."[2]

In this article Rothschild synthesizes a number of the concerns that had preoccupied her in the landscape paintings she had done during the last several years, and she discusses her experience of the tensions between working intuitively and working systematically. Although the article is mainly theoretical, it does contain an implicit autobiographical element. Rothschild notes that painters of her generation who were "trained in New York during and just after the Second World War" were encouraged to work spontaneously and to question a methodological approach to their art. She underlines the importance of Hans Hofmann, "essentially a romanticist," and the way he had dominated the teaching of painting. She notes, however, that as she had been trained as a musician before she became a painter she had experienced doubts about this spontaneous approach. Since her student days she had thought a great deal about "the idea of some sort of color-music scale correspondence" and had even discussed it with the composer Edgar Varèse. She then recounts the way in which Karl Knaths had introduced her to the Ostwald color system and explicates the way in which she used this system to verify her intuition and to explore color relationships "more accurately." What she was after, she recounts, was the kind of underlying structural order that she was aware of in musical compositions—the possibility that "by using the better understood tools of musical composition . . . I could gain more precision in painting." This seemed to be most directly realizable through color, and Knaths's meditations on the Ostwald system, which broke down color into twenty-four hues that could be conceived as corresponding to octaves, seemed a viable way to do this.

In particular, she felt that she would be able to ground her intuitive sense of color in a more "objective" notion of truth, which would to some degree transcend the subjectivity of her own responses to color: "for example, the establishment of 'tension' or discord in music by means of dissonance can be more exactly articulated because we know precisely the difference in function and effect of a *second* or a *seventh* and between *major* and *minor* modes." Although she does not go into any detail about her numerous conversations with Knaths, or about her own meticulous analyses of her own and Knaths's works

using the Ostwald system, she does discuss the way in which triadic relationships exist in the later works of Matisse. She emphasizes the importance that numbers have in all the arts and refers to Spinoza's description of "Beatitudo, the sense of being blest," which she says she understands "to mean the delight in finding order or coherence in the universe—a kind of overarching order."

Significantly, she concludes her article with a discussion of the "limitations and advantages" of her method—in which the limitations are emphasized. She refers to her earlier experience with trying to find precise color equivalents for the slow movement of Mozart's Piano Concerto in A Major (K. 488) and why it did not work (Figure 51). She notes in fact that at the same time that she "dreamt of developing a logical method for using color in paintings," independent of drawing or linear perspective, she also found herself driven back to a consideration of the flat surface of the canvas, which resulted in her "return to making *collages* with their flatness and incisive lines and with the acceptance of chance elements as part of the 'given' effects."

In a curious way, although this article sets out to articulate a theoretical approach to painting, it actually deconstructs a number of its own initial premises, and one comes away from it with a strong sense of the artist's ambivalence toward her subject. This involves not only her ideas toward the systematic use of color but her increasing uncertainty about the limitations of painting itself. Significantly, within the next few months she would dramatically change her technical approach to painting, and this in turn would result in a radical transformation of her imagery.

A number of these changes were already evident in what would turn out to be her last large oil painting, *Interior* of 1970 (Colorplate 21), in which the extensive line drawing is set against large rectangular areas of flat color, and in which visible brushstroke is almost entirely eliminated. The line quality in this painting is much more generalized and less "expressive" than it had been in her paintings of the early 1960s. Rather than *abandoning* line to achieve the "impersonal" effects that she was seeking, she began to use line in an impersonal way. Two elements seem to have fed into this. The first was that the linear elements in her collages seem to have led her back to the kinds of crisp forms that she had used in her geometric paintings of the mid-1940s, such as *Grey Tangent* (Colorplate 2). The second is that she began to give a lot more thought to figure drawing—a result of her preparations for teaching advanced drawing as an

Figure 51
Study of color equivalents for the andante of Mozart's Piano Concerto no. 23 in A major *(K. 488), from Journal no. 22, March 26, 1961. Ink on paper, 9¾ × 14½ inches.*

artist-in-residence at Syracuse University in the fall of 1971. Her preoccupation with the figure is clearly evident in *Interior*, in the full-breasted figure on the left and in the stylized rendering of the legs on the right. The source for this kind of imagery can be seen in a number of the drawings that she did around this time (for example, Figure 52).

In *Interior*, Rothschild set two opposing pictorial ideas against each other. The geometric forms of the background create a flattened and intangible space, which seems to preclude the possibility of being inhabited. But the drawn lines describe forms that insist on creating a habitable space around them. It is the tension between these opposing elements that gives the painting much of its force. Significantly, the line drawing here is done largely in white against darker background forms, creating a "negative" effect. This produces some of that

Figure 52
Untitled Figure Drawing, *1971. Ink on Bristol board,
30 x 40 inches.*

intriguing sense of disembodied tangibility that one
sometimes sees in linocuts—and that Rothschild herself
had employed in some of her earlier silkscreens and
woodcuts, such as *Apple Corer* of 1956 (Figure 53).

About the time that she did *Interior*, Rothschild went
to Paris to see the large Matisse retrospective at the
Grand Palais. She wrote to her parents that seeing the
Matisse show made her feel "as though someone had
injected an energy vitamin into my veins." She felt that
Matisse had "a mind like Yeats—full of flexibility &
complexity—yet able to simplify." And she was also
impressed by the exemplary way Matisse was able to
learn from his own past work—"the failures *and* the
advances." In her journal, she also noted this lesson,
which was so pertinent at this time of transition in her
own life. She noted in particular the way Matisse de-
ployed color in his early paintings, such as *Le Luxe*.[3]
But her subconscious attention seems to have been
directed in another way, toward Matisse's cutouts.

As we have seen, Rothschild had been involved with
collage since the 1940s and had continued to create col-
lages during much of the time that she was painting in
oils. Her collages, however, had always been quite small,
and she herself had considered them to be a relatively
minor activity. Her highest ambitions had been focused
on oil painting. Now she began to try to handle oil paint
in a collagelike manner, as is evident in *Interior* and in

some other large canvases done about the same time.
During this period she continued to do smaller collages.
Some mix casein or gouache with mechanically pro-
duced collage elements, such as newspaper clippings,
theater tickets, and fragments of book illustrations, as
in *The Parlour Magician* (Figure 54). Others, like *Beach
Plum Bounce* (Figure 55), are done entirely with colored
papers and seem to have been inspired directly by her
encounter with Matisse's cutouts. It was Matisse's cut-
outs, perhaps, that also prompted her to rethink the
question of scale in her work. Up until the 1970s, a 40-
by-50-inch canvas was, with rare exceptions, the largest
format that Rothschild worked in. In Paris she must
have remarked that when Matisse began to work on his
late cutouts the scale of his works had increased consid-
erably, and that their imagery had become more intan-
gible in part because of the way he set his colored forms
on broad expanses of white.

At this point, Rothschild seems to have hesitated. Her
own experience would have made her keenly aware of
the potential trap that something as "easy"-looking as
Matisse's cutouts could be for her. And yet, at the same
time, she almost certainly realized that they pointed a
way out of her current dilemma—precisely the dilemma
that she posed but left largely unresolved at the end of
her *Leonardo* article. There, she had associated collage
with the chance and randomness that had fascinated her
in the works of Kurt Schwitters and Francis Picabia.
Now, she related collage to something less whimsical and
noted the philosophical connotations implicit in chance,
which had been so provocatively set forth in C. J. Jung's
preface to the Wilhelm-Baynes translation of the Chinese
classic, *I Ching*. (This book was widely read in New
York intellectual circles at the time and came to be asso-
ciated with the ideas of John Cage and Marcel Duchamp,
among others.) In her article, Rothschild had cited
Jung's observation about conceiving of reality in a non-
causal way, in which "synchronicity takes the coinci-
dence of events in time and space as meaning something
more than merely chance, namely, a particular interde-
pendence of objective events among themselves as well
as with the subjective (psychic) state of the observer or
observers."[4]

This new relationship to chance provided her with a
fresh "objective correlative." As we have seen, during
the previous twenty years Rothschild had been persis-
tently disturbed by the way that her own subjectivity, as
evidenced in her paint handling and spontaneous draw-
ing, seemed to get in the way of the more impersonal

Figure 53
Apple Corer, *1956. Woodblock print
(white line print), image 8½ × 11⅛ inches.*

Figure 54
The Parlour Magician, *1972.
Collage with acrylic, ink, and found objects
on Bristol board, 20 × 30 inches.*

Figure 55
Beach Plum Bounce, *1970. Collage
and ink, 15⅝ × 19¾ inches.*

Figure 56

Henri Matisse, Acanthus, *1953. Charcoal and paper cutouts painted in gouache glued on paper on canvas, 122½ × 138 inches. Fondation Beyeler, Riehen, Basel.*

when Frank Stella also began to create his first reliefs.) In the mid-1970s she spoke of having been drawn to the relief medium as a way of being able to "increase the depth of the picture at the same time I am preserving that incredible flatness. The forward planes of the relief are really pushing back in a way, whereas some of the back planes, with the color push forward."[6] (The echoes here of Hofmann's "push and pull" dynamics are striking.) Soon, as she grew more confident, the scale of her pictures would also increase.

This change in style was accelerated by external circumstances. During the fall of 1971, when Rothschild was a visiting artist at Syracuse University, she had her students work largely from the human figure. This experience led her to focus on the figure in her own work, and while she was there she did a number of large ink drawings on Bristol board in which a pure and uninflected continuous line was used. Although the various parts of the body are clearly legible in these drawings, multiple figures are combined in a fragmentary way, so that the drawings as a whole emphasize the rhythmic interaction of forms on the surface, creating a friezelike effect (see Figure 52).

The university provided her with a studio in which to work, and it was there in the fall of 1971 that Rothschild did the first of her reliefs, *Frieze* (Figure 57).[7] The formal means of *Frieze* are reduced. It is basically a drawing in which a collage technique has made certain areas fragmentary and discontinuous. Unlike her earlier collages, however, which used preexisting printed matter, *Frieze* uses a unified medium. The white Bristol-board ground is not only drawn on but also has other shapes applied to it, which have been cut from the same white Bristol board. The title thus seems to refer not only to the friezelike space and the subject matter, which depicts a frieze of figures, but to the material itself, which, in its whiteness, alludes to the white marble of classical friezes. What was most interesting to Rothschild were not the disunities created by the disparate parts in *Frieze* but rather the possibility of creating a new kind of unity that would be based on disjunction and fragmentation but that would nonetheless emphasize an integral picture

and philosophically charged kinds of emotion she wanted her paintings to have. Now she began to be more confident about the ability of her pictures to determine their own networks of meanings, without her having to weigh them down with obviously stated intentions. She was finally willing to let go of the Knaths-inspired notion of using systematic color as a structural modulator that was supposed to create deep meanings. And she was also ready to allow herself to let go of color itself, if need be. Whiteness as a force, and even as a color, began to play a major role in her pictorial construction. Behind this notion of whiteness lay not only the model of Matisse's late cutouts, such as *Acanthus* (Figure 56). For the first time since the early 1950s she also began to see a way in which to build on her understanding of Mondrian. Although the whiteness that informs Rothschild's new relief paintings does not look like Mondrian's, it surely came to her under the star of Mondrian as well as Matisse. Not coincidentally, at this time she also began to reconsider her own early negative reaction about the "dehumanized nature" of Mondrian's late imagery.

These changes were accompanied—and to some degree made possible—by a change in materials and technique. During the early 1970s Rothschild began to use acrylic paints instead of oils, and to work almost entirely on a board support instead of canvas, building her pictures up from the support with cut-relief forms.[5] The rectangle of the canvas was no longer a simple flat plane but began to be articulated in three dimensions. (Rothschild was also no doubt responding to something that was very much in the air in New York at this time,

Figure 57
Frieze, *1971. Relief of Bristol board*
with pen and ink on Bristol board,
15¾ x 30 inches.

space. Although her new works would employ a collage-like technique, their effect would be opposite to that of her collages.

During the previous several years, Rothschild had been doing collages that employed a highly fragmented, compartmentalized space, which is read in an almost textual fashion, part by part. *The Parlour Magician* of 1972 (see Figure 54) is a typical example of her work in collage around this time. Until now, she had kept these two activities—making paintings and making collages—separate. In 1971 she began for the first time to use a collagelike technique for works that were on the same scale as her paintings and that employed a simi-

larly unified space. In fact, at first her reliefs employed a fairly literal underlying spatial reading, as can be seen in *Alcestis #3* of 1971 (Figure 58), in which two fragmentary but basically integral figures are set against a clear delineation of the horizon, as if they are standing beside the sea next to a setting sun. But soon Rothschild began to explore the further possibilities that this new way of working offered. This is vividly seen in *And Dance upon the Level Shore* of 1972 (Colorplate 22), which at first appears to be entirely abstract but in which a kind of horizon with figures can also be made out. The figures here, however, are so fragmented and so given over to the abstract rhythms of the composition that one senses

Figure 58
Alcestis #3, *1971. Acrylic and ink*
with collage and relief on Bristol board,
30 x 40 inches.

them more as an abstract figural presence than as literal figures, such as existed in her paintings of 1959–60 (Colorplates 11–14).

Although Rothschild uses the figure only as a point of departure for the abstract composition, it creates a kind of buried subject matter that guides the artist's conception as the picture develops. The title of this work, like her works a decade earlier, evokes a literary theme. It is taken from Yeats's "Who Goes with Fergus?"—a poem whose subject matter was very much in accord with Rothschild's state of mind at this time. The poem asks who will go with the hero, Fergus, "And dance upon the level shore?" The reader is implored to transcend earthly woes:

And lift your tender eyelids, maid,
And brood on hopes and fear no more.

And no more turn aside and brood
Upon love's bitter mystery;
For Fergus rules the brazen cars,
And rules the shadows of the wood,
And the white breast of the dim sea
And all dishevelled wandering stars.

Whereas Rothschild's treatment of literary subjects had in the past been somewhat passive, here the painting more actively engages the subject matter of the poem, though still as an abstract equivalence for it rather than as a literal illustration. The figural forms not only appear to have taken up the invitation to go with Fergus and dance upon the shore but also suggest the ecstasy of "the white breast of the dim sea" and the whirling disorientation of the "dishevelled wandering stars." The relief technique is used here in an active way to energize the movement of the forms so that they push forward into real space as well as into the illusionistic space suggested by the drawing. Color is used in a strategic and accented way: the brightly colored areas are made all the more telling by the way in which they are set against large areas of white, gray, and pale ocher. This contrapuntal dialogue is also followed through by the brushstrokes, which are played against large areas of unpainted foamboard in a varied way, ranging from the thin washes of ocher to the more thickly applied reds and violets.

This painting also signals a new attitude on Rothschild's part toward her artistic predecessors and sources. For although they are present, she has now, perhaps for the first time since the 1940s, mastered them and begun to find a voice that is truly her own. The fig-

ural form at the upper left, for example, calls to mind certain of Matisse's late cutouts, especially the Blue Nude series he did in 1952, which Rothschild had seen at the artist's 1970 retrospective in Paris. But there is only an echo of Matisse here, and it is moreover combined with other forms that are rooted more firmly in the constructivist tradition and in Mondrian. In fact, from this time forward her work frequently displays an imaginative and original response to what would seem to be two completely opposed notions in picture making: the lyricism of Matisse and the austere geometry of Mondrian. For although the overall spatial conception seems at first to be much closer to Matisse, one realizes that Mondrian is often at least equally present. This is especially evident in the modulated luminosity of Rothschild's whites and grays, and in the way that telling areas of confined color are played against the expansive whiteness of the ground. Rothschild was beginning to make her eclecticism work for her rather than against her.

A few years earlier Rothschild had noted that the linear and coloristic elements in her works were at odds; now she was beginning to use that tension to create a new kind of unity, based on opposition. She was also beginning to find a way to do something that she had spoken of frequently in the preceding years: simultaneously to keep two opposing ideas in a dynamic equilibrium with each other.

On a personal level she had also freed herself not only from Myer but also from Knaths. And now, released from a number of the psychological restraints that had limited her in the past, she began to follow through on the implications of her work with a fresh energy and focus. Even though she was still smarting from the wounds inflicted by the breakup of her marriage, she also felt "*much* more totally alive as an artist" and felt committed to doing "what I *really* want to do w/ what time is left to me."[8]

Now past fifty, she was beginning to realize how finite her time was, and she had a strong sense of wanting to make a clear break with her past as an artist. Reflecting on how much she missed the relative stability of married life with Myer, she nonetheless reflected that "what was truly horrible about those years—at least about the last 18 of them, was his absorption of my mind & attention. It is so clear in my painting. From about 1950 to 1966 was like one long 'longueur'—I painted with that Woolfian angel on my shoulder all the while. Now I must battle to regain my*self* very clearly and intensely or all is lost. It is almost too late. But I think not entirely."[9]

In the coming years, Rothschild would also begin to exhibit more frequently and more widely. In 1972 she had solo exhibitions at the State University of New York at Buffalo and at Saint Peter's College in Jersey City, and in the spring of 1975 she showed her large relief paintings in New York City for the first time, at Lee Ault's gallery—the first of an extended series of one-person exhibitions in New York and London that would give her a new visibility.

Rothschild's references to literary subject matter in her works of the early 1970s seem to have played an interesting and constructive role in her working process. These literary themes, which are often evident only in the titles, provided her with a nonpictorial line of thought that she could use as a kind of corrective to what she felt was her excessive susceptibility to her sources in earlier art. The literary themes allowed her to move against those historical sources at the same time that she was using them, by providing her with an ultimate goal that was at odds with that of her sources, and that therefore literally *forced* her to take those sources in another direction. Her engagement with literary themes also forced her to rethink the role narrative would play in her pictures. Although she later asserted that it was the abstract qualities of her pictures that were of prime importance, nonetheless the subject-matter implications of the titles clearly draw our attention to the implied figural elements and to the narrative overtones that many of these pictures contain.

As we have seen, Rothschild had done something similar in her paintings of the late 1950s and early 1960s, such as *Io* and *Alcestis*. But there, the subject matter operated in a more passive way; it was something that the viewer could associate, for example, with the figure in the foreground but that remained general and rather arbitrary, and that sometimes was not followed through in the formal structure of the picture as a whole. What we were given in those earlier paintings was a static *situation*—such as a woman placed in front of a landscape—rather than an implied action or narrative that could be related to that situation. In pictures like *And Dance upon the Level Shore*, the very structure of the painting seems to articulate a pictorial equivalent for the emotions and formal rhythms of the poem. What Rothschild created was not merely a reference to the poem, but a new poem set forth in pictorial terms.

The increased ambition that Rothschild began to associate with this way of working is evident not only in the substantial size of these paintings but also in a subtle but significant change in attitude that grew out of her technique. Whereas the first reliefs had been executed in Bristol board, which is fairly thin, by 1972 she was working in a thicker foamboard, a support in which a central ethafoam core is laminated between smooth, highly calendered white paper that has a smooth, slightly glossy surface and substantial thickness. The foamboard, usually about one-half-inch thick, is very light in weight. This made it possible for her to use thicker relief elements and also provided firm support over large areas without making the picture either excessively heavy or susceptible to warping. Moreover, it was relatively easy to cut, and therefore she could work on it alone, without any assistance.

The physical procedure involved in working with this medium also necessitated a certain discontinuity in the making of the picture—since painting, cutting, and assembling were all separate activities. These physical interruptions in the picture-making process probably played an important role in the evolution of her imagery. They provided her with an organic way of fighting against the facility of her own hand and forced her to retain an emotional distance from her imagery—something she had been struggling with for most of the past twenty years, and that was especially evident in the landscapes of the late 1960s.

This ideal of transcendence through emotional distancing was one that haunted her, and she felt that it was especially well expressed in a passage from Yeats's *Autobiography* that meant so much to her she copied it out in her notebooks several times. At the beginning of the passage Yeats writes, "I know now that revelation is from the self, but from that age-long memoried self, that shapes the elaborate shell of the mollusc and the child in the womb, that teaches the birds to make their nest; and that genius is a crisis that joins that buried self for certain moments to our trivial daily mind." And at the end, he reflects: "And as I look backward upon my own writing, I take pleasure alone in those verses where it seems to me I have found something hard and cold, some articulation of the Image, which is the opposite of all that I am in my daily life, and all that my country is; yet man or nation can no more make this Mask or Image than the sea can be made by the soil into which it is cast."[10]

This "something hard and cold" in the "articulation of the Image" was an ideal that Rothschild had long aspired to. And if it had eluded her for many years, that was in some measure because of the way in which she

often got carried away by the physical excitement of the painting process itself and lost her aesthetic distance from it. She had been better able to achieve that "something hard and cold" in her collages. But in the collages, one might say, the coolness prevailed in too strong a way: it was in a sense too easily achieved because of the nature of the medium itself. In her new manner of relief painting, she was able not only to combine collage and painting in a literal sense but also to synthesize those aspects of each medium that she found most compelling. She was able to make the painting part cooler and harder, and the collage part softer and warmer.

The realization of this ambition is especially evident in *And Dance upon the Level Shore*. The subject of the poem sets up a strong tension between the bitterness of love and transcendence of common hopes and fears. But it does so with language that does not indulge itself in wistfulness, nostalgia, or melancholy. The poem, for all its barely articulated sadness, is written as if in a major key. And this is something that undoubtedly had great appeal for Rothschild. Only a few years later, she expressed her great admiration for Schubert's ability, in his late sonatas, to create tragedy in a major key. The implication is that anyone could address tragic subjects in a minor key, but that to do so in a major key with the full clarity and light that one sees in Yeats's poem constituted a different level of accomplishment.

This was a goal she now set for herself. During the last twenty years of her life she was in continual pursuit of it.

Rothschild's work during this period was not programmatic and did not follow a straight line of development. *Beach Scene*, done about a year later (Colorplate 23), for example, is much more clearly figurative than *Dance upon the Level Shore*, although even here the various elements are not entirely literal. Here the ocher color that acts as a sign for the sand is treated as a flat, slightly undulant vertical plane; it is sliced by the blue horizontal band that acts as a sign for water. At the upper right, curving lines suggest clouds, while below them a row of four sprung vertical curves suggests a pier. The two large figures near the center are fairly straightforwardly suggested, but the shapes around them act as fragmentary signs of other figures. Some of the process of synthesis that is involved here can be seen by comparing this painting with a number of large drawings done about the same time, similar to *Untitled Drawing* of 1971 (see Figure 52), which contain more literal renderings of figures crowded together on a beach. In *Beach Scene*,

Rothschild has translated a scene from daily life into an emblematic equivalent for that scene, articulated in a fragmented and dissonant way.

But Rothschild seems not to have felt entirely comfortable with either the degree of abstraction or the cool surfaces that her work was headed toward. Although *Landscape I* (Colorplate 24) is monochromatic, she indulges in a degree of painterliness that recalls the fluid surfaces she had employed in the early 1960s. And as if to try something like the opposite extreme, in *Landscape II* (Figure 59) she refrains entirely from painterly touch, avoids atmospheric effects, and reduces the landscape elements to an ensemble of condensed signs.

At the same time, she also experimented with direct musical equivalents, as in *Ludus Tonalis IX* of 1975 (Figure 61), one of a large series of works based on Hindemith's piano music, which she had been playing ever since she acquired the piano at 212 Soledad Drive in Monterey, and which she characterized as Hindemith's "version of the Well Tempered Clavichord—moving around the scale as J. S. Bach did w/ prelude & fugue in each key."[11] Certain aspects of the spatial structure of this and the Garden paintings that she did around the same time were clearly prefigured in some of the collages she had done before she began the relief paintings, such as *Garden* of 1968 (Figure 62).

As if to test the possibilities and limits of her new way of working, Rothschild also returned to some older themes. One of the most intriguing of these is *Alcestis I* of 1974 (Colorplate 25). Here, the figurative elements seem to be entirely eliminated, and whatever landscape suggestions remain are so abbreviated as to be unrecognizable. And yet, because of the division of the composition into horizontal bands, and because of the sequential movement of the forms across the surface, one senses that a time-bound narrative is being alluded to, even though the precise nature of that narrative remains resistant to reading. Given the circumstances of Rothschild's life, however, it is tempting to read the large diamond shape near the center as the presence of Alcestis herself, arms spread in a gesture of supplication and sacrifice, encompassed by the colors of the setting sun. And it is further tempting to note that the artist's initials are placed right next to this form—a most unusual place for her to sign a picture—as if to suggest an identification between the artist and the subject of her picture.

A similar kind of literal reading is also strongly implied in *Scene II* of 1975 (Colorplate 26). Here the

Figure 59
Landscape II, *1974. Relief of foamboard,*
collage, acrylic, and ink on foamboard,
40¼ x 60⅛ inches.

Figure 60
Trees, *1975. Relief of foamboard, collage, acrylic,*
and ink on foamboard, 36¼ x 48⅝ inches.

Figure 61
Ludus Tonalis IX, *1975. Relief of*
foamboard and acrylic on foamboard,
30⅛ x 28¾ inches.

contrast between the concreteness of the setting (even the rounded curves that denote the drifts in the sand are rendered fairly literally) and the utter illegibility of most of the other forms in the picture produces a kind of surrealistic effect. (This sense of disorientation is something that Rothschild seems to have been intrigued by; in her notebooks she occasionally refers to paintings that have a "surrealistic" feel.)

Earlier Rothschild had occasionally done more than one picture of the same theme or subject. But now she began to do so in a systematic and self-conscious way, frequently numbering each work in the sequence (which sometimes differed from the order in which she did them). It seems that certain kinds of compositional formats began to take on a typological validity for her.[12] Both *Ogygia I* of 1974 (Figure 63) and *Ogygia II* of 1975 (Colorplate 27), for example, are based on lines sweeping in from the edge of the picture that are played against bulbous, organic forms. The title itself incorporates a kind of double entendre, in that Ogygia in the *Odyssey* is the island of Calypso, where Odysseus was a sexual prisoner for seven years; yet at the same time, the word has cosmic overtones, designating the navel of the universe. Rothschild was aware of this. In a note to her parents, she explained the title of these works when she showed them at Lee Ault's gallery in 1975: "*Ogygia:* Island—Greek—meant 'navel of the universe' to the Greeks. . . . in Joyce 'omphallos [sic] apollo'—etc—. Or simply it is a place name. But I meant it as the life force place, etc."[13] *Ogygia II* is an especially dynamic composition, in which the various curving elements pivot from the exact geometric center of the canvas, suggesting the intense generative force of its subject(s).

In the Ogygia paintings the metaphor is built into the structure of the picture. In other paintings, however, Rothschild used structures that are more like similes than metaphors. That is, she suggested her subjects through comparisons between parts of the image, as in *Cereus I* of 1975 (Figure 64), in which the goddess of grains is literally referred to in the plantlike form at the upper left. A second version of the same theme is treated synthetically. In *Cereus II* (Colorplate 28) the leaf forms are abstracted and the vitality of the mythological goddess is suggested chromatically by a vertical band of red that is boldly set against the earth tones of the background.

Rothschild's exhibition at the Lee Ault gallery in the spring of 1975 had a strong energizing effect on her. Whereas in previous years she had often been depressed after her exhibitions, she now felt that she had entered a new phase in her work and in public perception of it. She received great encouragement from artists she knew and was especially struck by the comments of her friend Alice Yamin, who understood Rothschild's desire to create "Ur forms" and who confirmed that the show signaled a breakthrough because the language that Rothschild had developed in these works was one that she could "use anywhere."[14]

Rothschild herself was pleased by her sense that "it is there & good & the best one can do." And she could not help remarking that it proved that previously she *had* let her attention be "totally deflected by Tony, that this is really the first time since 1947" that she had indeed worked at full capacity.[15] For the first time in almost twenty years, this exhibition also brought Rothschild notice in the pages of the *New York Times.*

Hilton Kramer, who wrote of her work as "a serious, headlong assault at wresting something personal and inventive out of [her] encounter" with Matisse's late cutouts, felt that she had come away from the encounter with mixed results. He noted that she had "a keen understanding of the relation of color to drawing in late Matisse" and that she was making "a heroic attempt to reshuffle the components of this art to yield a new imagery. She also understands the sculptural quality of the cut-outs, and adopts relief-collage as a means of underscoring this sculptural aspect of the problem." But Kramer felt that she had remained too firmly locked into Matisse's "repertory of shapes and gestures" and had missed "establishing a firm ground of her own." Although she seemed to be on the verge of realizing a "flight into the personal," he felt that she had fallen short. "Which is a pity," he concluded, "for the work is handsome and persuasive in its fundamental visual presence, and only an artist of considerable talents could have carried the effort this far."[16]

The criticism stung, but it made her even more determined to stake out her own territory more clearly.

Figure 62
Garden, *1968. Collage of painted papers, gouache, and ink on paper, 12⅜ × 19⅝ inches.*

Figure 63
Ogygia I, *1974. Relief of foamboard and acrylic on foamboard, 40¼ × 59¾ inches.*

Figure 64
Cereus I, *1975. Relief of foamboard, collage, acrylic, and ink on foamboard, 40⅜ × 60 inches.*

The Articulation of the Image, 1975–1993

Since the 1950s Rothschild had been interested in Yeats's "Crazy Jane" poems, that series of astonishingly violent and irreverent poems whose subject is a lusty, unconventional woman—a woman who meets men on her own terms and refuses to yield to them. Jane is the opposite of the docile Alcestis, who dutifully sacrifices herself for her husband. Jane instead sees behind the sanctimonious face of hypocritical self-interest that women like her are constantly forced to confront. Impulsive and passionate, she is constantly defeated not by her purity but by the primeval energy of her impurity— and by the hypocrisy of men. Jane, for example, sides with her lusty lover against the bishop who banishes him, invoking the oak under which she lost her virginity and asserting, "there is shelter under it." And says of the bishop, in a wicked double entendre: "But should that other come, I spit."

Jane, wronged in love, her body falling apart, nonetheless retains a self-confident pride and, despite the lowness of her position, a profound nobility. This is movingly expressed in her response to the bishop in "Crazy Jane Talks with the Bishop":

> "A woman can be proud and stiff
> When on love intent;
> But Love has pitched his mansion in
> The place of excrement;
> For nothing can be sole or whole
> That has not been rent."

As early as July 1958, the summer after she returned from Europe, Rothschild had written about sketching in a Crazy Jane painting, now lost, and not long afterward she had written "Io Alcestis Jane" on a sheet of compositional sketches (Figure 65).[1] In 1975 Rothschild took up the theme again. In *Crazy Jane I* (Figure 66) she creates a purposely dissonant image and fragments the figure to the point where it is unrecognizable. Rothschild consciously sought this sort of discordant effect in her work at this time, what she referred to a few years later as the "Waldstein principle"—referring to Beethoven's "Waldstein" piano sonata, with its fragmented melodic lines: "Perfect cadences & fragments of a divine melody. Snatches. Like blue sky between clouds. Sense it is 'all there' that permanent blissful perfection of form. Human condition keeps us from holding it."[2] This kind of dissonance is carried further in *Crazy Jane II* of 1976 (Figure 67), in which the lyrical figurative elements on the right are abruptly truncated by the vertical blue band that chops the space in two. As in a number of Rothschild's paintings of this time, a kind of dialogue is set up between the left and right sides of the picture, in which the isolated forms on the left are made to function as if they are commentaries on the "action" of the forms on the right. The figural forms on the right, splayed and askew, seem to evoke the disheveled state of Jane herself.

Around the same time, Rothschild began two series of paintings, the Neruda pictures and the Gothics, in which she explored compositional formats that were the oppo-

Figure 65
Sheet with studies for four compositions: "Io Alcestis Jane," 1959.
Ink on paper, 8½ × 11 inches.

Figure 66
Crazy Jane I, *1975. Relief of foamboard, collage, acrylic, and ink on foamboard, 39⅝ x 59⅞ inches.*

Figure 67
Crazy Jane II, *1975. Relief of foamboard, collage, acrylic, and ink on foamboard, 32½ x 60¾ inches.*

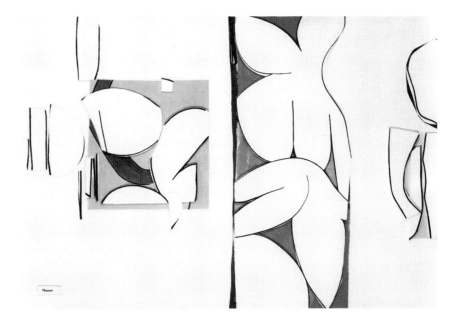

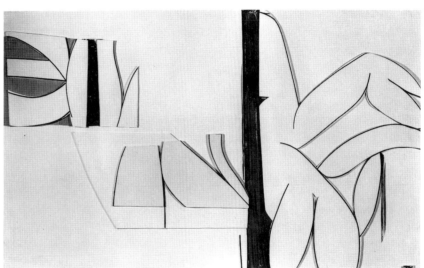

site of the fluid and violent Ogygia and Crazy Jane paintings. Both series seem to be informed by Rothschild's growing interest in Islamic calligraphy. She had been drawn to Islamic calligraphy in large measure because of the way in which her own vocabulary of forms was beginning to take on a calligraphic quality. Moreover, she was beginning to conceive of her own forms as having a quasi-narrative quality, as capable of being seen as a kind of "script," which could be "read" visually even if their exact referents were unclear.

In January 1976, when Rothschild went to London for the opening of her exhibition at the Annely Juda gallery, she made arrangements to go to the British Museum Library to look at Islamic manuscripts. She was partic-

ularly enthusiastic about an early-fourteenth-century Persian Koran she saw there. In a letter to her parents she described how she perused it for hours and studied it closely enough to be able to speculate that although it was supposed to have been written by a single calligrapher, she discerned what seemed to be three separate hands in it.[3]

At this time she was especially interested in the notion of finding forms that had a universal meaning, that could relate to a kind of Jungian collective unconscious. Less than a year before, at the time of her show at the Lee Ault gallery, she herself used the term *Ur forms* to describe her work, and she had been particularly pleased that others also understood her evolution toward devel-

oping forms that could express a primal and universally understood aspect of human culture.[4]

Even when she had gone to Italy in 1958, Rothschild had been drawn to the immaterial qualities of Byzantine imagery rather than to the more matter-of-fact style of the Florentine Renaissance.[5] Her involvement with Islamic art was to some degree a continuation of that interest, and through the 1970s she became increasingly engrossed in it. In 1978 she went to Iran to see prime examples of it firsthand, traveling to Shiraz, Bishipur, and Isfahan, as well as to Persepolis and Teheran. In her journal she recorded that she was made literally speechless by the things she saw there and called them the "most important things I've seen in years."[6] The following year she reflected on her travels at length:

> Essentially I see now how the Islamic experience was so inevitable for me . . . so central. When you stand in a bay at the great mosque in Isfahan the center of your vision is occupied by an intense and brilliant image which is a series of interweaving forms, dense, concentrated, abstract but full of motivated meaning, which only now and then erupts clearly into meaning, as when a word is spelled out, or the name of Allah is invoked . . . (and this is usually at *the outside edges*). . . . All the time, there is a harmonious and contrasting, and expansively related and not dissimilar bay next door, and a screen area between, and one's peripheral vision (and one's memory) is aware of this. . . . Thus the total effect is of a total harmony so vast that one cannot encompass it . . . that is some of the fascination. The sense that within the controlled set of visual means that the artists have chosen there is a

plan, an intricate vast harmony far beyond deciphering without a long long deep study. And there is something about the way it is presented that makes one want to avoid study of this structure, and want instead to let it "work on you." . . . It is, indeed just like a vast garden. One looks at one flower, which suddenly opens, revealing great intensity and simplicity and complicated tight relationships within it, and yet, which one both knows and sometimes sees as well, it is just one of a vast plan, a vast cosmology, which one hardly dares to categorize much less try to understand.[7]

This encounter obviously affected her more decorative works, such as *Sideo's Garden I* (see Figure 74) and *Lemons of Bishipur III* (see Figure 75). But it also impacted her art in indirect ways, as in the Neruda series. The Neruda paintings were meant as an extended homage to the Chilean poet Pablo Neruda, whom Rothschild read closely and with enthusiasm; one of his poems was on the wall next to her desk the day she died.[8] In the Neruda paintings, Rothschild developed a static format in which the large central area of the canvas is bordered above and below by calligraphic forms. The central area is itself heavily brushed and is usually divided vertically, a compositional format that is possibly meant as a reference to the "zip" paintings of Barnett Newman (whose old Carnegie Hall studio she worked in from 1977 to 1983), but that here functions in a very different way. This series would become one of her major preoccupations over the next sixteen years.

In the first painting of the series, *Neruda I* of 1976 (Figure 68), the rectangular form occupies only part of

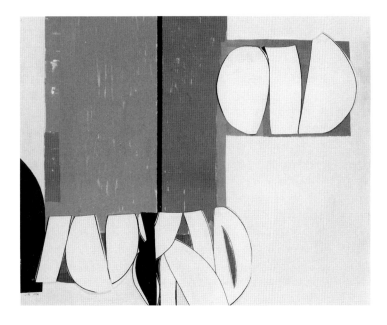

Figure 68
Neruda I, *1976. Relief of foamboard, collage, acrylic, and ink on foamboard, 48¼ × 60⅞ inches.*

Figure 69
The Gothic I, *1976. Relief of foamboard, collage, acrylic, and ink on foamboard, 65 × 48⅛ inches.*

the left side of the painting. But in *For Neruda* of 1977 (Colorplate 29), which employs a similarly harsh color harmony—dominated by red, blue, and black—this rectangular form becomes central and dominates the entire composition. The color schemes in the series vary considerably, as do the use of calligraphy and the division of the central rectangle. In *Neruda IV* of 1987 (Colorplate 43), the colors within the rectangle are dark and sonorous, creating a melancholy mood that is given even greater poignancy by the lyrical, glissando-like quality of the green calligraphic forms that dance above it. In *Neruda VI* of 1990 (Colorplate 44) the composition is painted mostly in whites and grays with just small accents of color, while in *Neruda VII* of 1990 (Colorplate 45) the calligraphic elements are more dissonant. In *Neruda IV* the calligraphic elements function as lyrical passages that contrast with the architectural mass of the central rectangle, whereas in *Neruda VII* the calligraphic forms themselves have an architectonic function. The color in this painting is also different from that of the earlier works in the series, based as it is on a dissonant three-part harmony of greens and yellows, separated by a slatelike black.

Around the same time that she was working on the Neruda paintings, Rothschild began her first Gothic paintings, which also evolved into an extended series. In *The Gothic I* of 1976 (Figure 69), two splayed forms in the lower half of the picture seem to support a series of rhyming forms above. The color is extremely reduced and the curving forms seem to be locked in a struggle with the rectilinear format within which they are contained. In *The Gothic IV* of 1976 (Colorplate 30) the compositional format has been turned upside down, and the splayed forms now seem to float above the figural forms that are set below them. Here, too, the color is used in a sparse and somewhat ascetic way, with small amounts of primary colors played against large areas of white.

In *The Gothic VI* of 1977 (Colorplate 31) Rothschild formulates the basic format that she will use for the rest of the series. Here we are dealing not so much with a compositional dynamic as with a fixed architectonic image, based on plant forms as well as on architectural

and calligraphic ones. The image is supposed to constitute an entity unto itself—a unified construct that comes to be known as a "Gothic." (In the earlier paintings in the series the idea of "the gothic" seemed to involve a clash of opposites.) The point of the reference is, of course, the French Gothic style, which Rothschild associated with structural daring, formal complexity, and a fervently numinous quality. In these paintings she combines in a concentrated and synthetic way a number of the qualities that she admired in Gothic cathedrals: the simultaneous feeling of both structural necessity and fanciful irregularity; the subdivision of large forms into richly variegated parts; and the elaborate counterpoint established between organic and geometric forms. At the same time that the general image of the Gothic paintings evokes the openness of Gothic ribs, vaults, and buttresses, the colors sometimes further suggest the dense luminosity of stained glass, as in *The Gothic XI* (Colorplate 48). Moreover, Rothschild evidently felt that the European Gothic style was itself emblematic of art that combined a high-art aesthetic sensibility—elitist, courtly, and sumptuous—with an accessible and popular aesthetic. As far back as 1960 she had remarked that she felt that Gothic art represented such a synthesis of

mass art and aristocratic art and had mentioned her own ambition to achieve one day something like that.[9] The Gothic series, which was to occupy her until the end of her life, and in which she would produce some of her grandest pictures, was part of an ongoing attempt to achieve such a synthesis.

The Gothic I was first shown at Lee Ault's gallery at the end of 1976, along with a number of her other recent works. In a review article that contained the most extensive discussion of Rothschild's work to date, B. H. Friedman discussed her past history and her present concerns. He saw her as "a Classicist, influenced by Constructivism and Cubism, and particularly by Mondrian and then Gris," and discussed the "unresolved tug toward bolder color and ... a freer line" in her earlier work. But it was in her recent work, he asserted, that she had really come into her own: "In 1973 or 1974 ... there is in Rothschild's work an unsudden, absolutely organic fusion of intellectuality and sensuality. She is *herself*—the culmination of all those earlier years." Friedman also noted how the sensuousness of her work was wedded to what he called "intellectual illumination," and discussed the diversity of her subjects, especially the way she was able to synthesize abstract forms from lived experience.[10]

Although Rothschild was working more productively than ever, this period corresponded with an especially difficult time in her life. Her father, who had been ill with heart disease, died in the fall of 1976. And at the beginning of 1977 she herself began to suffer from serious health problems. Early in the year she learned that she had a heart murmur, and shortly afterward tests indicated that she was suffering from lymphoma. Although this diagnosis was confirmed by several doctors, she eventually was able to rid herself of the symptoms. Whether this was actually effected through diet, vitamin treatments, and mental exercises, as she liked to believe, or whether the illness was misdiagnosed, remained an open question, even for her.

In the fall of 1979 her mother died, and two years later Rothschild was diagnosed as having a fast-growing cataract in her right eye and was told that her left eye would undoubtedly also soon develop one. Her mother had suffered from similar eye problems, and several specialists told her that she might well lose the sight in both her eyes. As might be imagined, she was extremely distraught and went through a period castigating herself for all the time that she felt she had wasted.[11] This problem was not resolved until the spring of 1984, when a lens implant restored her vision.

Despite these problems, she continued to work and exhibit regularly. In the spring of 1981 she showed again at the Annely Juda gallery in London. This time a catalogue accompanied the exhibition, with essays by Roland Penrose and John Bernard Myers.[12] Myers's essay gives a nice overview of Rothschild's career, emphasizing her painterly concerns and her incorporation of "subject matter" into abstract imagery. "Judith Rothschild," he concludes, "has given most of her working life to the discovery of visual metaphors.... At times the forms come close to nature ... at other times she examines blackness, the negative, the unknowable. Just as many of her cut-out forms, the bas-reliefs, and elements of collage bring a picture's substance to an edge of certainty, or what we call reality, equally we are diverted into the ambiguities and contradictions of the unknowable cosmos."[13]

Her work had begun to take on a strong enough life of its own that, perhaps for the first time, she had achieved another ideal of Yeats's, one that she had also copied out in her notebooks. This was to create an art that came "when a nature that never ceases to judge itself, exhausts personal emotion in action or desire so completely that something impersonal, something that has nothing to do with action or desire, suddenly starts into its place, something which is as unforeseen, as completely organized, even as unique, as the images that pass before the mind between sleeping and waking."[14]

In 1975 Rothschild had begun another series of paintings based on bathers, which was an extension of the figure drawings that had led to her relief paintings at the beginning of the decade. This series is especially interesting because it was done over a relatively short period of time and because it had a clear linear development, which was not always the case with her work. In *Bathers I* of 1975 (Figure 70) the forms are crowded together on the surface. There is virtually no differentiation between so-called positive and negative space, between figure and ground. Here she reverts to the friezelike concept that had initiated the relief paintings. And although the figural elements are by no means naturalistic, the overall effect is of a mass of crowded figures on a beach. In *Bathers II* of 1975 (Figure 71) she begins to synthesize the original image into a strikingly shaped and organized composition. Here there is a characteristic division between the left and right sides of the

Figure 70
Bathers I, *1975. Relief of foamboard,*
collage, acrylic, and ink on foamboard,
40 x 59⅞ inches.

Figure 71
Bathers II, *1975. Relief of foamboard,*
collage, acrylic, and ink on foamboard,
40 x 60¾ inches.

canvas, and the rhythmic leglike verticals at the upper right seem to make an oblique reference to an earlier picture, *False Legs Hang Down* of 1974 (Figure 72), which took its title from a line in Weldon Kees's poem "Farrago":

> *The housings fall so low they graze the ground*
> *And hide our human legs. False legs hang down*
> *Outside. Dance in a horse's hide for a punctured god.*

In *False Legs Hang Down*, the forms at the upper left clearly suggest the legs of standing figures, but in *Bathers II* Rothschild synthesizes them into an abstract ensemble that makes only an oblique reference to their source. In *Bathers III* of 1976 (Figure 73), the measured horizontal-vertical axis of *Bathers II* explodes into expansive bursts of tumbling forms. These two canvases, both done in the same 40-by-60-inch format, are like two musical variations on the same theme, one andante, the other allegro con spirito.

The series takes a surprising turn in *Bathers IV* of 1977 (Colorplate 32), which is larger than the other paintings in it, and vertical instead of horizontal. Here, in what is one of Rothschild's most powerful works from this period, the calligraphic forms are cantilevered into the surrounding yellow space to create a dynamic and precarious sense of balance. The paint around the forms

Figure 72
False Legs Hang Down, *1974. Relief of foamboard, collage, and acrylic on Bristol board, 28 × 38⅛ inches.*

is boldly applied and emphasizes the forcefulness of the ensemble as a whole. And here the original subject matter has been so utterly transformed that one would be hard pressed to find more than a generalized suggestion of individual figures. They have been, as it were, translated into a vocabulary of "Ur forms," and they suggest a kind of primal power that transcends the initial subject.

Although Rothschild was moving toward increasingly synthetic forms, she also remained attached to her earlier notion of directly translating natural forms into her

new pictorial language. The works in which this is done are not usually among her most successful ones. In *Trees* of 1975 (see Figure 60), for example, Rothschild returned to a theme that she had been painting a decade earlier (see, for example, *Woodland*, Figure 43), but now emphasizing the calligraphic quality of the forms. Here, the translation does not work very well, precisely because she remains too close to the literal appearance of her subject. More successful are the works in which she employs different levels of representation and demonstrates a strategic awareness of how the forms can be made meaningful by the context in which they are placed. This is especially true in her treatment of mythological themes.

In *Persephone* of 1980 (Colorplate 33), for example, the metaphor of death and resurrection is expressed both graphically and coloristically. The black and gray rectangular forms on the right side suggest the somberness of the underworld, while the calligraphic, leaflike forms on the left, set as they are against the bright green ground, symbolize a return to life. What makes this painting so effective is that, although one can read it literally in the way that has just been done, it has a completely independent pictorial existence. Even without the "program" information about the literary theme, one understands not only the distinctions between the two halves of the painting but also the extreme tension that is set up between them. It is this that makes it a *moving* as well as an intellectually engaging work.

A similar emotional energy is present in *Alcestis's Song* of 1980 (Colorplate 34), in which the leaflike forms rise in a lyrical outpouring.[15] In the Alcestis paint-

Figure 73
Bathers III, *1976. Relief of foamboard, acrylic, and ink on foamboard, 39⅝ × 59⅞ inches.*

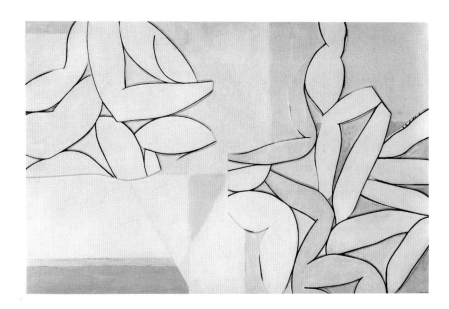

Figure 74
Sideo's Garden I, *1980. Relief of foamboard, collage, acrylic, and ink on foamboard, 40½ × 32¾ inches.*

Figure 75
Lemons of Bishipur III, *1982. Collage on foamboard, 18¼ × 16¾ inches.*

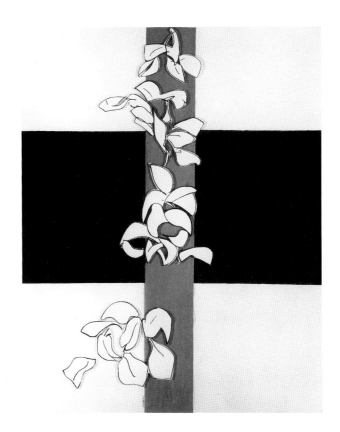

ings that Rothschild did about 1960, she had set the figure of Alcestis against a landscape. Here, she gives us the rectangle of the landscape as a separate view, a picture within the picture, which is both distinct from and related to the surrounding picture space. We see the dark rectangle as a view into another space—in this case a dark and foreboding one that seems to suggest the presence of death itself. But at the same time, the relief forms near the lower right corner of the rectangle overlap it, thus relating it back to the entire picture space. Although color is sparsely used, it functions in a way that is integral to the subject. The forms above and below the dark rectangle are similar; yet we read those below as figural elements and those above as plant forms. This is effected partly through the way they are colored and partly because of the way the ends of the forms above the rectangle are articulated like leaves.

Around this time, Rothschild was very much involved in broadening her iconographic repertoire by incorporating more literal renderings of landscape elements into abstract spaces. It was at this time that she began a series of Garden paintings, in which literally rendered leaf forms were spread against the abstract rectangular forms of the background, almost like plants growing across a trellis, as in *Sideo's Garden I* of 1980 (Figure 74). This was one instance where Rothschild had first begun to work with a general compositional format in small collages, then later worked with them on a larger scale. A number of the collages were shown at the Landmark Gallery in an exhibition called "Sideo's Garden," which opened in February 1979. The garden motif was one that she continued to work with in small collages over the next several years, often incorporating pages of Islamic manuscripts along with her own cusplike forms, as in *Lemons of Bishipur III* of 1982 (Figure 75). On the whole, this compositional motif tends to work better on the small scale. In many of the larger Garden paintings, the leaflike forms are not entirely integrated with the

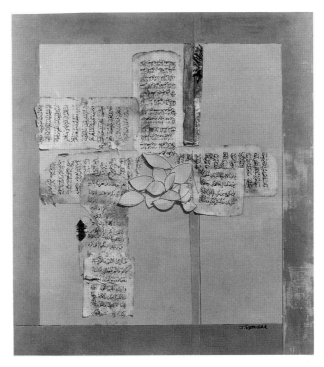

underlying structure, and as a result those pictures often become overly decorative.

Rothschild's desire somehow to incorporate naturalistic elements in her large compositions is also evident in the Skywatch series, where she inserted landscapes as pictures within the pictures, contrasting the overall space and the "window" that she creates within it. As we have seen, she did something similar in *Persephone* (Colorplate 33) and in *Alcestis's Song* (Colorplate 34), but there the rectangles did not contain legible landscapes. In a painting like *Skywatch III* of 1980 (Colorplate 35), the landscape is descriptive and atmospheric, similar to those she had done in the late 1960s. By Rothschild's own account, the landscapes for these paintings were prepared separately from the paintings themselves and placed on the canvas in the early stages of the painting's development. To some degree, the small atmospheric landscapes provoked or determined the development of the pictures around them, and the pictures as a whole can be seen as a commentary on, or variation of, the landscape motif.[16] In *Skywatch III* the dark landscape is surrounded by blackness, and even the leaf shapes and the red bar next to them are nocturnal and somber.

The motif of the picture within the picture is present in a number of Rothschild's works during the 1980s— as if she was not quite able to give up her involvement with literal depictions of nature and somehow wanted to have it both ways by utilizing naturalistic and abstract imagery in separate sections of the same painting. But here, as in other instances where Rothschild tried to bypass an overriding synthesis of disparate elements, the paintings often work less well. Perhaps nowhere is this format more successful than in *Southwest* of 1980 (Colorplate 36) and in a series of related paintings that she did around the same time. In *Southwest* the painting as a whole is itself somewhat like a landscape, and as a result the landscape that is framed within it seems to relate in a more integral way than in the Skywatch paintings, which are purposely based on contrasts rather than on unity within contrast. In *Southwest*, for example, it is as if we are viewing simultaneous night and day views of the same landscape. The day scene is rendered abstractly and evokes the heat of the place and the way the brilliant light flattens and eats away the details of forms, while the dark view within it seems to evoke the way in which the forms of the landscape actually become clearer as the light fades, and the way in which coolness is perceptible by the eye as well as by the rest of the body. It is interesting to see how directly *Southwest* is related to the *Southwest* painting that Rothschild had done in 1957 (Colorplate 10). The 1957 painting had followed a number of relatively naturalistic and atmospheric landscapes and was remarkable for its strong synthesis of a sense of place with austere and nonreferential abstract forms. In the 1980 *Southwest*, the contrasts that were suggested in the earlier painting are made more explicit. And coming nearly twenty-five years later, it is fascinating to see to what degree Rothschild was still wrestling with some of the same problems that had engaged her earlier in her career: how to reconcile and synthesize her notions of lived and painted experience.

During the 1950s, Rothschild had read Lattimore's translation of the *Iliad* with Anton Myrer in Monterey. In the early 1980s, she read Lawrence Durrell's book *The Greek Islands*, which renewed her interest in Homer and led her to Robert Fitzgerald's recent translation of the *Iliad*, which gave her fresh insights into the emotional nuances and intensity of the work. She was deeply moved by these reading experiences and decided to begin a series of paintings on themes from Homer. When these paintings were shown together at the Iolas-Jackson Gallery in New York, in May 1985, Rothschild prepared a text called "Notes from a Journal," which describes her growing engagement with the project during the previous year. She noted that most of the pictures were "linked to the subject of Achilles in one way or another. Metaphorically linked, that is to say." And she described her fascination with "the dichotomies, the contrasts in life." She had been especially moved by the "toughness" and "hard plangent vividness" of Fitzgerald's translation, which she felt was "not as rich as Lattimore's but deeper in its harshness. One feels the proximity to the emotions of Achilles—even in its histrionic moments," such as the death of Patroklos.[17]

The harshness and toughness that drew Rothschild to Fitzgerald's translation were also qualities that she wanted to convey in her *Iliad* paintings, which can be seen as an antidote to the more lyrical Garden pictures that she continued to do around the same time, and to the small, lyrical collages that she continued to produce. Her intention seems to have been to create a series of pictures that would suggest an epic coolness and at the same time be charged with strong emotional overtones— to explore a range of feelings similar to those that she had sought in her landscapes of the late 1960s. Now,

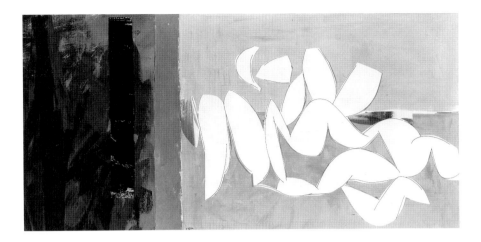

having regained her emotional balance, she was better able to deal with themes of love and death than she was a decade earlier, when she herself had still not sufficiently recovered from the psychological wounds inflicted by the breakup of her marriage and by the reappraisal of her whole life that had followed.

Right from the beginning of the *Iliad* series, even in paintings that were not quite fully realized, such as the small gouache that initiated it, *Achilles and Briseis I* of 1984 (Figure 76), her pictorial strategies were given a high degree of emotional focus. The network of complex motivations and the emotional wildness of the story obviously struck a deep chord in her. Moreover, certain themes provided her with vehicles that she could use to work out important formal and expressive issues in her painting, most especially the notion of being able to express contradictory emotional states.

The story of Achilles and Briseis was especially interesting to her. Not only because Briseis herself, though only occasionally referred to directly in the *Iliad*, plays a central role in its action, but also because Achilles and Briseis together could be seen as a powerful example of love holding firm in the face of impending tragedy. In the *Iliad*, Briseis is the captive mistress of Achilles, who has acquired her as a prize after the plunder of her native village—when her husband, children, and three brothers were massacred by the Greeks. After the Greeks are afflicted with a plague as they lay siege to Troy, the prophet Kalchas tells the assembled Greek warriors that Apollo is displeased because Agamemnon, the Greek leader, has taken Chryseis, the daughter of Chryses, a priest of Apollo, captive as his own mistress. Agamemnon is persuaded to relinquish Chryseis, but in return he demands that Achilles turn Briseis over to him. Through the intervention of Athena, Achilles is forced to accede

to Agamemnon's demand, but he then refuses to fight and withdraws to his tent. Within the narrative of the *Iliad*, Briseis is the agent who provokes the feud that dominates the action of the epic, but she makes only brief appearances, at the beginning of the story and again after the death of Achilles' friend Patroklos, whom she mourns with deep emotion in book 19, in a moving passage where she also gives an account of her own history.

Patroklos, it will be remembered, went out to fight in Achilles' stead, wearing Achilles' own armor, when Hector and his Trojan army seemed about to win a decisive victory over the Greeks. And it was Patroklos's death that eventually prompted Achilles to return to battle and lead the Greeks to victory. The triangle of love and tragic destiny among Achilles, Patroklos, and Briseis provided the catalyst for most of Rothschild's paintings based on themes from the *Iliad*. None of these themes, however, is directly illustrated. Rothschild herself described the relationship between the paintings and the text as intentionally "metaphorical." And as might be expected, her interpretations of those themes were weighted by her own experience of love and betrayal.

In *Achilles and Briseis I*, the composition is divided into a rectangular wall-like shape on the left, next to which figural elements are set against an ocher ground. The area on the right side contains a clear horizon line, which suggests some sort of place and an action happening within it—in contrast to the left side, which is painted in harsh black set against pale blues, and which seems to evoke a state of mind rather than a place. Read this way, it is as if the left side of the painting is an emotional commentary on what is taking place—although it must be emphasized that exactly what is "taking place" on the right remains purposely ambiguous. Speaking of

this theme at the time she was working on these pictures, Rothschild remarked, "I keep being drawn back to memories of the *Iliad*. But really beneath is a simple fascination: the dichotomies, the contrasts in life. The sensual delights (I envisage A & B on some Aegean beach enjoying themselves, that is before they were separated) made perhaps all the more alluring by the threatful pressure of disaster. Can I get these two opposing feelings condensed into a single small rectangle? A rectangle that is, finally, unified."[18]

The means that Rothschild chose for condensing these opposing feelings was the division of the canvas into two distinct areas: one carrying imagery that suggests being, such as the bodies of lovers intertwined; the other suggesting an abstract notion or emotional state, such as the idea of impending tragedy. In *Achilles and Briseis I* the area on the right side verges on literally representing intertwined bodies set against sand, while the area on the left is like a lamentation in anticipation of impending tragedy. One side carries imagery that suggests action, while the other side carries imagery that suggests commentary: together, they strengthen the temporal implications of the image by allowing us to envision more than one psychological and chronological event at a time.

While she was working on the *Iliad* series, Rothschild experimented with a number of different ways of deploying her narrative and expressive means. In *Achilles' Dream II* of 1985 (Colorplate 37), the entire image is divided into three registers, with the central red and white area once again suggesting a figural presence. But here, in keeping with the insubstantial nature of dream imagery, the imagery of the picture seems to float before our eyes, an effect that is enhanced by the broken brushwork in the flanking areas. In *Aegean I* of 1985 (Colorplate 38) the implication of narrative is made even clearer because of the reduced means of representation. Unusually for Rothschild's paintings at this time, the relief effect is built up as much with canvas as with foamboard, so the relief seems shallower and the painting has a pictorial "stripped-down" quality that reinforces its minimal narrative effect. Here, the wall-like areas on the left are painted in colors symbolic of death and blood. They are set next to a more straightforwardly pictorial area on the right, in which a blue sky surmounts a sandy ocher beach on which white forms seem quite clearly to represent figures. This painting has an arresting directness, which is made all the more affecting by the intriguingly near-literal nature of the narrative representation.

As Rothschild developed the theme, however, she moved away from this sort of literalness and achieved the synthesis she desired through more highly compressed and signlike means. *Achilles and Briseis XXX* of 1987 (Colorplate 39) is the culmination of that series. Although there are still remnants here of the left-right division of the canvas, now the space and the narrative implications are much more abstract and intangible. The combination of pictorial and emotional wholeness evokes a moving sense of tragedy.

Closely related in general format is the *Death of Patroklos*, also of 1987 (Colorplate 40). Here, both death and mourning are simultaneously suggested, as if to combine the violent physical intensity of the death of Patroklos in book 16 of the *Iliad* with the lamentation over his death by Menelaos, Achilles, and Briseis in the pages that follow. And here, unlike *Achilles and Briseis XXX*, the vertical divisions of the canvas serve as background—one is tempted to write, as orchestration—for the powerful rush of blood red and black forms that sweep across the lateral expanse of the canvas. In this picture the expressive potentials of the relief technique are given a particular poignancy and emotional force by the way the black forms are made to cast beneath them shadows of an even more intense black: blacks blacker than black. The forms that roll across the canvas successfully evoke both a momentous event and a strong emotional response to that event.

The process of abstraction in Rothschild's work after about 1974 had been a quest for giving form to the ineffable. Her paintings on themes from the *Iliad*, the landscape and figure imagery, the allusions to poetry, had all been meant as visual realizations of things that are in and of themselves invisible. These notions had become perhaps most acutely evident in the *Iliad* paintings, in that there she was compressing complex narratives and emotional states into specific static images. Now she turned her attention to what in a sense was the unspoken subject matter of a number of her earlier images. In *Eidolon* of 1949 (see Figure 14) she had alluded to the way that paintings can evoke ghostlike forms. In that painting, the eidolon, or spirit-form, took on a distinctly human shape and acted as a kind of specter that made its presence felt among the abstracted forms around it. In 1987 Rothschild painted the numinous presence of the eidolon itself as her subject. Around this time, she copied out a cluster of meanings for the word *eidolon* that gives some sense of what she was after in the paint-

ings. On a sheet of paper filled with miscellaneous quotations that she kept in her studio, she wrote: "An insubstantial image; a small winged figure—animal & human; an atomic emanation from the surface of an object which impinges on the senses—a sensation or even *impinges on the thought process.*"[19]

In *Dark Eidolon* of 1987 (Colorplate 41) the pale relief forms pivot against each other as if they are about to whirl around within the dark vertical banding of the background. The colors suggest a minor key, and the brushwork has a kind of quiet fury about it. In *Grey Eidolon* of 1987 (Colorplate 42) the same kind of relief forms are set against a paler background, in which their curves are echoed in the large white form below and in the gray curving form to the right. Here, the background itself is more dynamic, the colors suggest a major key, and the brushstroke has a lyrical, ethereal quality.

Around the same time, Rothschild returned to her Neruda series. In 1987, a year in which she produced a large number of works of remarkably high quality, she also painted *Neruda IV* (Colorplate 43), one of the most brooding and resonant paintings in the series. In 1990, in preparation for her upcoming exhibit of relief paintings at the Tretyakov Gallery in Moscow, she painted both *Neruda VI* (Colorplate 44) and *Neruda VII* (Colorplate 45). It was at this time that Rothschild also returned to the Gothic series, which she had begun in 1976.

In the Gothic series, rather than continuing to work broad changes on the general format, she worked in another direction—toward a distillation of the image in which the variations would be carried out almost entirely through color. The color harmonies in the Gothic paintings tend to be quite simple and flat, as can be seen in *The Gothic VII* of 1990 (Colorplate 46), *The Gothic XII* of 1991 (Colorplate 47), and *The Gothic XI* of 1991 (Colorplate 48). Each of the three paintings is rendered in a simple two-part color harmony: green and white; red and blue; pale blue and violet. Although the basic format is the same in each—consisting of the two simple splayed forms on top, buttressed by the more complex forms below—the drawing of the forms is filled with subtle variations. In *The Gothic VII*, for example, the archlike form at the lower left is supported by four thick near-verticals, while the same area in *The Gothic XI* combines thin and burgeoning forms. In *The Gothic XII*, by contrast, the forms in this area are thinner and the space more open. All three paintings also share thin horizontal and vertical divisions amid the larger, dominating organic forms. At first these straight lines seem to be structural divisions, that is, they appear to be accidents of the process of constructing the aluminum panels that the painting is made of. But on closer inspection, it can be seen that they serve no structural purpose. Rather, they constitute a partial grid, a network of rectilinear forms set in counterpoint to the elaborately drawn organic forms that make up the "image." Among the oppositions that are reconciled in the Gothics is the basic formal division between organic and geometric forms that had underlain Rothschild's imagery throughout her career.

By the late 1980s Rothschild felt that the relief paintings in themselves constituted a significant body of work, and she became eager to exhibit them in a retrospective fashion. In 1988 the Pennsylvania Academy of the Fine Arts in Philadelphia mounted an exhibition that gave an overview of her production in the technique; it was also shown at the Portland Museum of Art in Maine. In a thoughtful review of the Philadelphia exhibition, Edward Sozanski wrote about the way that Rothschild's work was directed toward "reconciling contradictory forces within a single field." He emphasized the expressivity that was built into the way in which Rothschild used relief and asserted that, taken as a whole, Rothschild's paintings represented "a many-faceted investigation over time into the various permutations of equivalence, balance and reconciliation, all of it on a formal, abstract level." Although her way of working may have been "out of fashion," he noted, "even in this age of egocentric art, the concept is far from invalid, and Rothschild's solutions to the problems are fresh and poetic."[20]

For the previous several years, Rothschild had developed a working relationship with the Galerie Gmurzynska in Cologne, which had shown her work there and at the Palazzo Grassi in Venice. In 1988 Gmurzynska brought Rothschild's work to the attention of officials at the Tretyakov Museum in Moscow, and the Soviet Ministry of Culture invited her to have a major exhibition of the relief paintings there. Since this would be the first exhibition at the Tretyakov of a living Western artist, Rothschild was especially excited by the plans for this show, and she gave it a great deal of her time and energy. Working to put together works for what was to be a retrospective exhibition of her work over the twenty years of her career that she felt really counted became a major undertaking. In preparation for the catalogue, she

reviewed many of her own writings and went through old notebooks, activities that prompted her to reevaluate her work from all periods.

The traumatic political events of 1991, during which the Soviet Union began to collapse, occurred just before her show was about to open, and for a while the fate of the exhibition was very much in doubt. But against all odds, the exhibition opened pretty much on schedule, on September 17, 1991.

After the Moscow exhibition and an exhibition of recent work at the André Zarre Gallery in New York the following fall, Rothschild was exhausted, and it took her a while to recuperate and begin a new series of works. During the next few months she worked especially with images related to the *Gothic* series, and she did a number of small collages, as if to generate imagery for another extended campaign of large works. In some of them, such as *Short Story (I)* (Figure 77), she experimented with new ways of combining figurative and abstract elements.

As she prepared to work on a new series of relief paintings, she also began to reread Joachim Gasquet's book on Cézanne, and she devoted a fair amount of time to playing late Schubert sonatas on the piano. Her studio was on the top floor of her house, and sometimes she would take one of her works downstairs to look at while she was playing the piano. Nearly twenty years earlier, she had written to her parents of a curious test that she had for her paintings: "When I have got a painting nearly finished I like to carry it downstairs and . . . play

something on the piano. Then, while mainly involved in that harmony or rhythm, I let my eye covertly switch to the picture. It is like seeing it under another mode. . . . against a more perfect harmony."[21] After practicing the piano one day in the spring of 1992, she remarked that she was "reading (I daren't say 'playing') a late Schubert Piano Sonata." She was amazed by how much energy the music contained and how much it gave off. "That energy," she wrote, "that kind, doesn't get burned up by use. It is always there if only one has the energy & will to look."[22] Trying to capture that kind of inexhaustible energy was one of the goals she set for her next series of paintings.

But this was not to be. On March 4, 1993, she had a stroke while she was coming down the stairs from her studio, and she died of a cerebral hemorrhage two days later.

During the last twenty years of her life, Rothschild had forged an original and intensely personal pictorial language and produced most of her best work. But the path for accomplishing this had been neither direct nor easy. Seen from our current perspective, it seems evident that the breakthrough of her late work had grown out of her ability to return to her beginnings, at a time of great stress, and to redirect her focus by revisiting the assumptions and ambitions of her earliest work. In the mid-1940s, she had been deeply involved with issues of abstraction, paint application, and pictorial structure that had come from early European modernism and that

Figure 77

Short Story (I), *1992. Collage with pastel, acrylic, and ink on paper, 14¼ × 30¾ inches.*

were then very much at the heart of avant-garde American painting. Her stylistic precociousness had been paralleled by the precocious beginnings of her public career. But during the next twenty years or so, she had struggled with grave doubts about the direction that contemporary painting was taking; in doing so, she had in effect removed herself from the historical arena. Or perhaps one should say that she had repositioned herself in relation to the historical arena by lingering with the early European modernists—especially the pre-abstract Mondrian, the cubists, and Cézanne—at a time when they could be only indirectly useful to a painter with her ambitions.

The way in which she subsequently rethought her relationship to her contemporaries is especially interesting. Because Abstract Expressionism did in fact emerge as the dominant mode in American painting during the 1950s, one forgets that at the time it was considered by many serious artists to be a historical dead end rather than a particularly vital response to early modernism—as we see it now. And in large measure this skepticism was framed precisely in terms of the issues that preoccupied Rothschild through the 1950s: namely, the degree to which the New York School painters seemed to have removed themselves from concerns about composition and deliberate layerings of symbolical meanings—and even, as it seemed at the time, from emphasis on the individuality of individual works. That is, most of the abstract expressionists were involved with the creation of a signature format, or "image," which was understood to be the private property of a single artist. Such an image is different from a style, in that it is based not so much on a specific way of painting as on a specific manner of working a particular format. The creation of such a signature image implies a serial production in which individual paintings tend to be subsumed within—or to be seen as variations of—the overriding pictorial schema. By contrast, Rothschild conceived of her progress in a very different way, which proceeded picture by picture, and in which variation of compositional structure was more highly valued than constancy of image.

Because most of the abstract expressionists had taken an aggressive stance in relation to the early European modernists they most admired, during the early 1950s they seemed to be at war with early modernism, rather than continuing it. Painters such as Karl Knaths, on the other hand, were so deeply engaged with early modernism on its own terms that they were unable to break through to a fully original means of expression. Rothschild's dilemma throughout the 1950s had been that of trying to find an alternative to Abstract Expressionism while maintaining a deep sense of continuity with early modernism—and at the same time to assert her own voice. Although she produced a number of strong and interesting paintings, in relation to the general trajectory of American painting she was then still working within a framework that was more retrospective than forward looking.

During the 1960s, the hegemony of painting itself within the visual arts began to weaken considerably as the increasing prominence of sculpture, installation art, conceptual works, and earthworks led to talk about the "death" of painting. Moreover, even within the practice of painting itself, the emergence of Pop Art challenged the basic assumptions of the abstract expressionists—and in so doing changed the nature of what was at stake historically with regard to such issues as figuration versus abstraction. The reverberations of this were felt during the late 1960s, when significant stylistic shifts occurred within the work of several major abstract artists. Richard Diebenkorn, for example, who had been working representationally since 1955, again began to work abstractly toward the end of 1967. Robert Motherwell, a leading abstract expressionist, began his austerely geometric Open series about the same time. And Philip Guston, who had been a leading advocate of painterly abstraction, returned to figurative painting only a couple of years later. It was at this time that Rothschild also began to reengage her contemporaries in the austere and minimal landscapes which both continued her involvement with early modernism and took a fuller account of what was happening around her.

It was not until the 1970s, however, that Rothschild really came into her own. To some degree this had to do with the circumstances of her personal life. After the breakup of her marriage, she felt a greater intellectual and spiritual freedom, and by returning to New York City she became more intensely involved with what was happening around her. If the cocoon of her marriage had allowed her to remove herself from the flow of history and think in terms of "timelessness," her reentry into the rough-and-tumble of New York artistic life seems to have forced her to reassess her work in relation to her contemporaries. Paradoxically, reentering the fray allowed her to begin to create a more transcendent and more "timeless" art. This was also facilitated in part by the revalidation that minimalist art gave to the kind of

Figure 78
Photograph of Judith Rothschild's studio as it was at the time of her death, taken April 1993.

coolness she had perceived in Mondrian and Arp back in the mid-1940s, and which she had struggled with for two decades.

That her late style was built on the unlikely combination of the sensual richness of Matisse's late cutouts and the geometric austerity of late Mondrian is not surprising when one becomes acquainted with the history of her work. In the late 1960s she gradually came to realize that her absorption with the pre-abstract Mondrian, and through him with Cubism and Cézanne, was an aspect of modernist painting that was virtually impossible for an artist of her generation to make good use of—in part because its many specific painterly moves obviated its being a base on which to build something original. This

was the impasse that the abstract expressionists had skirted by willfully "misreading" early modernism at precisely the same time that Rothschild was trying to continue to work her way through it.

But starting about 1971 Rothschild made a real breakthrough when she found a way of reconciling the polarity between the "abstract" and the "human" that had troubled her from the beginning of her career. She did so by inventing a vocabulary of cusplike forms that were at once abstract but still had strong figural connotations. This allowed her to create abstract pictures while remaining involved with specific subject matter— whether from the physical world or from literature and mythology. It also allowed her to synthesize the kinds of

discontinuous pictorial incidents that she so admired in Matisse's late cutouts with the unified but disembodied sort of space that had long impressed her in Mondrian's late works.

For although her relief paintings were viewed by most people as basically abstract, for her their underlying representational elements remained crucial. "I always return to nature," she wrote in 1976, noting that she sought her images in the complex interactions between feelings, things, and ideas. "Usually I circle around an idea, coming at it from many angles. In the process it seems to me as valid to move from abstraction towards realism and back again as it is for a poet to move from Lyric to Villanelle and back. The process of work being the discovery of the idea. Sometimes an idea which has been inchoate is defined. Sometimes an idea is inchoate—a song or a poem can help to define it. Or hold it in focus."[23] As we have seen, the relief technique itself allowed her simultaneously to deny and assert the figurative presence in her work—to deny it by emphasizing the objecthood of the total work of art while paradoxically asserting it by emphasizing the suggestiveness and gestural energy of its individual elements.

Rothschild's involvement with relief during the early 1970s reflected a concern she shared with a number of other painters who began to work in relief about the same time or shortly afterward—for example, Frank Stella and Elizabeth Murray. For many painters at the time, working in relief was a way of coming to grips with a radical shift that was taking place in relation to the definition of the art object generally. Artists such as Donald Judd, Robert Smithson, and Eva Hesse had not only called painting into question but had also opened up the parameters that separated painting from sculpture and had questioned the ways in which objects related to their surrounding spaces. The movement toward relief painting during the 1970s can be seen, among other things, as a way of both acknowledging this shift and at the same time reconciling it with the medium of painting by extending the physical limits of painting itself. "Are reliefs necessarily a form of sculpture?" Rothschild asked in 1976. To which she answered (in a way that casts an interesting light on the polarity between her dissonant and lyrical modes): "I don't think of these in that way. These works come from two kinds of experience. The 'demolitions' come from the more abrasive human and usually urban, experiences. The 'celebrations' are from that great restorative antidote: Nature."[24]

Both the formal vocabulary and the physical process that Rothschild used in the reliefs allowed her to intensify their emotional content at the same time that she kept a certain distance from it. And here even the tools she used played their part. She spoke of her use of the razor blade that she used to cut her forms as "a tool which is at once violent and rending, and yet also is consolidating and defining. I like its coldness, which is like a pen-line or a burin."[25]

The image of the coldness of the razor here leads one to think of the detached and stony passion Rothschild associated with Yeats. And in fact, at the time of her death, on one of the worktables in her studio, among the collage papers and paints and brushes (see Figure 78), was a handwritten copy of the passage from Yeats's *Autobiography* that she had set so much store by. It is the one that begins, "I know now that revelation is from the self, but from that age-long memoried self, that shapes the elaborate shell of the mollusc and the child in the womb, that teaches the birds to make their nest," and that ends with the poet's assertion of his own preference for "those verses where it seems to me I have found something hard and cold, some articulation of the Image . . ."

This articulation of a luminous and transcendental vision of life was something that had been at the core of Judith Rothschild's artistic ambition from the very beginning, and that she had been able to realize at last in her reliefs.

Unless otherwise noted, journals and letters are the property of The Judith Rothschild Foundation, New York.

Following the pattern established by the people involved, abbreviations have been used: JR = Judith Rothschild; HMR = Herbert M. Rothschild; NFR = Nannette F. Rothschild; HMRs = Herbert and Nannette Rothschild; AOM = Anton Olmstead Myrer.

INTRODUCTION

1 See Judith Rothschild, "On the Use of Color-Music Analogy and on Chance in Paintings," *Leonardo* 3 (July 1970), pp. 275–83. This essay is discussed in greater detail in Chapter 6.

2 Rothschild wrote to her parents on February 1, 1953, regarding a novel about a painter named Faubion: "Faubion (means flesh-pots in Egyptian) Humberg." Initially it was "meant as a kind of spoof on modern painters' pretensions," but when the novel was actually begun in January 1959, it became a Bildungsroman, with characters based on people they knew and full of details from the couple's life.

3 Nannette Rothschild, unpublished reminiscences, typescript, p. 18.

4 Journal no. 55, November 1, 1980, n.p.

5 Journal no. 80, 1985, n.p.

6 Nannette Rothschild, unpublished reminiscences, typescript, pp. 16–17.

7 Journal no. 9, July 8, 1955, n.p.

8 Journal no. 54, February 23, 1980, p. 19.

9 In 1959, at the height of Knaths's influence on her work, Rothschild recorded a striking dream in which Knaths and her father seem indeed to be conflated. In the dream, Rose Fried, her dealer at the time, tells her that her work is derivative. When Rothschild asks of whom, Fried says, "Your father." Rothschild replies that her father isn't even a painter, and Fried answers: "Can I help it if your father isn't a painter?" Journal no. 17, February 28, 1959, p. 29.

10 Journal no. 17, June 29, 1960, p. 209.

11 Although the Myrers lived on Louisburg Square and gave the impression that they were Boston Brahmins, both of Anton Myrer's parents came from modest backgrounds. His mother, Angele E. Cormack Myrer (1895–1970), was the daughter of a Scottish immigrant father and an American mother. His father, Raymond Myrer (1893–1988), was apparently raised in straitened circumstances: Raymond's father, Walter S. Myrer, was a Canadian carpenter who immigrated to Massachusetts and seems to have died young. At the time of the 1900 census,

Walter Myrer's wife, Eliza Taft Olmstead Myrer, was living with her two children but without a husband as a boarder in the home of Mr. and Mrs. George Moody in Holliston, Massachusetts. In the 1920 census, Raymond Myrer's occupation was given as "traveleing representative for a business school." Evidently it was not until the 1930s that he acquired his wealth. Ironically, although Rothschild had the impression that she was marrying the scion of an old and distinguished American family, Raymond Myrer and Herbert Rothschild had both made their fortunes about the same time and both sides of Rothschild's own family had actually been in the United States longer than had Myrer's. (Information from the Massachusetts Society of Genealogists Research Committee, the Public Archives of Nova Scotia, and the New England Historic Genealogic Society Library.)

12 JR to Carole Adlee, May 25, 1980.

13 Ibid.

14 Journal no. 17, May 15, 1959, pp. 43–44.

15 Journal no. 18, April 17, 1962, n.p.

16 Insert to Journal no. 36, June 6, 1969.

17 Discussing the possibility that they might try to work in separate places during part of the year, she chafed against a sense of being closed in and noted: "I am loathe to give up the little I've got. And it seems to me it puts too much of a burden on our marriage—just as my having had a child & thus forcing Tony to give up writing would have done the same thing possibly in another way." Journal no. 28, April 23, 1962, pp. 1–3.

18 Journal no. 9, July 8, 1955, n.p.

19 Nannette Rothschild, "The Reminiscences of Nannette F. Rothschild," in George H. Marcus, ed., *Encounters with Modern Art* (Philadelphia, 1996), p. 37.

20 Journal no. 28, September 19, 1963, p. 60.

21 Journal no. 17, January 27, 1959, pp. 12–13.

22 Journal no. 17, February 20, 1959, pp. 26–28.

CHAPTER 1

1 Rosalind Bengelsdorf, Byron Browne, Herzl Emmanuel, Hananiah Harari, Leo Lances, Jan Matulka, and George McNeil, letter to the *New York Times*, August 8, 1939; as cited in Judy Collischan Van Wagner, "The Abstractionists and the Critics, 1936–1939," in *American Abstract Artists: Fiftieth Anniversary Celebration* (New York, 1986), p. 10.

2 This attitude was well characterized in the famous 1943 letter to the *New York Times*, written by Adolph Gottlieb and Mark Rothko, in which they stated that "there is no such thing as good painting about nothing. We assert that the subject is

crucial and only that subject matter is valid which is tragic and timeless." Consequently, "if our work embodies these beliefs, it must insult anyone who is spiritually attuned to interior decoration; pictures for the home; pictures for over the mantel; pictures of the American scene; social pictures; purity in art; prize-winning potboilers; the National Academy, the Whitney Academy, the Corn Belt Academy; buckeyes; trite tripe; etc." *New York Times*, June 13, 1943, sec. 2, p. 9; as cited in Clifford Ross, *Abstract Expressionism: Creators and Critics* (New York, 1990), pp. 206–7. The letter, which was dated June 7, 1943, was coauthored by Barnett Newman, who did not cosign it.

3 Judith Rothschild, "Abstract versus Non-objective Art," *12th Street: A Quarterly* 1, no. 1 (May 1944): 18.

4 Judith Rothschild, "Technique and Ideas," *12th Street: A Quarterly* 1, no. 3 (Summer 1945): 14.

5 Rothschild, "Technique and Ideas," pp. 14–15.

6 Tape-recorded autobiographical statement, 1990, made for Richard Axsom.

7 Journal no. 4, n.p. In France they went to Paris, Chartres, Tours, Blois, the Loire valley, Carcassonne, Montpelier, Avignon, Arles, Marseilles, and along the Riviera to Nice. At Oxford she also waxed enthusiastic about a "wonderful & beautiful" performance of T. S. Eliot's recent play, *Murder in the Cathedral*.

8 Rothschild wrote of her enthusiasm to her parents from Paris; JR to HMRs, August 8, 1937.

9 She later recounted that she had selected Wellesley largely because it gave credit for studio time along with the required art history. Judith Rothschild, "How Unacademic," in Wellesley College Club of Los Angeles, *Wellesley After-Images* (Los Angeles, 1974), p. 129.

10 That September she wrote about wanting to spend the winter at Cranbrook and of the "great reinforcement from Sepeshey about the justification—the need ever—for being all but painfully serious about art. This is certainly nec[essary] for anyone who wants to paint." Journal no. 6, September 1942, n.p.

11 The manuscript is typewritten in red ink; it ranges in date from July 16 to October 9, 1943. Insert to Journal no. 7.

12 Journal no. 5, October 19, 1943, n.p.

13 Journal no. 5, October 26, 1943, n.p.

14 This formulation was to have a great influence as well on the critic Clement Greenberg, who attended Hofmann's Friday night lectures about 1937. See Greenberg's *Art and Culture* (Boston, 1961), p. 7.

15 "I like my abstraction w a blue backgr[ound].... How easy its been after all to cast off *W*'s binding training." Journal no. 5, October 27, 1943, n.p.

16 Journal no. 5, October 26, 1943, n.p.

17 When he visited the show, Hofmann left her an undated note on a copy of the announcement card for the exhibition: "Dear Judith—Your show is very beautiful—I like best some of the little one [*sic*], but the big No. 5 *[Figure and Objects* [Figure 7]] is fine balanced in color and shapes. In the little

one is an open suspended quality which I prefer."

18 Judith Rothschild, "Karl Knaths... As I Knew Him," in Jean Young and Jim Young, eds., *Ornament and Glory: Theme and Theory in the Work of Karl Knaths* (Annandale-on-Hudson, N.Y., 1982), p. 17.

19 See, for example, Krasner's 1938 drawings in Barbara Rose, *Lee Krasner: A Retrospective* (New York, 1983), pp. 26–30, and the photograph of a still-life composition setup in Hofmann's studio on p. 26. Blaine's *Composition (Duck)*, done while she was studying with Hofmann in 1943, uses a formal vocabulary that is similar to Rothschild's in *Abingdon Square*, done while she was working with Hofmann the following year. The Blaine painting is reproduced in Anne Eden Gibson, *Abstract Expressionism: Other Politics* (New Haven and London, 1997), p. 100.

20 In a January 2, 1948, letter to her parents, she speaks of "a sense of people confused and frightened and used, to the point where the realities they began by seeking have become lost in mechanical unrealities, until they don't know what they want or why or even who they are anymore."

21 Ben Wolf, "Jane Street Find," *New York Herald Tribune*, December 30, 1945.

22 The eleventh annual exhibition of the American Abstract Artists was shown at the Riverside Museum in New York, from March 30 to April 20, 1946.

23 Léger had been in New York for the preceding five years, and Rothschild had the chance to visit him in his studio and watch him work. She later remembered being disappointed by Léger's working procedure at the time, which involved moving drawings around on the canvas to arrive at a definitive composition. At the time she saw it as insufficiently spontaneous. It was only years later, when she was doing her relief paintings, which involved a similar discontinuity in procedure, that she came to see this in a different light. Judith Rothschild, taped interview with Gretchen Langner, Portland, Oregon, 1988.

24 Carlyle Burrows, *New York Herald Tribune*, November 10, 1946.

25 Edward Alden Jewell, *New York Times*, November 3, 1946.

26 René Arb, "Judith Rothschild," *Art News* 45, no. 10 (November 15, 1946), p. 54. The review is signed, Arb.

27 Ben Wolf, "Village Vitality," *Art Digest* 21, no. 3 (November 1, 1946), p. 18.

28 Rothschild, "Karl Knaths... As I Knew Him," p. 25.

29 JR to HMRs, July 3–4, 1947.

CHAPTER 2

1 JR to HMRs, November 15, 1947. The postal address was Route #1, Box 120, Carmel Highlands, Calif.

2 JR to HMRs, March 29 and April 6, 1948.

3 JR to HMRs, March 29, 1948.

4 Rothschild had met Fried in 1945. At the time of her show at the Jane Street Gallery she had used the money from the

sale of a work to the Smith College Museum of Art to buy a Schwitters collage from Fried, and Fried in turn had taken an interest in her work.

5 "The only other news here comes via Rose Fried and the Pinacotheca Gallery. She says that Marcel Duchamp (Nude descending the Staircase, to mention the most obvious but least of his works) and Katherine Dreier (one of THE collectors in this country... probably one of the five or ten first and best collectors of modern art in the world) want to see 'all' my work.... 'and then they want to buy.' I shall send her some things from here as I do them. There is no hurry. But *please* say nothing of this to *anyone*.... It has not happened yet." JR to HMRs, December 1, 1947.

6 JR to HMRs, May 31, 1948.

7 JR to HMRs, June 28, 1948.

8 Rothschild's letters are sometimes signed "Judith and Tony" or "Tony and Judith," even though they are clearly written solely by her. Myrer's occasional letters to his in-laws are almost invariably signed only by him.

9 JR to HMRs, January 17, 1949. The passage is worth quoting at length: "I know it is hard to manufacture excuses so let me give you one which is not altogether untrue by any means. You could quite honestly and truly say that we do not know how long we are going to be able to stay here, and that since we know our days may be numbered we have decided to take no time out for socializing.... And perhaps because it is part of the business of painters and writers to be acutely sensitive, they make more of an interruption to us than they would to you, or than you might imagine they do for us. Maybe your feeling is that we are getting too sensitive for our own good."

10 JR to HMRs, December 22, 1947. The writers she names are André Breton, Max Ernst, Paul Eluard, Marcel Duchamp, Tristan Tzara, and what she refers to as "the American School" of writers associated with Kenneth Patchen.

11 The burlap is printed with the following, cropped at the right: "EGG FO[AM?]/MANUFACTURED/POULTRY PROD/ OF/CENTRAL CALIF/." Rothschild later remembered that this painting was done in Carmel Highlands, which means that it was executed shortly after she got to California.

12 Various stages of its completion are recorded in Rothschild's letters and journals between February and June 1949. The title, *One Bread, One Body*, was taken from Corinthians I: "For we being many are one bread, and one body: for we are all partakers after that one bread." The book was eventually published, however, as *Evil under the Sun*.

13 JR to HMR, November 13, 1948; Myrer had responded with his own four-page letter on November 11.

14 HMR to AOM and JR, November 29, 1948.

15 Originally published in *Combat* in 1946, it had been translated by Dwight MacDonald in the July–August 1947 issue of *Politics*.

16 AOM and JR to HMR, December 8, 1948.

17 HMR to AOM and JR, December 15 and 28, 1948. Herbert Rothschild could not, however, resist pointing out that Judith

and Tony were basing some of their arguments on what he saw as misquotations of both himself and Frank, nor could he refrain from attacking what he perceived to be the pessimism of the Camus article.

18 AOM to HMRs, July 8, 1948.

19 JR to Robert and Maurine Rothschild, March 4, 1949.

20 JR to HMRs, July 6, 1949.

21 Dorothy Gees Seckler, "History of the Provincetown Art Colony," in Ronald A. Kuchta, ed., *Provincetown Painters, 1890's–1970's* (Syracuse, N.Y., 1977), p. 65.

22 Robert E. Knoll, ed., *Weldon Kees and the Midcentury Generation: Letters, 1935–1955* (Lincoln, Nebr., and London, 1986), p. 125.

23 JR to HMRs, July 1949.

24 JR to Robert and Maurine Rothschild, August 1, 1949.

25 Journal no. 9, February 16, 1950, pp. 26–27.

26 Journal no. 9, December 5, 1949, p. 2.

27 Journal no. 9, December 8 and 9, 1949, pp. 3–4.

28 Journal no. 9, December 12, 1949, pp. 11–12. She also remarked on her admiration for Bearden's attitude toward his own work: "His remarks were much more objective & better altogether than Knaths.... Also was very much heartened by his attitude towards me. I spoke of my preoccupation with the human as well as the plastic & he understood what I was saying! It was a great relief to find such easy communication & understanding interplay with a painter I respect.... I have had such doubts about myself & my small eekings [*sic*] out of work lately that it came at a most crucial moment for me. He is a fine person. And his manner is deceptive—actually his mind is acute & his painting eye & memory *unusually* sharp. I admire him a lot for his attitude towards his own work. He only shows *when* he is really ready. Does not consider every canvas his hand touches a masterpiece."

29 *Réalités Nouvelles 1950* (Paris, 1950), p. 40.

CHAPTER 3

1 Rothschild, "Karl Knaths... As I Knew Him," p. 25.

2 Rothschild, "Karl Knaths... As I Knew Him," p. 26.

3 Rothschild was working on this painting in March 1954 and finished it on June 4; Journal no. 9, p. 40.

4 Although the painting is signed "*Prisms & Pavannes 1955 / J Rothschild*," the painting is dated "1/30/56" in Rothschild's 1956 inventory list indicating it may have been retouched that January. Journal no. 10.

5 Robert E. Knoll, *Weldon Kees and the Midcentury Generation*, p. 135.

6 Knoll, p. 136. The characterization of Kees's departure is a quotation from Fritz Bultman.

7 Knoll, p. 174.

8 JR to HMRs, December 1, 1954.

9 Journal no. 9, October 22, 1955, insert, n.p.

10 JR to HMRs, May 1953. After this, Rothschild would have the French paints sent to her from Paris on a regular basis.

11 JR to HMRs, July 1954. In this same letter she says that she has temporarily abandoned dividing her time between small paintings in gouache and the larger oils: "And am enjoying the increased intensity of not having to split my interest between the two media. I guess I don't make as many misplays as I used to, because I don't find myself having to overpaint or scrape as much." A few months later she remarked that she was "currently very much 'up' about the oils I am doing. For so long I felt a kind of tension about the medium, which kept a lot of my best work from coming to fruition in oils. But I think I really have gotten over that in the last year or less. . . . One can really say and feel so much more in the larger scale and quality of oils." JR to HMRs, January 17, 1955.

12 Journal no. 9, July 2, 1955, p. 62.

13 The painting is described simply as "another untitled 34 x 42 seascape," but an accompanying sketch makes it clear that the painting in question is indeed *Antelopes*.

14 JR to HMRs, August 24, 1951. A few days earlier Rothschild had described how "every afternoon we have been taking about an hour off to play a game of something which resembles badminton but which we call 'antelope' because usually that is what we end up resembling. As you know, the land here slopes ferociously." JR to HMRs, August 20, 1951.

15 Journal no. 9, September 6, 1955, insert p. 3.

16 Journal no. 30, October 10, 1966, p. 125. She was then deeply involved with experiments in pure color, and she went on to remark of *Byzantium*: "No color—but forms relate well & it sits well. It was hung w/ Picabia, Kandinsky & on opposite wall the de Chirico."

17 JR to HMRs, December 2, 1955.

18 JR to HMRs, December 28, 1955.

19 Rothschild saw paintings by Richard Diebenkorn, Hassel Smith, and David Park, but they appeared to have little effect on her.

20 JR to HMRs, November 16, 1953.

21 Journal no. 9, May 24, 1957, pp. 109–10.

22 JR to HMRs, January 19, 1956.

23 She explained this to her parents in a letter dated March 24, 1956.

24 The three statements reflected her eclectic reading:

Perhaps beauty will become a feeling useless to humanity, and art something halfway between algebra and music. —Flaubert

All that Cézanne said and did was not enough to make Malraux understand what no earlier age could have failed to understand: that to Cézanne the realization of the picture necessarily involved the realization of the mountain. —Randall Jarrell

The great antidote for manner is the study of Nature. —Poussin

25 Martica Sawin, "Judith Rothschild," *Arts Magazine* 32,

no. 1 (October 1957), p. 59.

26 Lawrence Campbell, "Judith Rothschild," *Art News* 56, no. 6 (October, 1957), p. 17.

27 Emily Genauer, "New Rothschild Show," *New York Herald Tribune*, September 28, 1957.

28 Stuart Preston, "One-Man Shows," *New York Times*, September 27, 1957.

29 E. C. Goossen, "Judith Myer's Work," *Monterey Peninsula Herald*, March 8, 1956. Goossen's column was syndicated and appeared in other newspapers across the country.

30 E. C. Goossen, "Judith Rothschild," *Monterey Peninsula Herald*, September 20, 1957.

CHAPTER 4

1 Journal no. 11, December 18, 1957, pp. 54–55.

2 Journal no. 11, December 28, 1957, p. 86.

3 Journal no. 11, December 30, 1957, p. 92.

4 Journal no. 11, December 31, 1957, p. 93.

5 Journal no. 11, pp. 96–97. Myer noted it in his European Journal "Eur I," November 1957–February 1958. Mugar Memorial Library, Boston University.

6 Journal no. 11, January 7, 1958, pp. 98–99.

7 Journal no. 11, January 8, 1958, pp. 99–100.

8 Journal no. 11, January 9, 1958, p. 103.

9 Journal no. 11, December 29, 1957, p. 89.

10 Journal no. 11, January 11, 1958, pp. 105–7.

11 Journal no. 11, February 12, 1958, p. 181.

12 Writing to her mother from Cannes about a collage that was about to be sent to an exhibition, she noted that the "picture may be signed J. R. M. Doesn't matter. *But* would you *please* see that *Judith Rothschild* is name at back—& of course that it (Judith Rothschild) is name in catalogue if there is to be one." JR to NFR, undated letter, January 1958.

13 Journal no. 9, January 1, 1959, n.p. In the same entry Rothschild also resolves to make better use of her time, "pressing harder after the ideas I have," doing "many versions of each one (if necessary) to refine & strengthen" her idiom. But at the same time she makes it clear that her own work schedule will be in large measure subservient to her husband's, and discusses the importance of being "more thoughtful to T. in minor ways—such as *not* get the mail 'til *he* is ready for its interruption—& trying to keep interruptions of his time at a minimum."

14 Journal no. 12, February 16, 1958, pp. 1–2.

15 Journal no. 17, August 17, 1959, p. 110; and Journal no. 17, July 14, 1959, p. 99.

16 *Faubion* was begun in January 1959 and seems to have been abandoned in 1963. Rothschild and Myer evidently took turns working on the manuscript, and for a while Rothschild gave it precedence over her own painting.

17 Rothschild's anxieties about her marriage that winter are

evident in an "idea for a play" that she recorded in her journal, which recounts a thinly veiled allegorical version of her own marriage: "Girl (cf. JR) falls in love w/ & marries man because he made supreme sacrifices for principle: i.e., war hero or some such.... Girl, from sophisticated Jewish circle which never was capable of real commitment, loves quality in him of committed, unequivocating position. Husband loves girl but not 'for' such reasons. Is just charmed by her—perhaps because her background is alien.... Situation arises requiring stand on committed position (in another sphere from main original one). Girl discovers she hasn't psychic stamina for it—that she feels she *must* urge him to temporize. Disillusioning to them both not because she is not equal to it—this would be only being human—but because it becomes clear that her whole concept of loving his courage is a sentimental one—that she only loves it as a *past*—as a matter of pride—not as a living reality.... Result of situation marriage either breaks up, is irrevocably altered—or most true to life—both he & she start having illicit affairs—she because she is ashamed & wants to debase herself or seeks the relief of being w/ someone who isn't 'better' than she.... He because he has lost pride in his own image of himself now that he sees his wife really doesn't have a pride in him (—or because he has given in to her...) & because he has lost faith in their raison d'être—either also starts playing around—or, more likely, starts to drink. Thinks of himself as unimportant." Journal no. 17, February 15, 1960, pp. 161–63. In a marginal note, the husband in this story is identified as "T."

18 Journal no. 9, December 11, 1958, n.p.

19 Journal no. 17, July 14, 1959, p. 97.

20 On February 19, 1959, Rothschild noted that while she was at work on the earlier picture, she had stretched up another 40-by-50-inch canvas for a "new version of Marché." Journal no. 17, pp. 23–24. Both of these paintings make a striking contrast with a smaller version of the same theme that she did near the beginning of her work on the larger painting, a 36-by-44-inch version of the same theme, also called *Marché* (Judith Rothschild Foundation oeuvre cat. no. 59.1), an energetically and very loosely brushed picture, which is a straightforward still life of the fruits available in the market.

21 When this painting was photographed about 1961, the title was noted as *Family Portrait*. But by 1962, when it was shown at Rothschild's exhibition at the Knapik Gallery, the title was given as *Marché*. At the "Art USA 59" exhibition at the New York Coliseum, Rothschild showed a painting entitled *Marché at Antibes* with the same dimensions (cat. no. 180a), and this was presumably *Marché (I)*. After this exhibition, however, *Marché (I)* was rolled up and did not come to light until after Rothschild's death. The two figures in *Marché (II)* echo the pair of figures in the drawing *Two Figures in an Outdoor Market* (Figure 37).

22 On February 19, 1959, Rothschild mentions being hard at work on both of them. Journal no. 17, pp. 25–26. The whirling image seems to take its cue from Alcestis's memorable lines, "Sun and light of the day, / O turning wheel of the sky, clouds that fly." *Alcestis*, in David Grene and Richmond Lattimore, eds., *Euripides I* (Chicago and London, 1955), Lattimore translation, lines 244–45.

23 Lattimore, introduction to *Alcestis*, in Grene and Lattimore, p. 3.

24 Over the course of the year she designated two different versions of *Alcestis*, which were numbered 1 and 2. The first version was 40 x 50 inches, the same dimensions as the two *Marché* paintings, while the size of the second is given as 30 x 48 inches. The larger version appears to have been destroyed or painted over; the smaller version, initially *Alcestis 2*, is our Colorplate 13.

25 The description, framed in the Ostwald notation system, is worth quoting literally: "Hard at wk on 48 x 60 & 40 x 50 Marché. Dervish almost landed new 40 x 50 Alcestis paysage drawn in. Color scheme wavering in my mind—between sun-bleached dryness in 3's with the fragmentations & inexorable sun more intense & set vs. 2 dark streaks pressing out to right & bottom of canvas like a terrible crack in the fabric of the world. Or to do it in a kind of night walkers song scale of unreal colors—purple 13's & seven-ish reds making a kind of dance in the sky w/ less intense versions of the same colors in [the] foreground & streak running out of bottom possibly black or bright orange—like a shocking wound—& with the only relief the horizontal bar of silvery pale green. —Shld do both versions—here only one canvas stretched tho (or rather, want 2nd 40 x 50 for new version of Marché)." Journal no. 17, February 19, 1959, pp. 23–24.

26 Journal no. 17, February 19, 1959, pp. 25–26.

27 Journal no. 17, February 19, 1959, p. 25.

28 Journal no. 11, February 4, 1958, p. 146.

29 Journal no. 17, July 18, 1959, p. 103.

30 Journal no. 17, July 18, 1959, p. 104.

31 "[Knaths] liked *Alcestis* very much. Was really excited by it I think (I am still not quite satisfied w/ this—may try to do again. For surer unity etc)." Journal no. 17, November 16, 1959, p. 125. Knaths also saw *Marché (II)* at the same time and criticized its blue-violet and yellow color harmony. The detail and specificity of their conversations are well reflected in her Journal notes on Knaths's remarks:

"Structure of pic[ture] is *[sketch]*

1= Tonic & 3 = 7th

6= Dom[inant]

13 sub d[ominant].

roughly speaking. K said 1 & 6 & 13 are all 'natural' relat[io]ns whereas 13 & 3 are not & therefore latter need more room. He is right that complex of 13 & 3 has always been 'wrong' but must think about this idea of 'naturalness' natural harmony of red white & yellow. Why natural? I asked K & he said only 'that was all Piet Mond[rian] really used'." Journal no. 17, pp. 125–26.

32 It is so described in Rothschild's inventory of paintings at the end of Journal no. 16. The painting may have been taken up again as late as 1962; on January 17, 1962, Rothschild

noted that she had nearly finished a painting of a "Girl w/ hand near face on Truro dunes. Started out as Io but is too lyrical in color." Just which painting is referred to here is not certain. Journal no. 25, n.p. The painting we illustrate (Colorplate 14) was in any case exhibited as *Io* in Rothschild's exhibition at the Knapik Gallery that April.

33 Journal no. 17, April 17, 1962, pp. 298–99.

34 Journal no. 17, May 3, 1961, p. 253.

35 Journal no. 17, October 26, 1960, pp. 237–38.

36 These follow the October 1958 entries in Journal no. 15.

37 Rothschild went on to describe her psychological relationship with Knaths: "What a happy impersonal honesty of relationship I now have w/ KK at such times. All his criticisms were tempered w/ wads of great praise & an obvious attitude of great respect for me." Some idea of the specificity of Knaths's critiques can be gleaned from the following: "Equilib. should be disturbed *then* reestablished. Otherwise he seemed to feel it was pretty well worked out. Though it did not excite him at all, I felt. . . . The Marché pic (24 x 40) I did 1st of series. He spoke of specifics—liked pa[int]ing of pic in gen esp liked centre section & figs in right & center. Suggested too much equilib entre lower left & right & suggested bringing down since grays as in center top into right 3's & 10's. Can see he's right in this — as usual he spotted at once *just* the places I knew were weak & had not 'adjusted' perfectly." Journal no. 17, January 14, 1959, pp. 6–7.

38 "Perhaps in another 10 years," she continued, "he might have done it. . . . That is might have transcended the rigor of his 'middle period' (which lasted to the end of his life!) as Cézanne did in his last works—& got back to the sonorous depths of the '13 period, but w/ the later researches & discoveries serving to deepen & intensify the very human qual[ity] of those early *Trees*, etc." Journal no. 17, February 20, 1959, p. 27.

39 Journal no. 17, June 6, 1959, pp. 75–76. When the painting was well under way, she analyzed its color and found that she was wavering between using intense colors and a more grayed-out general tonality, a "dominant (called technically Tonic) tone." She saw this as a conflict in her original conception. "I really had 2 images in mind at once," she wrote. "One was of the canvas being held by this sort of a structure—which is essentially diatonic & sequential. [The] other was of more equilibrated even high intensities such as Matisse often used—what KK calls a balanced color—which is more or less non-sequential in that the modulations through the grays are almost eliminated." Journal no. 17, June 7, 1959, pp. 79–80.

40 Journal no. 17, June 7, 1959, p. 80.

41 Journal no. 17, January 13, 1960, p. 141.

42 Journal no. 17, June 29, 1960, p. 209.

43 JR to HMRs, February 14–16, 1961. Rothschild wrote an extended essay on this painting by Knaths, which is preserved at the end of Journal no. 22.

44 Journal no. 28, August 20, 1963, p. 55.

45 A month after the incident she observed, "We have not been back since & though some of this is Tony's deep resentment of those afternoons still I hope Karl has drawn the right conclusions from our absence." Journal no. 28, September 19, 1963, pp. 63–64. See also journal no. 28, p. 70.

46 Journal no. 28, June 12, 1964, pp. 104–5.

47 Journal no. 28, July 29, 1964, p. 105.

CHAPTER 5

1 Journal no. 30, September 11, 1964, p. 2.

2 Journal no. 30, September 27, 1964, p. 15.

3 Journal no. 28, September 19, 1963, p. 60. They had read the play the day before, on September 18 (noted in journal no. 29, n.p.). Rothschild further noted: "T. bro[ugh]t tears to J w/ sugg[estion] that we actually split up for a while. This said lovingly, but only bec[ause] he feels guilty ab[ou]t 'J's career.' Always brings me back to real prob[lem] for me. That relation to T is more imp[ortan]t to me than my art." Journal no. 28, p. 62.

4 Journal no. 30, January 24, 1966, p. 102.

5 In a letter to her parents about her 1967 exhibition at the Albany Institute of History & Art (February 22, 1967), Rothschild described the picture: "Lieutenant Island was the one with the greenish bunched dunes on the left middle ground, that hung in the first room as you entered. I think it is also sound in the way that Bound Brook Marsh is." In 1965 she had done a number of drawings of Lieutenant Island, which is about seven miles from Rothschild's Bound Brook house.

6 On March 1, 1966, she noted that she had "started pic[ture] of Spannish [*sic*] Mtns." And on March 6, a list of recent paintings includes "22 x 38 Spain–Mtn." Journal no. 32.

7 In her February 22, 1967, letter to her parents, Rothschild noted that the "impactual impression of this is of many hues hovering around acid yellows with some warmed colors at horizon. Dunes."

8 In Dorothy C. Miller, *Americans 1963* (New York, 1963), p. 83.

9 Journal no. 30, May 3, 1966, p. 113.

10 Journal no. 30, August 30, 1966, p. 117, for Knaths's opinion about de Staël; JR to HMRs, March 14–15, 1966, for Rothschild's comment about de Staël's importance to her.

11 Journal no. 30, January 25, 1966, p. 103.

12 Journal no. 30, March 14, 1966, pp. 108–9.

13 Journal no. 30, March 14, 1966, pp. 109–10.

14 Journal no. 30, May 17, 1966, p. 116.

15 Journal no. 30, October 10, 1966, p. 125.

16 Journal no. 30, March 22, 1967, pp. 138–39.

17 Journal no. 34, September 18, 1967, p. 10. She drew a distinction between this and her earlier, Knaths-influenced work: "Thus this picture does not have the 'KK dichot[omy]' within it."

18 Journal no. 34, September 18, 1967, pp. 10–12.

19 Ralph Pomeroy, "Judith Rothschild," *Art News* 66, no. 10 (February 1968), p. 16.

20 Cindy Nemser, "Judith Rothschild," *Arts Magazine* 42, no. 4 (February 1968), p. 62.

21 His travel receipt was for two plane tickets, and he had left one of his journals out where it could be read—whether on purpose or not is difficult to say.

22 Journal no. 36, June 29, 1969, pp. 8–9.

23 Journal no. 34, April 29, 1969, p. 225.

24 Journal no. 21, n.p. (written at the end of the journal).

25 Journal no. 34, April 29, 1970, pp. 235–36.

26 Insert to Journal no. 36, June 6, 1969.

27 On April 12, 1969, at the height of the crisis, for example, she noted in her journal that she worked on two oil paintings all morning. Journal no. 34, p. 175.

28 "Have been doing a new series of pic[ture]s," she wrote in her journal. "*Could* be worth pursuing. Alcestis theme. Very abstract. Am really excited ab[ou]t it despite inner turmoil. Long days of w[or]k here may pay off?" Journal no. 36, June 29 or July 6, 1969, p. 15.

CHAPTER 6

1 JR to HMRs, November 20, 1969.

2 Rothschild, "On the Use of a Color-Music Analogy and on Chance in Paintings." Rothschild had originally titled the article "Structuring a Space Odyssey," but the more sober title was closer to the journal's style. The final draft was sent to Malina on December 10, 1969. The following January she became acquainted with Wilma Hatfield, who was the New York representative of the journal, and she soon became involved in helping to promote it, in part by making memberships available at a special rate to members of the AFA.

3 JR to HMRs, September 17, 1970; Journal no. 50, September 13, 1970, p. 4.

4 C. J. Jung, preface to *I Ching* (London, 1951); as cited in Rothschild, "On the Use of a Color-Music Analogy," p. 282.

5 First this was done with thick paper, then with cardboard, and eventually with foamboard that she cut with a razor; later, in the mid-1980s, she also began to work with sheets of aluminum.

6 Journal entry dated March 29, 1975, taken from journal and kept in a separate portfolio.

7 About 1988 Rothschild wrote a detailed account of how she came to do the reliefs: "The idea of working in Relief came to me in 1971–2 when I was teaching a course in advanced figure drawing as Guest Artist in Residence at the University of Syracuse. It was the first contact I had had with figure drawing in a class situation since the days of studying with Hofmann. And its impact led me first to doing large pen and ink drawings, but one day I confessed to a student that what I was really dreaming of was of doing Reliefs. However, I admitted, that technical problems defeated me.

"The student I happened to speak to was Pauline de Blasi, who recently was in Provincetown, working with Robert Motherwell on the design and layout for an important book on his graphic oeuvre. Pauline has become a superb graphic designer, and even as a young graduate student she had a prodigious knowledge of new materials and techniques. She immediately introduced me to a whole range of new materials. Out of which evolved the techniques I am currently working with." Judith Rothschild Foundation Archives.

8 Journal no. 36, March 29, 1971, p. 64.

9 Journal no. 39, July 7, 1972, pp. 32–33.

10 William Butler Yeats, *The Autobiography of William Butler Yeats* (New York, 1953), pp. 164–65.

11 Rothschild's copy of the sheet music was the 1943 edition, inscribed with her name as Judith Myrer and her address as 212 Soledad, Monterey. The characterization of Hindemith's music is from an undated note from Rothschild to her parents, ca. 1975.

12 She would sometimes change the name of a painting if she felt that it fit more appropriately into another subject sequence. *Ogygia II* of 1975 (Colorplate 27), for example, was later also given a title in the Celebration series as *Celebration III*. But since her manner of doing this was not systematic, we have retained the original titles.

13 Undated note to her parents, spring 1975.

14 Journal no. 39, March 27, 1975, p. 53.

15 Journal no. 39, April 12, 1975, p. 63.

16 Hilton Kramer, "Judith Rothschild," *New York Times*, March 29, 1975.

CHAPTER 7

1 Journal no. 15, July 8, 1958, p. 10.

2 Journal no. 53, July 20, 1980, p. 11. Rothschild wrote this as a specific description of working on relief paintings and jotted down the opening chords of the Waldstein sonata next to her text.

3 JR to HMRs, January 24, 1976.

4 "Have had enormous encouragement from some artists. Alice Yamin . . . Suggests that it is a real breakthrough, a language she says I can use anywhere. She understands my 'UR forms' hope in these evolutions. . . . Others: many see only gayety & ease. This is maddening but inevitable." Journal no. 39, March 27, 1975, p. 53.

5 This is clear in a number of journal entries written in Florence and later in Rome and Ravenna, in Journals nos. 11 and 12.

6 Journal no. 59, April 19, 1978, n.p.

7 Journal entry, April 10, 1979. This was found after Rothschild's death loose with other entries in a portfolio called "Journal." She probably had intended to reinsert them into the journals from which they came.

8 In 1977, when reading Neruda's memoirs, she had praised their "beautiful compactness" and "natural vividness" and

had remarked that he wrote as if "to remind himself & to repossess the moment." JR to NFR, May 27, 1977.

9 Speaking of the differences between mass art and aristocratic art, she had noted that "these two areas blend & overlap & criss cross at times (cf. notably Gothic Cathedrals etc.)." Journal no. 17, January 27, 1960, pp. 147–49.

10 B. H. Friedman, "Judith Rothschild's Recent Work," *Arts Magazine* 52, no. 3 (November 1977), pp. 94–95.

11 Fearful of losing her sight completely, she considered beginning to edit her past work to destroy what she felt was inferior. Journal no. 53, September 1981, pp. 11–15.

12 Annely Jude Fine Art, *Judith Rothschild: Relief Paintings* (London, 1981), n.p.

13 John Bernard Myers, "A Fine Edge—the Paintings of Judith Rothschild," in *Judith Rothschild: Relief Paintings*.

14 Rothschild copied out this and a longer passage from Yeats's *Autobiography* in her notebooks several times. This quotation was copied out in September 1976, on the first page of Journal no. 53.

15 We retain the original title. The painting was retitled *Alcestis* by Rothschild in 1991, just before her exhibition at the Tretyakov Gallery in Moscow. This change in title was presumably the result of her wanting to make the titles of the works in the show more uniform.

16 Rothschild, taped interview with Gretchen Langner, Portland, Oregon, 1988.

17 Judith Rothschild, "Notes from a Journal," n.p. Mimeographed at the time of the exhibition "Judith Rothschild: The Shield of Achilles, Relief Paintings and Collages," Iolas-Jackson Gallery, New York, May 7 to June 1, 1985. In these notes, Rothschild discusses the impact made on her by Durrell's recounting of the story in which Odysseus comes to the court of Lycomedes, where Achilles was staying disguised as a girl. Odysseus, aware of the deception, brought gifts for the women of the household, amid which he placed a shield and sword. When an alarm was sounded, Achilles instinctively seized the sword and shield and prepared to defend himself, thus revealing his true identity. See Lawrence Durrell, *The Greek Islands* (New York, 1980), p. 212.

18 Rothschild, "Notes from a Journal."

19 From a sheet of quotations inserted into the end of Journal no. 80.

20 Edward Sozanski, "Exhibit Honors Ten-Year Morris Gallery Program," *Philadelphia Inquirer*, July 21, 1988.

21 JR to HMRs, July 29, 1974.

22 Journal no. 53, April 17, 1992, p. 49.

23 "Statement about Relief Paintings," one of several loose sheets written about the time of Rothschild's participation in the "Ten Artists" group show at the Landmark Gallery.

24 Untitled note written for Landmark Gallery group show, November 1976.

25 Ibid.

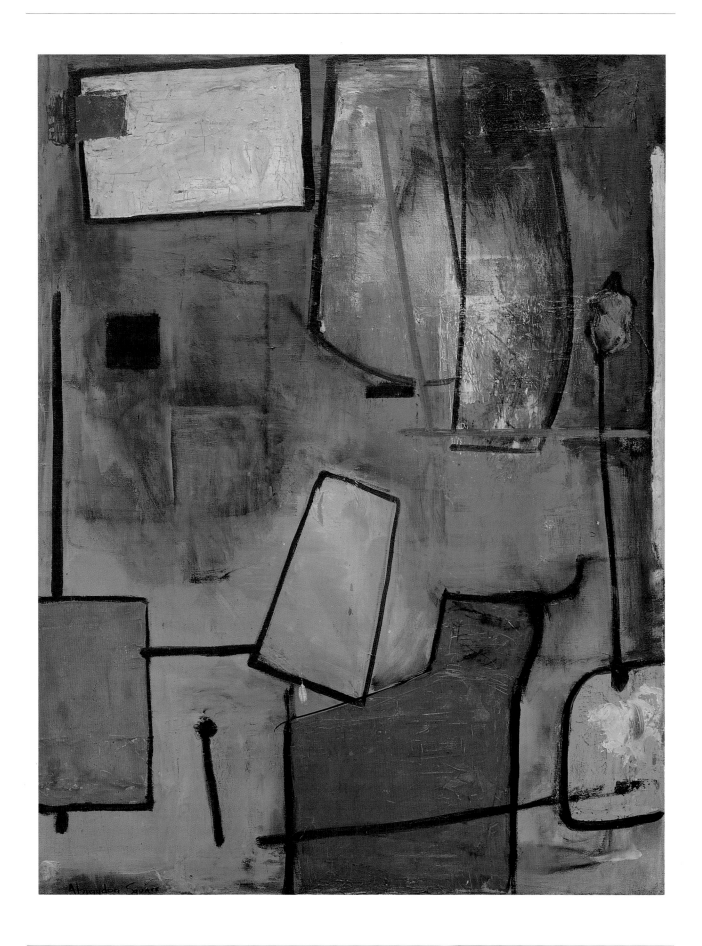

Abingdon Square, *1944. Oil on canvas, 35¼ × 27⅛ inches.*

Colorplate 2
Grey Tangent, *1945. Oil on canvas, 29⅞ × 24⅞ inches. Collection The Metropolitan Museum of Art, New York.*

Mechanical Personnages, *1945. Oil on canvas, 40 × 27⅞ inches.*

Mechanical Personnages III, *ca. 1947. Oil on canvas, 40⅛ × 47⅞ inches.*

Colorplate 5
Untitled Composition, *1947. Oil on burlap, 24 x 24 inches.*

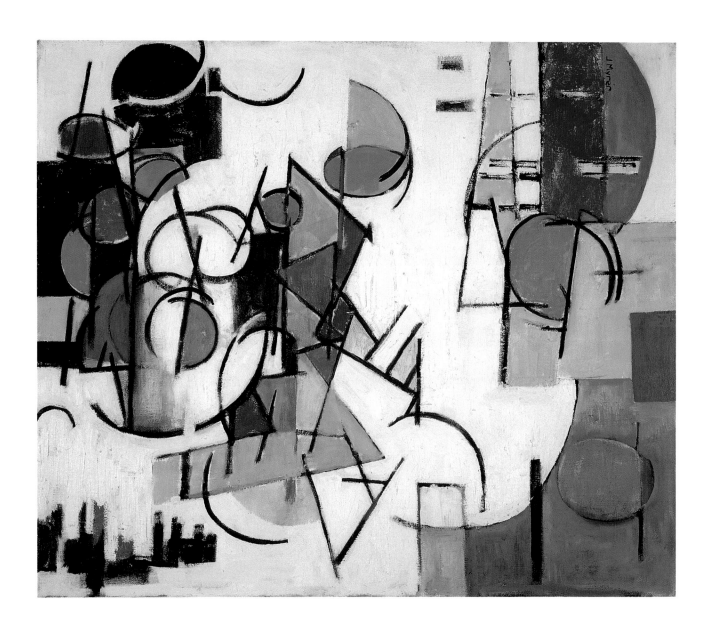

Untitled Composition, *1952. Oil on canvas, 20 × 24 inches.*

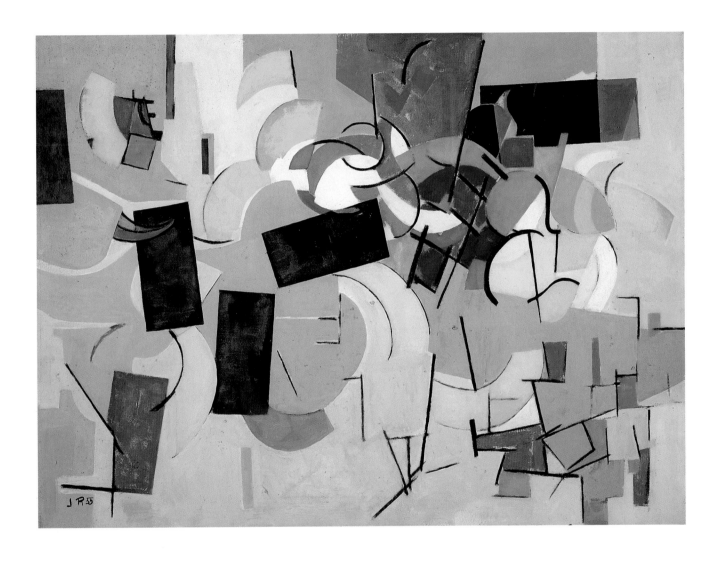

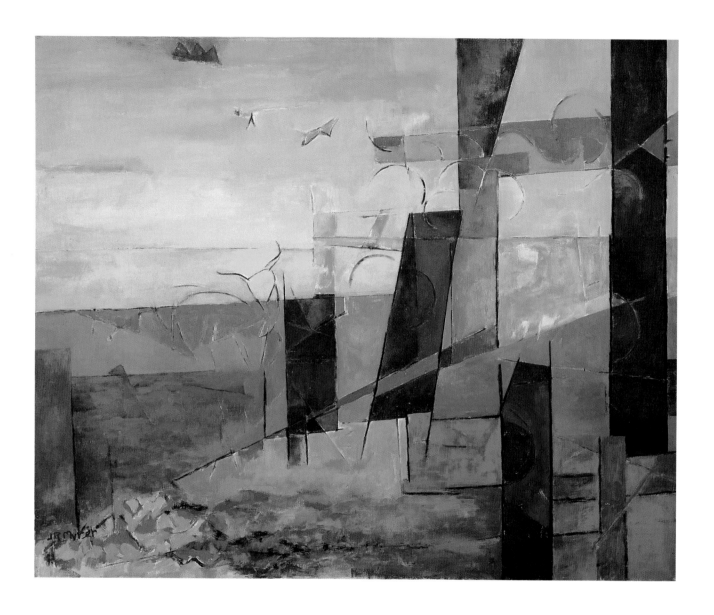

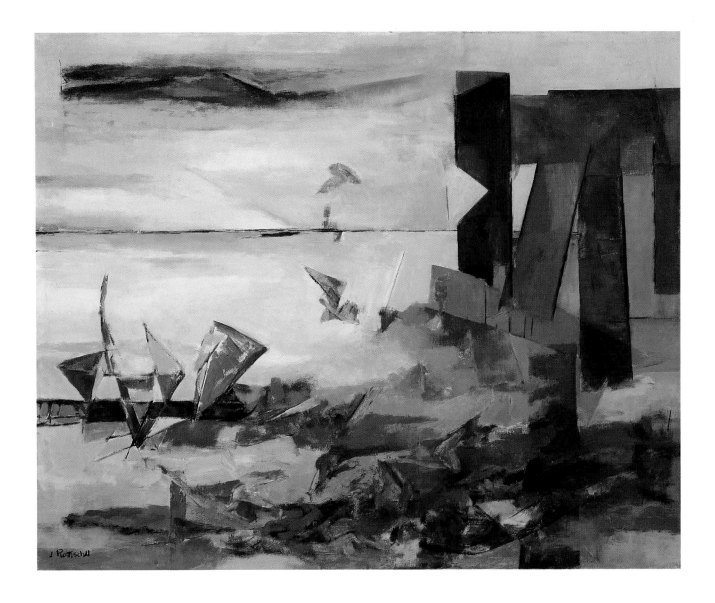

Byzantium, *1955. Oil on canvas, 33⅞ × 42 inches.*

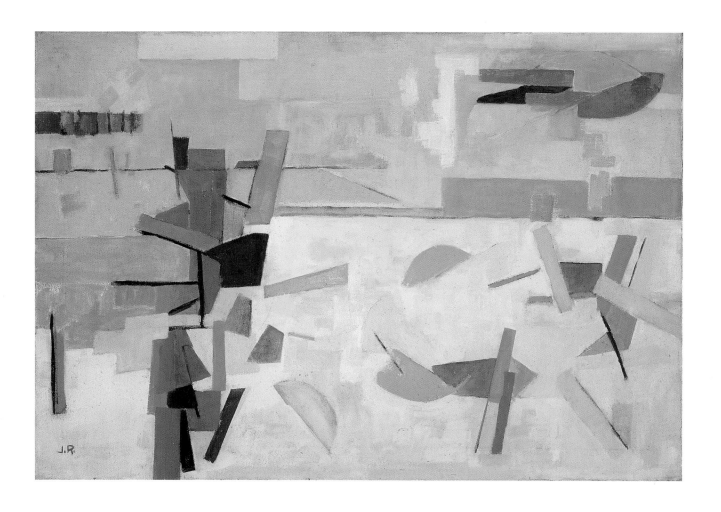

Colorplate 10
Southwest, *1957. Oil on canvas, 24¼ × 36 inches.*

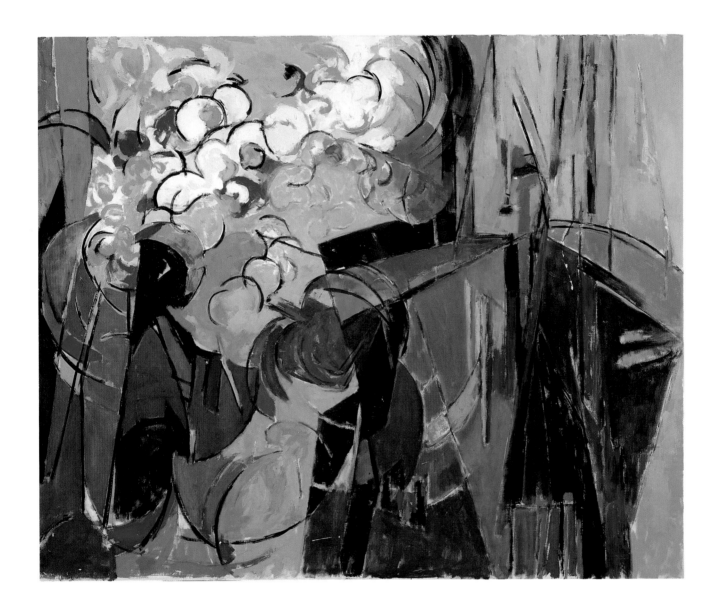

Marché (I), *1959. Oil on canvas, 40½ x 49 inches.*

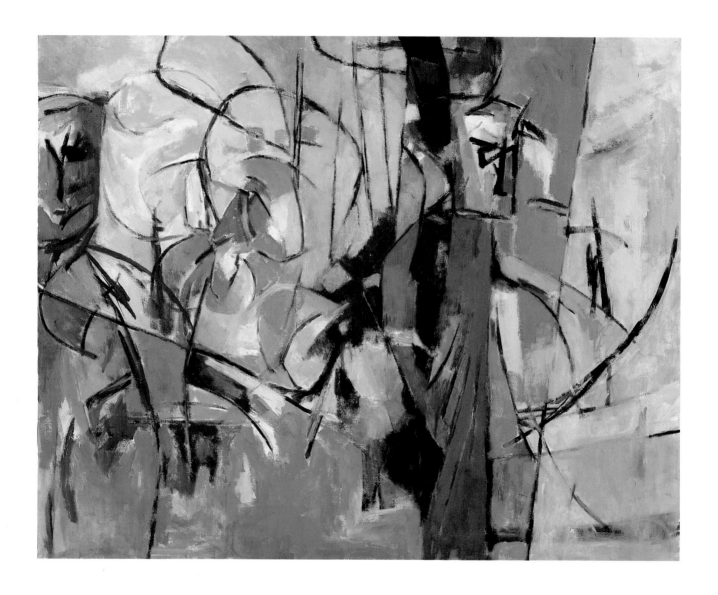

Colorplate 12
Marché (II), *1959–60. Oil on canvas, 40 x 50 inches.*

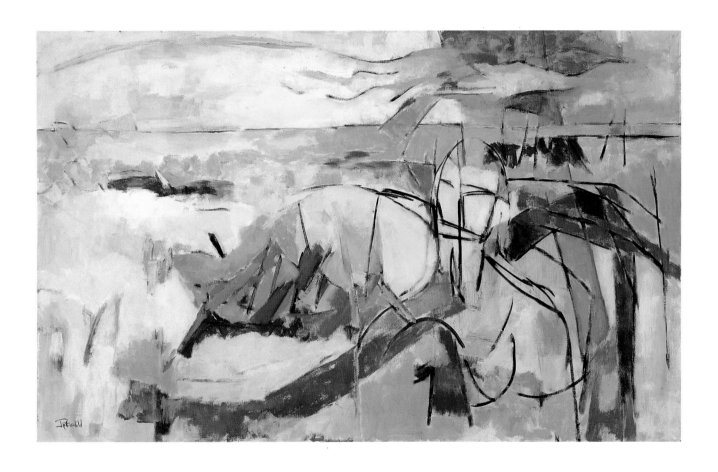

Alcestis, *1959–60. Oil on canvas, 30 × 48¼ inches.*

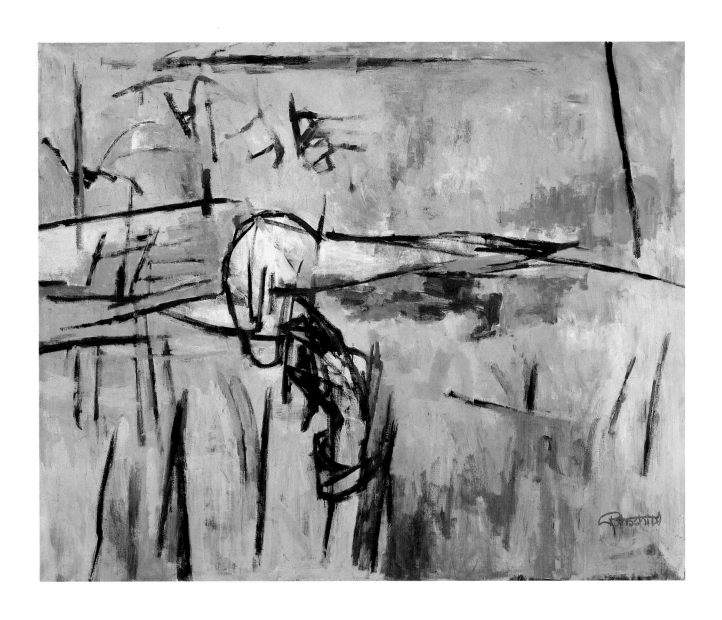

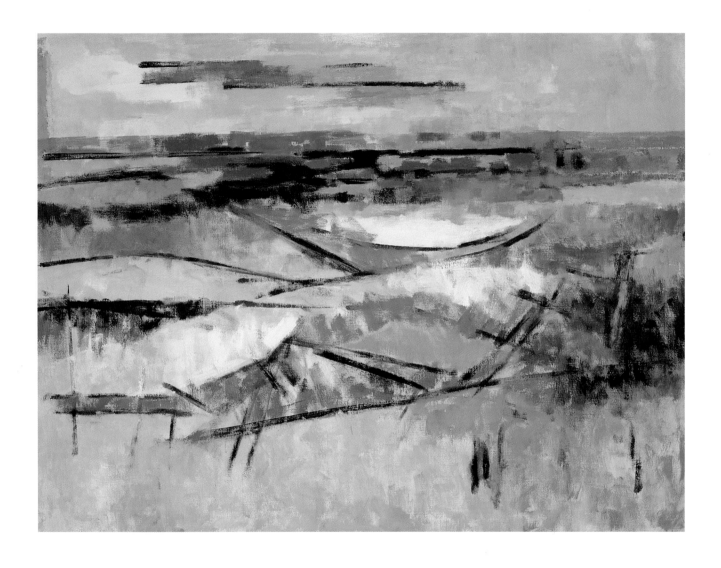

Untitled Landscape, *ca. 1965. Oil on canvas, 30 × 40 inches.*

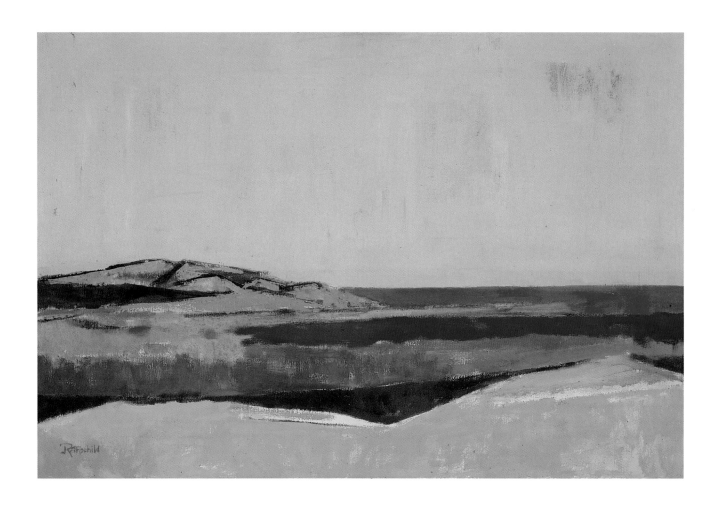

Lieutenant Island, *1966. Oil on canvas, 23⅞ x 36 inches.*

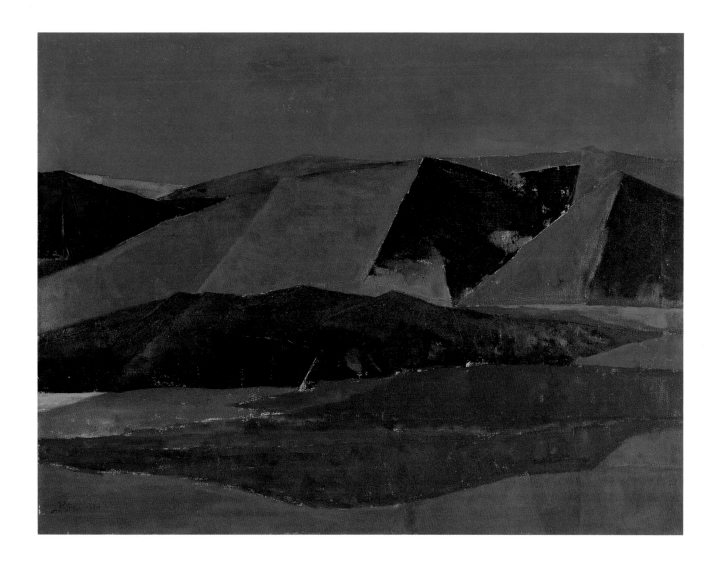

Sierra de Gredos, *1966. Oil on canvas, 30 x 40 inches.*

Algarve II, *1966. Oil on canvas, 30 x 40¼ inches.*

Estremadura, *1966. Oil on canvas, 20⅛ x 36⅛ inches.*

Alcestis VI, *1970. Oil on canvas, 24 × 34 inches.*

Colorplate 21
Interior, *1970. Oil on canvas, 40 × 60 inches.*

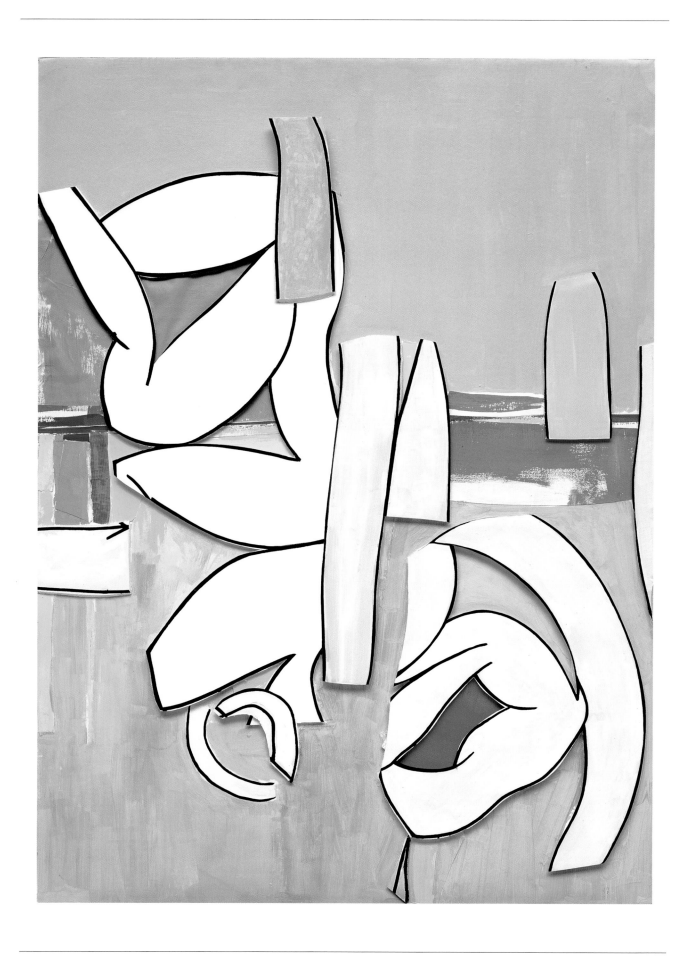

Colorplate 22
And Dance upon the Level Shore, *1972. Relief of foamboard, collage, acrylic, and ink on foamboard,*
40⅛ × 30⅛ inches.

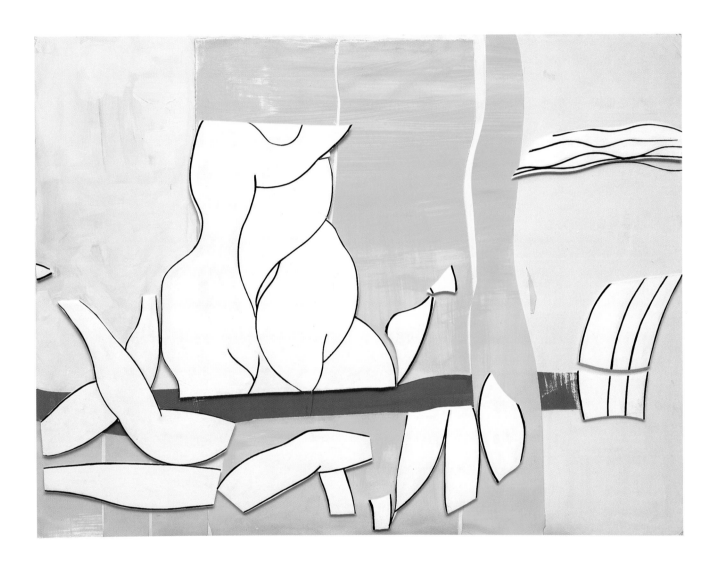

Beach Scene, *ca. 1973. Relief of foamboard, collage, acrylic, and ink on foamboard, 30¼ x 40¼ inches.*

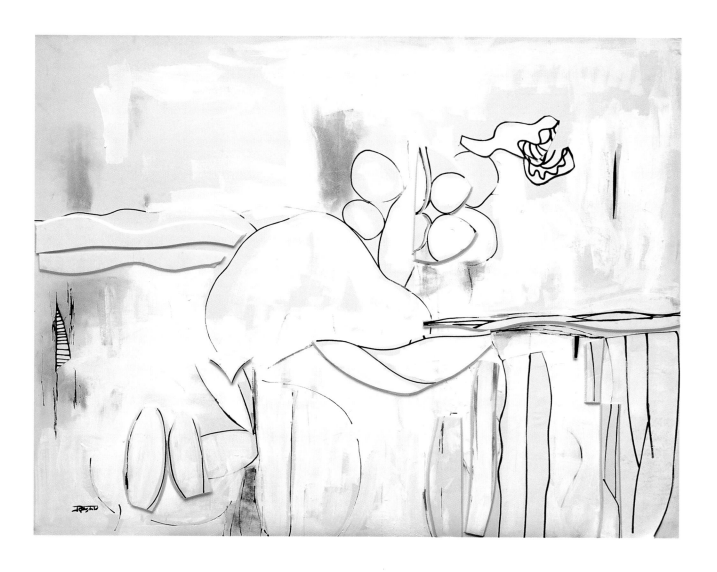

Landscape I, *ca. 1974. Relief of foamboard, collage, acrylic, and ink on foamboard, 30 x 40 inches.*

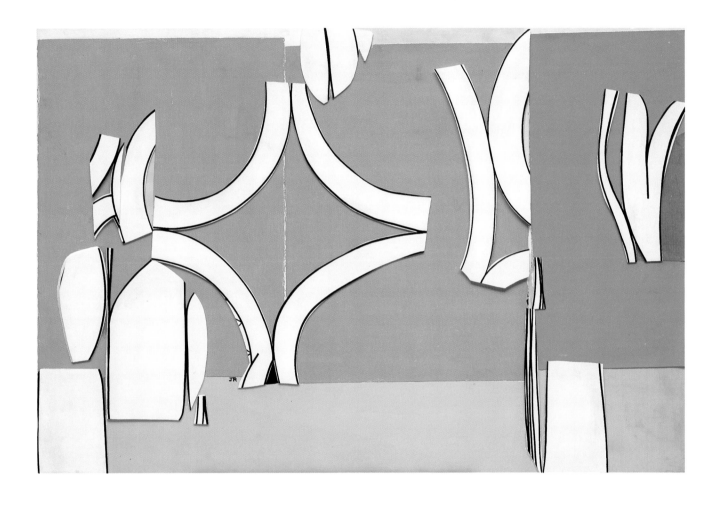

Alcestis I, *1974. Relief of foamboard, collage, acrylic, and ink on foamboard, 40 x 60 inches.*

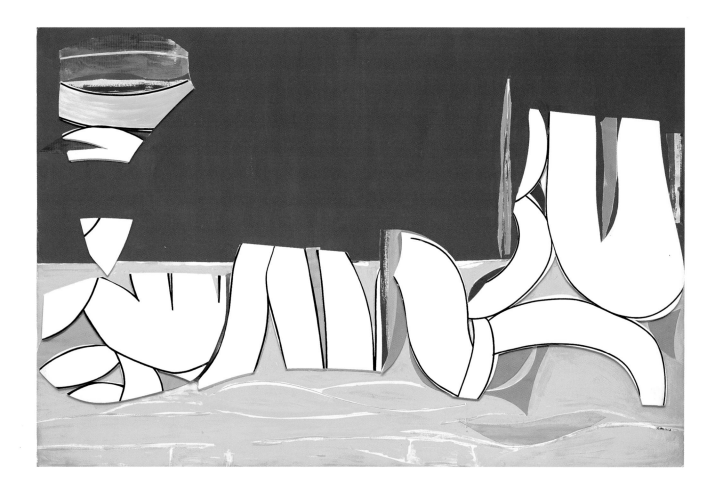

Colorplate 26
Scene II, *1975. Relief of foamboard, acrylic, and ink on foamboard, 40⅛ x 60⅛ inches.*

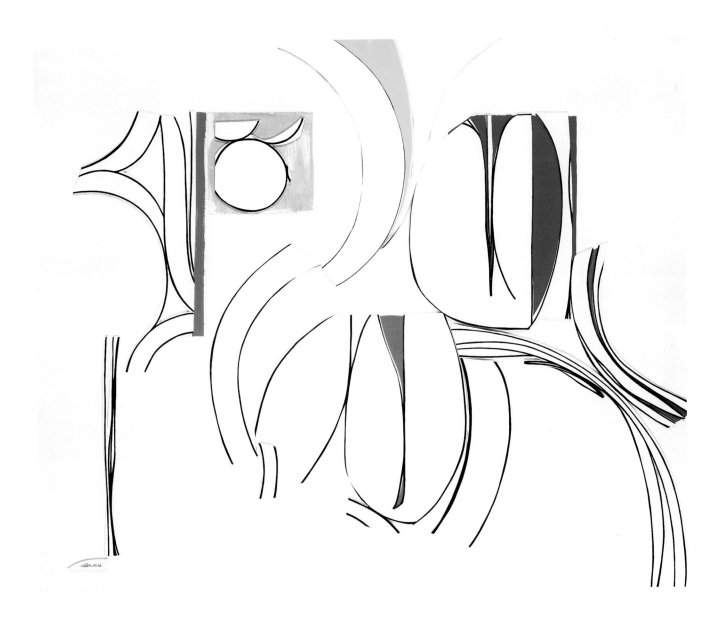

Colorplate 27
Ogygia II, *1975. Relief of foamboard, collage, acrylic, and ink on foamboard, 48 x 60 inches.*
Collection Neuberger Museum of Art, State University of New York at Purchase.

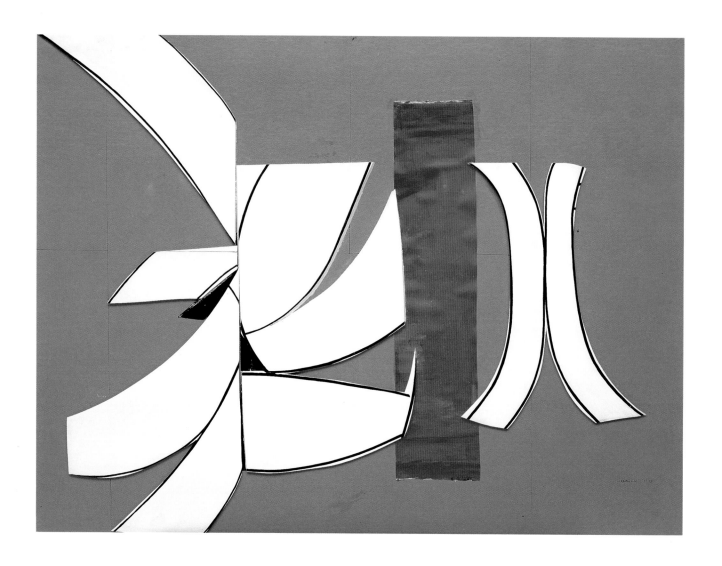

Cereus II, *1975. Relief of foamboard, collage, acrylic, and ink on chipboard, 29¾ x 40 inches.*

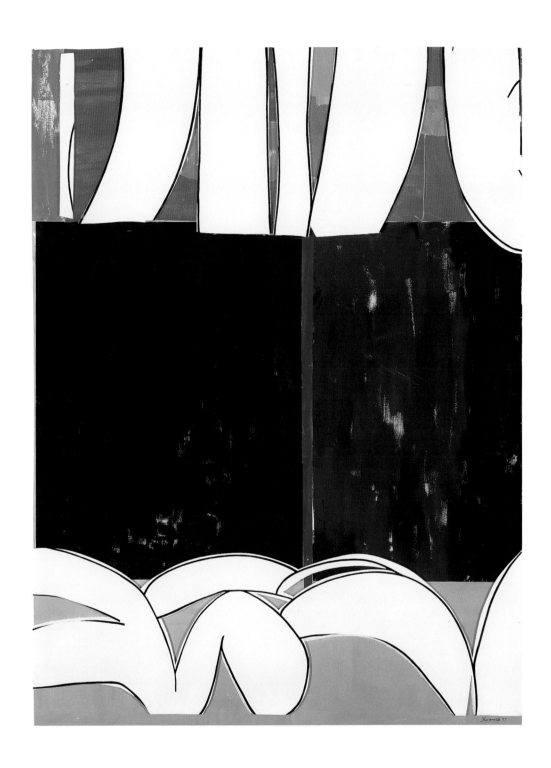

Colorplate 29
For Neruda, *1977. Relief of foamboard, collage, acrylic, and ink on foamboard, 40½ × 36½ inches.*
Collection Mr. and Mrs. John S. McDaniel, Baltimore, Maryland.

The Gothic IV, *1976. Relief of foamboard, collage, acrylic, and ink on foamboard, 60⅛ × 48⅞ inches.*

The Gothic VI, *1977. Relief of foamboard, acrylic, and ink on foamboard, 60¼ × 41⅛ inches.*

Colorplate 32
Bathers IV, *1977. Relief of foamboard, collage, acrylic, and ink on foamboard, 80⅝ x 48⅜ inches.*

Persephone, *1980. Relief of foamboard, collage, acrylic, and ink on foamboard, 36⅜ x 48⅜ inches.*

Alcestis's Song, *1980. Relief of foamboard, collage, acrylic, and ink on foamboard, 60 x 40⅛ inches.*

Skywatch III, *1980. Relief of foamboard, collage, acrylic, and ink on foamboard, 24¾ x 40 inches.*

Colorplate 36
Southwest, *1980. Relief of foamboard, collage, acrylic, and ink on foamboard, 40 × 54 inches.*

Achilles' Dream II, *1985. Relief of foamboard, collage, acrylic, and ink on foamboard, 40¼ x 60 inches.*

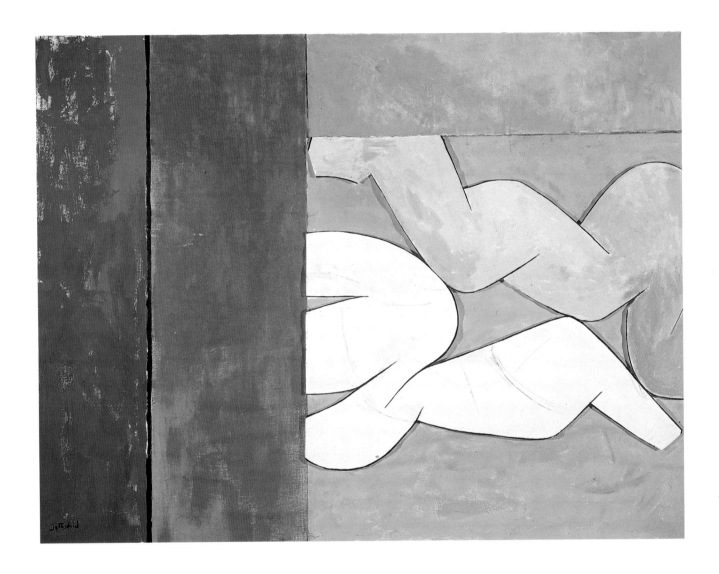

Colorplate 38
Aegean I, *1985. Relief of foamboard, collage, acrylic, and ink on foamboard, 36¾ × 48¾ inches.*

Colorplate 39

Achilles and Briseis XXX, *1987. Relief of aluminum, collage of acrylic on canvas, and acrylic on fiberglass panel,*
30 x 40 inches.

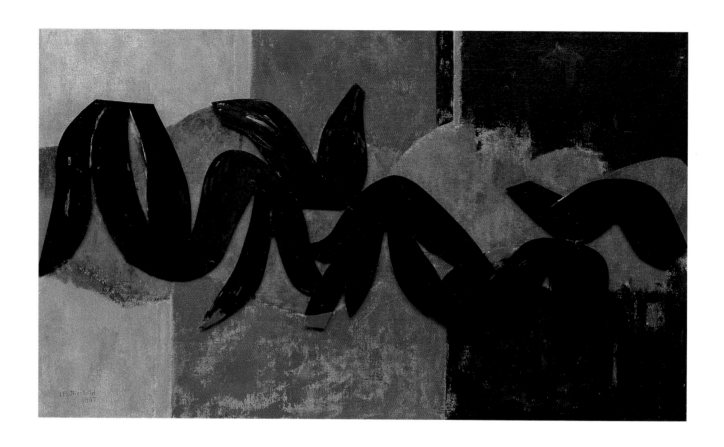

Colorplate 40

Death of Patroklos, *1987. Relief of aluminum, collage of acrylic on canvas, and acrylic on aluminum panel,*
26 × 44 inches. Collection The Metropolitan Museum of Art, New York.

Dark Eidolon, *1987. Relief of aluminum and acrylic on aluminum panel, 33 × 38¾ inches.*

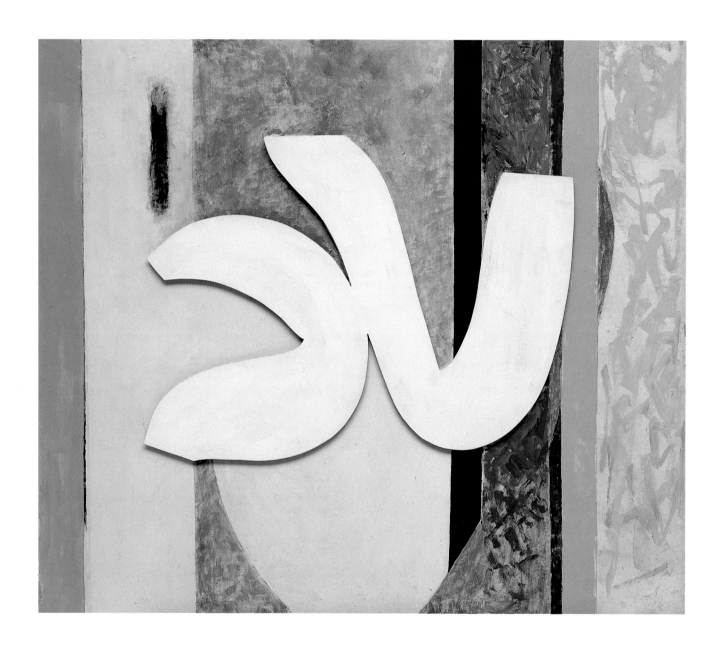

Colorplate 42
Grey Eidolon, *1987. Relief of aluminum and acrylic on aluminum panel, 32¾ × 38¼ inches.*

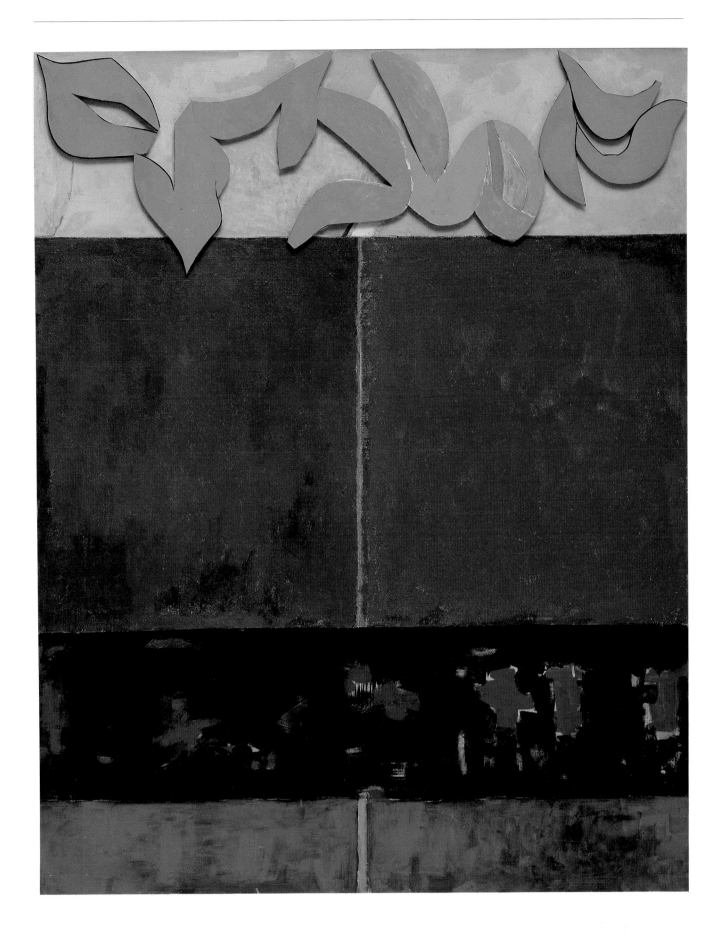

Neruda IV, *1987. Relief of aluminum, collage of acrylic on canvas, and acrylic on aluminum panel, 60 × 48 inches.*

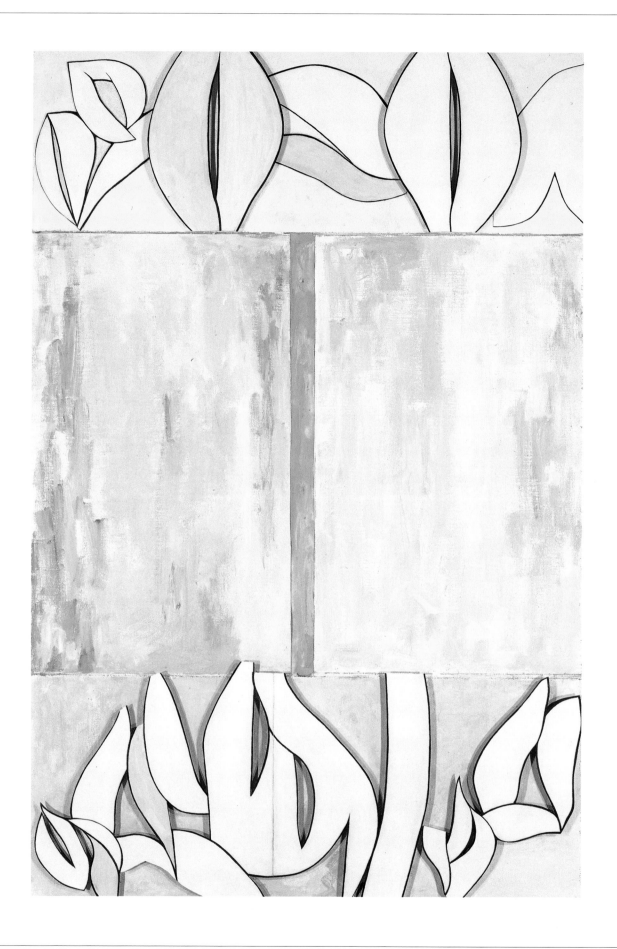

Neruda VI, *1990. Relief of aluminum and acrylic, and collage of oil on canvas on fiberglass panel, 60 x 40 inches.*

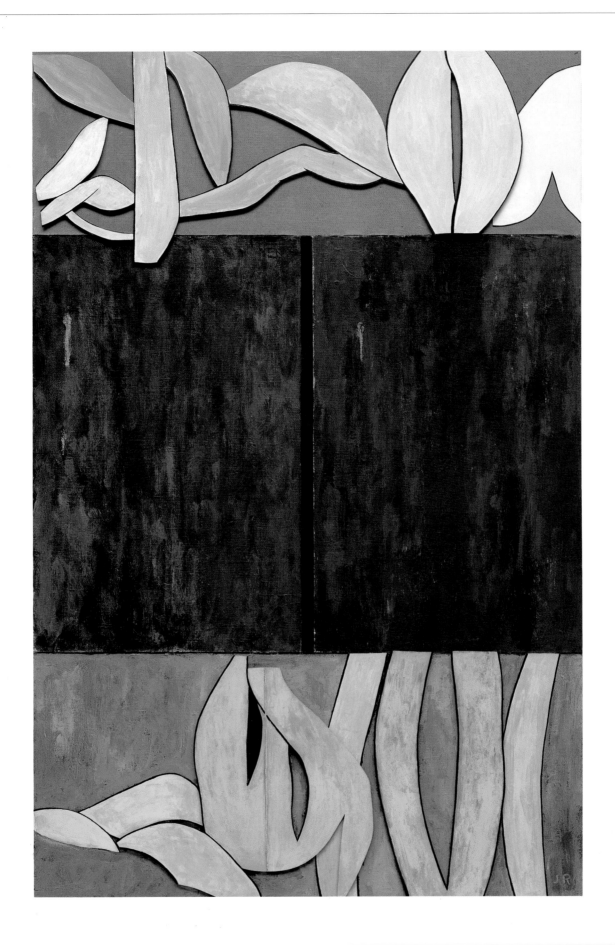

Neruda VII, *1990. Relief of aluminum and acrylic, and collage of oil on canvas on fiberglass panel, 60 × 40 inches.*

The Gothic VII, *1990. Relief of aluminum and acrylic on aluminum panel, 60¾ × 41 inches.*

The Gothic XII, *1991. Relief of aluminum and acrylic on aluminum panel, 90¼ × 60¾ inches.*

Colorplate 48

The Gothic XI, *1991. Relief of aluminum and acrylic on aluminum panel, 90¼ x 60¾ inches. Collection the National Gallery of Art, Washington.*

1921

Judith Rothschild born September 4 in New York. (Her brother, Robert, was born in 1918, and her sister, Barbara, was born in 1924.)

1937

Travels to Europe with her brother, Robert.

1939–42

Graduates from Fieldston School in June 1939 and begins at Wellesley in the fall. Summer study at the Cummington School, Cummington, Mass., in 1940. Studies with Maurice Sterne, summer of 1941. Studies at Cranbrook Academy of Art in Bloomfield Hills, Mich., with Zoltan Sepeshey in 1942.

1943–44

Graduates from Wellesley in June 1943; studies at the Art Students League with Reginald Marsh that summer. Studies with Hans Hofmann in New York, fall 1943–winter 1944. Publishes "Abstract versus Non-Objective Art" in *12th Street*.

1945

Lives and works in a studio at 299 West Twelfth Street in New York. Works at Stanley William Hayter's Atelier 17. Meets other artists working there, including Ann Ryan, Alexander Calder, Jacques Lipchitz. Becomes member of the Jane Street group, which includes Leland Bell, Nell Blaine, and Jane Freilicher. Meets Karl Knaths at the Jane Street Gallery. Publishes "Technique and Ideas" in *12th Street*.

Solo Exhibition

"Paintings by Judith Rothschild," Jane Street Gallery, New York. December 20, 1945, to January 20, 1946. Twenty works—some in gouache, some in oil—were shown.

1946

Elected to membership in American Abstract Artists. Introduced to the dealer Rose Fried by Marcel Duchamp. Becomes acquainted with Charmion von Wiegand and Burgoyne Diller. Visits Mondrian's studio. Meets Fernand Léger. Works on translations of statements by Arp, Ernst, Braque, Picasso, Miró, and Mondrian. In summer goes to Cape Cod for first time. Works on prints with Blanche Lazzell in Provincetown. Meets her future husband, Anton Olmstead Myrer (1922–1996). Becomes better acquainted with Karl Knaths.

Solo Exhibition

"Judith Rothschild, Exhibition of Paintings." Joseph Luyber Galleries, New York. October 29 to November 16, 1946. Twenty works were shown.

Group Exhibitions

Wins second prize at annual exhibition, Institute of Modern Art, Boston.

"American Abstract Artists Eleventh Annual Exhibition," New York. March 30 to April 20, 1946.

"Critics' Show," Grand Central Art Galleries, New York. December 10 to December 21, 1946. (Rothschild chosen by *New York Times* critic, Edward Alden Jewell.)

1947

Marries Anton Myrer in August. They live for two months in Provincetown, then leave by automobile for California, where address is Route #1, Box 120, Carmel Highlands. Reads symbolists and surrealists. Rose Fried notifies Rothschild that Marcel Duchamp and Katherine Dreier are interested in her work.

Group Exhibitions

"Small Paintings by the Group," Joseph Luyber Galleries, New York. April 21 to May 10, 1947.

"142d Annual Exhibition of Painting and Sculpture," Pennsylvania Academy of the Fine Arts, Philadelphia. January 25 to March 2, 1947.

"58th Annual Exhibition of American Painting and Sculpture —Abstract and Surrealist American Art," The Art Institute of Chicago. November 6, 1947, to January 1, 1948.

1948

In March she and Myrer move to 320 Hawthorne Avenue, Monterey, Calif., to studio-barn built by Jean Varda. Meets Edward Weston. Myrer finishes first novel in the spring. In the fall Rothschild's parents visit, and they all go to the Grand Canyon. Has dispute with parents on philosophical issues.

Group Exhibitions

Exhibition with Esther Geller and Carl G. Nelson, Boris Mirski Gallery, Boston. March 1948.

Group show, Pat Wall Gallery, Monterey, Calif. July 23 to August 14, 1948.

"59th Annual Exhibition of Watercolors and Drawings," The Art Institute of Chicago. November 4, 1948, to January 2, 1949.

1949

In the spring she and Myrer leave Monterey. Summer in Provincetown. Meet Ann and Weldon Kees. Becomes involved with the "Forum 49" group. In the fall they move to Thompson Street and then to 179 Stanton Street in New York; their neighbors are the Keeses. During this time is in contact with Milton and Sally Avery, Romare Bearden, Nell Blaine, Fritz Bultman, Adolph Gottlieb, Grace Hartigan, and Robert Motherwell.

Group Exhibitions

"55th Annual Exhibition," The Denver Art Museum. June 26 to August 30, 1949.

"Forum 49," Gallery 200, Provincetown, Mass. Summer 1949.

"New England Painting and Sculpture," Institute of Contemporary Art, Boston (traveled to nine New England museums).

1950

Summer in Provincetown. Extensive contact with Karl Knaths. She and Myrer return to California by automobile in December, live at Big Sur; read Melville's *Moby-Dick* aloud.

Group Exhibitions

"Réalités Nouvelles 5ème Salon," Palais de Beaux-Arts de la Ville de Paris. June 10 to July 15, 1950.

"Post-Abstract Painting 1950, France-America," Hawthorne Memorial Art Gallery, Provincetown Art Association, Mass. August 6 to September 4, 1950.

1951

Random House publishes Myrer's first novel, *Evil under the Sun*. Ann and Weldon Kees are living in San Francisco.

Solo Exhibition

Exhibition of paintings, watercolors, and collages, Blair Gallery, Monterey, Calif. August 16 to September 10, 1951.

Group Exhibition

"British, Danish, American Abstract Artists: The American Abstract Artists Observe Their 15th Anniversary with an Exhibition of Works of Abstract Artists of Three Nations," Riverside Museum, New York. March 12 to April 1, 1951 (traveled to London, Copenhagen, and other European cities).

1952

She and Myrer come east in May and fly back to California in June. She begins to sign her works "Judith Myrer" about this time. Move to 624 Waring Place, Route #1, Seaside, Calif. In December they move to 212 Soledad Drive, Monterey, where Rothschild has a piano. Works on collages and woodcuts.

Solo Exhibition

"Exhibition of Paintings, Oils, Water Colors, Collages by Judith Myrer," Blair Gallery, Monterey, Calif. July 2 to August 1, 1952.

Group Exhibition

"American Abstract Artists, Sixteenth Annual Exhibition," New York. February 24 to March 3, 1952.

1953

Introduced to Lefevre-Foinet paints by her mother. Decides to stop exhibiting with the American Abstract Artists.

Solo Exhibition

Exhibition of paintings, watercolors, and collages, Blair Gallery, Monterey, Calif. August 15 to September 15, 1953.

1954

Reads Greek tragedies. Ann and Weldon Kees separate and divorce.

Group Exhibition

"Twenty-first Annual Exhibition," Boston Society for Independent Artists. January 19 to February 7, 1954.

1955

Works on extended series of abstracted seascapes, including *Antelopes* and *Byzantium*. Spring in Provincetown. On July 18 Weldon Kees commits suicide. Rothschild returns to California in late July to prepare for opening of Santa Barbara biennial. Works on translations of Cézanne's letters.

Group Exhibition

"First Pacific Coast Biennial Exhibition of Paintings and Watercolors, 1955," Santa Barbara Museum of Art. September 20 to November 6, 1955 (traveled to California Palace of the Legion of Honor, San Francisco, November 19, 1955, to January 2, 1956).

1956

Invited to participate in collage show at Rose Fried Gallery in New York. Decides to leave California and return east. Receives bond from father to pay for trip to Europe. Returns to New York in the fall; lives at 210 Centre Street.

Group Exhibition

"International Collage Exhibition," Rose Fried Gallery, New York. February 13 to March 17, 1956.

1957

In New York for the winter, at 210 Centre Street. Moves to 8 East Ninety-second Street in March. Myrer's novel *The Big War* becomes a best-seller. Summer in Provincetown. Rothschild has her first one-person show in New York since 1947; begins to sign her work "Rothschild" again. She and Myrer leave for Europe in November. Travel to Paris, then by automobile to Burgundy and through Provence to the Mediterranean coast. Rent an apartment in Cannes on La Croissette.

Solo Exhibition

"Judith Rothschild: Recent Paintings," Rose Fried Gallery, New York. September 23 to October 19, 1957.

1 9 5 8

Begins the year in apartment at Cannes. Sketches at local outdoor markets. In February she and Myrer go to Italy, stopping in Florence, Siena, Rome, Assisi, Ravenna, Milan. Then return through western France to Paris. Return to New York in April. Live at 8 East Ninety-second Street. Spend the summer in Amagansett, where she reads Euripides' *Alcestis*. Fall in New York. In October she has idea for foundation to support museum acquisitions of works by underappreciated artists (as an example she names Romare Bearden); some thirty-five years later, this will become part of the mission of The Judith Rothschild Foundation. In November starts *Marché* paintings.

Group Exhibition

"Collage International—from Picasso to the Present," Contemporary Arts Museum, Houston. February 27 to April 6, 1958.

1 9 5 9

She and Myrer begin collaboration on the novel *Faubion*. She reads biography of Mendelssohn. Continues work on Marché series. Begins Alcestis paintings. Sees a good deal of Karl Knaths in New York and on Cape Cod. She and Myrer stay in Wellfleet for the spring and summer and decide to stay on for the winter. Works on translation of Carl Einstein's "Cubism" with Knaths. Rereads *Moby-Dick*. In November she and Myrer buy a house and property with studio space, High Woods, Route 2, Box 169, Saugerties, N.Y.

1 9 6 0

In Saugerties, she begins to work on abstracted landscapes. Spends summer in Provincetown. On December 31 buys first of many salukis, which she names Jezebel.

1 9 6 1

Works out color rapports with andante of Mozart's Piano Concerto K. 488 in March. Spends the summer in Wellfleet. In October she and Myrer buy a house at Bound Brook Island in Wellfleet. For the rest of the decade they will spend the winters in Saugerties and the summers at Bound Brook Island. In November Rothschild rents an apartment-studio in New York City at 1482 First Avenue.

1 9 6 2

Myrer's new novel, *The Violent Shore*, is published. First summer at Bound Brook Island. She begins series of paintings based on images of the surrounding landscapes.

Solo Exhibition

"Judith Rothschild: Recent Oils and Collages," Knapik Gallery, New York. April 3 to 31, 1962.

1 9 6 3

During the spring, continues work on paintings using Bound Brook Island images. Organizes and catalogues her past work at High Woods that spring and does Ostwald notes on most major paintings.

1 9 6 4

Rothschild realizes that much of Knaths's compositional system is now questionable to her. She and Myrer leave for six-week trip to Europe in September, arrive in Paris on September 8, and travel across eastern France to Germany, then back across France into Spain and Portugal, returning to New York on October 23.

Solo Exhibition

"Judith Rothschild: Exhibition of Paintings," Bragazzi Gallery, Wellfleet, Mass. August 6 to 20, 1964.

1 9 6 5

Myrer's fourth novel, *The Intruder*, is published to disappointing reviews. Rothschild begins landscape paintings based on Spanish and Portuguese motifs.

Solo Exhibition

"Judith Rothschild: Collages," Bragazzi Gallery, Wellfleet, Mass. August 24 to September 2, 1965.

Group Exhibition

"Small Works," Rose Fried Gallery, New York. December 6, 1964, to January 5, 1965.

1 9 6 6

In Bound Brook Island for the summer, does extended series of austere landscapes based on Iberian and Cape Cod motifs.

1 9 6 7

Begins preparation in January for her first solo museum show in Albany. In February agrees to a solo exhibition at La Boétie Gallery next year. Back at High Woods in fall, works with Myrer getting his new novel ready for publication.

Solo Exhibitions

"Recent Paintings by Judith Rothschild," Albany Institute of History & Art, N.Y. February 8 to March 12, 1967.

"Judith Rothschild: Recent Landscapes," Wellfleet Art Gallery, Mass. August 21 to 26, 1967.

Group Exhibition

"20 Contemporaries," La Boétie Gallery, New York. February 2 to March 11, 1967.

1 9 6 8

Myrer's novel *Once an Eagle* is published with great success. Rothschild gives lecture at Wellesley in May.

Solo Exhibition

"Judith Rothschild: Recent Landscapes," La Boétie Gallery, New York. February 13 to March 9, 1968.

1969

On March 11 moves into new studio-apartment at 11 East Ninetieth Street. At the end of March Myrer leaves for Europe without Rothschild. Over the course of the year, the marriage dissolves. Alone in Bound Brook Island for much of the summer, she does new series of landscapes with Alcestis theme. Goes to London in July. In the fall, writes an article about her work for *Leonardo*.

Group Exhibition

"American, Israeli, and European Paintings," La Boétie Gallery, New York. February 25 to March 15, 1969.

1970

Moves out of High Woods in February. Divorced from Anton Myrer on April 11; he marries Patricia Schartle on May 1. Rothschild works mostly on collages. Appointed AFA trustee. Her article is published in the July issue of *Leonardo*. Goes to Paris and Scotland in September. Sees Matisse retrospective at Grand Palais. Angele Myrer dies in October.

Group Exhibition

"The Still Poetic Moon," La Boétie Gallery, New York. September 22 to November 14, 1970.

1971

In July moves to house at 1110 Park Avenue in New York. As artist-in-residence at Syracuse University, she teaches advanced drawing from November 8, 1971, to January 19, 1972. Begins to work on first relief paintings there.

Solo Exhibition

"Judith Rothschild: Recent Collages," Wellfleet Art Gallery, Mass. July 19 to 30, 1971.

1972

Works on collages and relief paintings.

Solo Exhibitions

"Judith Rothschild: Recent Collages," State University of New York at Buffalo. June 30 to July 14, 1972.

"Judith Rothschild: Joint Solo Exhibition with John Ford," Centennial Art Gallery, Saint Peter's College, Jersey City, N.J. November 10 to December 15, 1972.

Group Exhibition

"The Non-Objective World, 1939–1955," Annely Juda Fine Art, London. July 6 to September 8, 1972 (traveled to Liatowitsch, Basel, and Galleria Milano, Milan).

1973

Rejoins American Abstract Artists.

Group Exhibition

"118 Artists," Landmark Gallery, New York. December 20, 1975, to January 8, 1976.

1974

Meets David Juda and Lee Ault.

1975

Reads Flaubert letters. To Paris and to London for two weeks; sees Annely Juda.

Solo Exhibition

"Judith Rothschild," Lee Ault & Co., New York. March 19 to April 19, 1975.

1976

Meets Antonina Gmurzynska. To London for two weeks in January to prepare for Annely Juda show. Studies Persian manuscripts at the British Museum Library. Herbert Rothschild dies on October 28.

Solo Exhibition

"Judith Rothschild," Annely Juda Fine Art, London. February 10 to March 6, 1976.

"Judith Rothschild," Lee Ault & Co., New York. November 17 to December 18, 1976; extended to January 15, 1977.

Group Exhibitions

"Women, Art 1976," Loeb Center, New York University, New York. November 3 to December 2, 1976.

"10 Artists," Landmark Gallery, New York. November 27 to December 16, 1976.

1977

Hospitalized with endocarditis and possible lymphoma. Forms group with twelve other artists to establish the Long Point Gallery in Provincetown.

Solo Exhibition

"Judith Rothschild: Relief/Collages," Neuberger Museum, State University of New York at Purchase. November 20, 1977, to January 8, 1978.

Group Exhibitions

"Group Exhibition of Gallery Artists," Long Point Gallery, Provincetown, Mass., June 28 to July 9, 1977.

"Provincetown Painters, 1890s–1970s," Everson Museum of Art, Syracuse, N.Y., April 1 to June 26, 1977; and Provincetown Art Association and Museum, Mass., August 15 to September 5, 1977.

1978

To London, Iran, and Paris for the month of April. Travel in Iran includes cities of Shiraz, Bishipur, Persepolis, and Teheran. In need of more studio space, in November moves into Barnett

Newman's former studio in Carnegie Hall Building at 881 Seventh Avenue.

Solo Exhibitions

"Judith Rothschild: Recent Reliefs," Philomathean Society Art Gallery, University of Pennsylvania, Philadelphia. January 27 to February 10, 1978.

"Judith Rothschild," Lee Ault & Co., New York. May 17 to June 7, 1978.

"Judith Rothschild, Relief Paintings," Williams College Museum of Art, Williamstown, Mass. July 1 to 31, 1978.

"Hopkins/Rothschild: Two One-Person Exhibitions," Long Point Gallery, Provincetown, Mass. July 23 to August 5, 1978.

1979

Finishes small pictures for "Sideo's Garden" show. Nannette Rothschild dies on November 17.

Solo Exhibition

"Sideo's Garden: New Relief/Collages by Judith Rothschild," Landmark Gallery, New York. February 17 to March 8, 1979.

Group Exhibitions

"Hans Hofmann as Teacher: Drawings by His Students," The Metropolitan Museum of Art, New York. January 23 to March 4, 1979.

"The Language of Abstraction, as Presented by the American Abstract Artists: Works from the 1950s, 1960s, 1970s," Betty Parsons Gallery, New York, June 19 to August 3, 1979; and Marilyn Pearl Gallery, New York, June 12 to August 3, 1979.

1980

Sees Mondrian show at Sidney Janis Gallery in New York in February. In March flies to Paris, then London, on way to Italy. Sees Monet show in Paris and "Towards Abstraction" show at Tate Gallery in London. Travels in Italy include Venice, Vicenza, Verona, Florence. Returns April 15. Travels to Cologne to Gmurzynska Gallery in October.

Solo Exhibition

"Judith Rothschild/Tony Vevers: Two One-Person Exhibitions," Long Point Gallery, Provincetown, Mass. August 3 to 16, 1980.

1981

Goes to London in March for opening of her second show at the Annely Juda gallery. Goes to Cologne for opening of new space at Gmurzynska Gallery. Gets diagnosis of cataracts in October.

Solo Exhibitions

"Judith Rothschild: Recent Relief Paintings," Wellesley College Art Museum, Mass. March 5 to 31, 1981.

"Judith Rothschild: Relief Paintings," Annely Juda Fine Art, London. March 12 to April 11, 1981.

Group Exhibition

"Tracking the Marvelous," Grey Art Gallery and Study Center, New York University, New York. April 27 to May 30, 1981.

"Klassische Moderne nach 1939," Galerie Gmurzynska, Cologne. May to August 1981.

1982

To Cologne in March. In April begins renovation at 1110 Park Avenue to have a larger studio.

Solo Exhibitions

"Judith Rothschild," Thorne-Sagendorph Art Gallery, Keene State College, N.H. January 10 to February 9, 1982.

"Leo Manso/Judith Rothschild: Two One-Person Exhibitions," Long Point Gallery, Provincetown, Mass. August 8 to 21, 1982.

Group Exhibition

"Meisterwerker der Moderne/Masterpieces of the Moderns," Galerie Gmurzynska, Cologne. June to July 1982.

1983

Goes to Venice, where she has works at Palazzo Grassi. Begins to work in new studio at 1110 Park Avenue.

Solo Exhibition

"Judith Rothschild: Relief/Collages," organized by Galerie Gmurzynska, Cologne, at Centro di Cultura di Palazzo Grassi, Venice. April 16 to 24, 1983.

1984

To hospital for eye operation on April 10 and again on September 14. Reads Lawrence Durrell on the Greek islands. Begins to work on paintings with themes from the *Iliad*.

1985

Begins single-image reliefs, including the Eidolon series.

Solo Exhibitions

"Judith Rothschild: The Shield of Achilles, Relief Paintings and Collages," Iolas-Jackson Gallery, New York. May 7 to June 1, 1985.

"Judith Rothschild: Recent Collages and Relief Paintings," Juda Rowan Gallery, London. May 3 to June 22, 1985.

"Judith Rothschild/Nora Speyer: Two One-Person Exhibitions," Long Point Gallery, Provincetown, Mass. July 28 to August 11, 1985.

1986

Joins the Gimpel & Weitzenhoffer Gallery.

Group Exhibitions

"American Abstract Artists, 1936–1986/Fiftieth Anniversary Celebration," The Bronx Museum of the Arts, N.Y. February 6 to April 20, 1986 (traveled to Hillwood Art Gallery, Long

Island University, C. W. Post College, Brookville, N.Y., October 1 to 24, 1986).

"Crosscurrents: An Exchange Exhibition between Guild Hall Museum and the Provincetown Art Association and Museum," Guild Hall Museum, Easthampton, N.Y. June 22 to July 27, 1986; and Provincetown Art Association and Museum, Mass. June 27 to July 24, 1986.

1987

Makes plans for Judith Rothschild Foundation in June.

Solo Exhibition

"Judith Rothschild: Selected Paintings," Gimpel & Weitzenhoffer Gallery, New York. February 10 to 28, 1987.

1988

Travels to Paris and Provence. Visits Cézanne's studio in Aix. Sees early Cézanne exhibition at Musée d'Orsay in Paris.

Solo Exhibitions

"Judith Rothschild: Reliefs and Paintings, 1986–1987," Gimpel & Weitzenhoffer Gallery, New York. January 26 to February 13, 1988.

"Judith Rothschild: Relief Paintings, 1972–1987," Pennsylvania Academy of the Fine Arts, Philadelphia. June 17 to September 18, 1988 (traveled to Portland Museum of Art, Maine. October 19 to November 11, 1988).

Group Exhibition

"Fläche-Figur-Raum," Galerie Gmurzynska, Cologne. February 6 to April 20, 1988.

1989

Goes to Cologne to see Krystyna Gmurzynska in October. Makes arrangements for Moscow show.

Solo Exhibition

"Eidolons and Whirligigs," Maurice M. Pine Library, Fairlawn, N.J. March 5 to April 9, 1989.

"Judith Rothschild Collages," Ingber Gallery, New York. May 2 to 27, 1989.

Group Exhibition

"Figuration-Abstraktion," Galerie Gmurzynska, Cologne. May 22 to June 30, 1989.

1990

Works on large Gothic paintings. Prepares material for Moscow exhibition catalogue. Rents house in Kinderhook, New York, for the summer and decides to buy it.

Solo Exhibition

"Judith Rothschild: Reliefs," Long Point Gallery, Provincetown, Mass. August 12 to 25, 1990.

Group Exhibition

"Four Abstract Painters: Sally Michel Avery, Ernest Frazer, Nicholas Marsicano, Judith Rothschild," Woodstock Artists Association, N.Y. January 6 to February 11, 1990.

1991

To Cologne for opening of new Gmurzynska Gallery building in April. Returns to Cologne and goes on to Moscow for opening of her exhibition there. Travels in southern France.

Solo Exhibition

"Beyond the Plane: Relief Paintings by Judith Rothschild," State Tretyakov Gallery, Moscow, September 17 to October 13, 1991 (traveled to University of Michigan Museum of Art, Ann Arbor. June 27 to August 16, 1992).

Group Exhibition

"Twenty-five Women Artists," Woodstock Artists Association, N.Y. January 12 to February 19, 1991.

1992

Works on new Gothic panels. Reads Gasquet on Cézanne. Arranges to take master piano classes with Vladimir Feltsman at New Paltz. Sees Matisse show at The Museum of Modern Art, New York, in December.

Solo Exhibition

"Judith Rothschild: Reliefs and Collages," André Zarre Gallery, New York. November 10 to December 4, 1992.

1993

Continues to work on Gothic paintings and on collages. Suffers a stroke on March 4 and dies on March 6.

Selected Museum and Corporate Collections

Museum of Contemporary Art, Auckland, New Zealand

The Baltimore Museum of Art

CIBA-GEIGY Collection, Elmsford, New York

City Art Gallery, Auckland, New Zealand

The Corcoran Gallery of Art, Washington, D.C.

Davis Museum and Cultural Center, Wellesley College, Massachusetts

William A. Farnsworth Art Museum, Rockland, Maine

First National Bank of Chicago, New York and Chicago

Fogg Art Museum, Harvard University, Cambridge, Massachusetts

The Grey Art Gallery, New York University, New York

Israel Museum, Jerusalem

The Metropolitan Museum of Art, New York

Monterey Peninsula Museum of Art, Monterey, California

The Museum of Modern Art, New York

National Gallery of Art, Washington, D.C.

NCNB Corporation Collection, Charlotte, North Carolina

Neuberger Museum of Art, State University of New York at Purchase

Museum of American Art of the Pennsylvania Academy of the Fine Arts, Philadelphia

Philadelphia Museum of Art

Portland Museum of Art, Maine

Provincetown Art Association and Museum, Massachusetts

Saint Peter's College, Jersey City, New Jersey

Sammlung Ludwig Museum, Aachen

Santa Barbara Museum of Art, California

Smith College Museum of Art, Northampton, Massachusetts

Solomon R. Guggenheim Museum, New York

Washington University Gallery of Art, Saint Louis

Weatherspoon Art Gallery, University of North Carolina, Greensboro

Whitney Museum of American Art, New York

PUBLICATIONS BY JUDITH ROTHSCHILD

"Abstract versus Non-Objective Art." *12th Street: A Quarterly* 1, no. 1 (May 1944), p. 18.

"Technique and Ideas." *12th Street: A Quarterly* 1, no. 3 (Summer 1945), pp. 14–15.

Artist's statement. In *Réalités Nouvelles, 5ème Salon 1950.* Exh. cat. Paris: Palais des Beaux-Arts de la Ville de Paris, 1950, p. 40.

"We Reply." *San Francisco Art Association Bulletin* 21, nos. 8–9 (November–December 1954), p. 6.

Statement. In *Judith Rothschild: Recent Paintings.* Exh. brochure. New York: Rose Fried Gallery, 1957.

"On the Use of a Color-Music Analogy and on Chance in Paintings." *Leonardo* 3 (July 1970), pp. 275–83.

Illustrations. In Robin Fulton, *The Spaces between the Stones Is Where the Survivors Live.* New York: New Rivers Press, 1971.

"How Unacademic." In *Wellesley After-Images.* Los Angeles: Wellesley College Club of Los Angeles, 1974, pp. 129–31.

"Summer '78: Provincetown Journal." *Art/World,* September 22–October 15, 1978, p. 15.

"Karl Knaths . . . As I Knew Him." In *Ornament and Glory: Theme and Theory in the Work of Karl Knaths,* ed. Jean Young and Jim Young. Annandale-on-Hudson, N.Y.: Bard College, 1982, pp. 16–27.

"Elizabeth deCuevas." *Art/World* 7, no. 8 (May 1983).

"Notes from a Journal." Printed for the exhibition "Judith Rothschild: The Shield of Achilles, Relief Paintings and Collages." New York: Iolas-Jackson Gallery, 1985.

PUBLICATIONS ABOUT JUDITH ROTHSCHILD

Adlow, Dorothy. "Gouaches and Water Colors." *Christian Science Monitor,* March 12, 1948.

———. "New Painters in Manhattan Galleries." *Christian Science Monitor,* September 28, 1957.

Alexander, Irene. "Rothschild One-Man Art Show Opens." *Monterey Peninsula Herald,* August 20, 1951.

———. "Distinctive Exhibition by Judith Myrer Opens." *Monterey Peninsula Herald,* July 15, 1952.

———. "Judith Myrer Exhibit Proves Notable Art Event." *Monterey Peninsula Herald,* August 18, 1953.

Arb, René. "Judith Rothschild." *Art News* 45, no. 10 (December 1946), p. 54.

Axsom, Richard H. "Determined Relations and Internal Necessity." In *Judith Rothschild: Relief Paintings, 1972–1987.*

Philadelphia: Pennsylvania Academy of the Fine Arts, 1988, n.p.

———. *Beyond the Plane: The Relief Paintings of Judith Rothschild.* New York: Hudson Hills Press, 1992.

Brown, Gordon. "Judith Rothschild." *Arts Magazine* 51, no. 3 (November 1976), pp. 18–19.

Burrows, Carlyle. Exhibition review. *New York Herald Tribune,* December 30, 1945.

———. Exhibition review. *New York Herald Tribune,* November 10, 1946.

———. "Art Exhibition Notes." *New York Herald Tribune,* September 28, 1957.

Campbell, Lawrence. "Judith Rothschild." *Art News* 56, no. 6 (October 1957), p. 17.

Cantu, John Carlos. "Rothschild Show: Is She Challenging 'Progress.'" *Ann Arbor News,* July 12, 1992.

D'Harnoncourt, Anne. "Introduction: Encounters with Modern Art." In *Encounters with Modern Art,* ed. George H. Marcus. Philadelphia: Philadelphia Museum of Art, 1996, pp. 13–26.

Dolbin, B. F. "Zwei Ausstellungen von Belang: Judith Rothschild: 'Recent Landscapes.'" *Aufbau,* February 16, 1968.

Friedman, B. H. "Too Little Attention: Chronicle II." *New Boston Review* 3, no. 1 (Summer 1977), p. 12.

———. "Judith Rothschild's Recent Work." *Arts Magazine* 52, no. 3 (November 1977), pp. 94–95.

Friedman, Sally. "Stark Simplicity Marks PAFA Exhibit." *Bucks County Courier Times,* August 28, 1988.

Genauer, Emily. "Young Artist Holding Her First Solo." *New York World Telegram,* December 29, 1945.

———. "New Rothschild Show." *New York Herald Tribune,* September 28, 1957.

Gilmour, Pat. "Gallery Reviews: Judith Rothschild." *Arts Review* 28, no. 2 (January 23, 1976), p. 38.

Goodman, Cynthia. "Judith Rothschild's Work." In *Judith Rothschild Relief/Collages.* Venice: Galerie Gmurzynska, 1983, n.p.

Goossen, E. C. "Judith Myrer's Work." *Monterey Peninsula Herald,* March 8, 1956.

———. "Judith Rothschild." *Monterey Peninsula Herald,* September 20, 1957.

Heller, Jules, and Nancy G. Heller. *North American Women Artists of the Twentieth Century: A Biographical Dictionary.* New York: Garland Publishing, 1995, p. 478.

Henry, Gerrit. "Judith Rothschild." *Art News* 92, no. 2 (February 1993), p. 114.

Jewell, Edward Alden. Exhibtion review. *New York Times*, November 3, 1946.

Jones, Nicolette. "Abstract Passion." *London's Alternative Magazine*, May 21, 1985.

Annely Juda Fine Art. *Judith Rothschild: Relief Paintings.* London: Annely Juda Fine Art, 1981.

Kelley, Mary Lou. "Artist Values Museum's Style." *Portland Maine Press Herald*, November 9, 1988.

Kramer, Hilton. "Judith Rothschild." *New York Times*, March 29, 1975.

Lloyd, Ann Wilson. "Artistic Sensibilities and Judith Rothschild." *Cape Cod Antiques & Arts*, September 1990, pp. 18–20.

McInnes, Mary Drach. *Provincetown Prospects: The Work of Hans Hofmann and His Students.* Boston: Boston University Art Gallery, 1994.

Myers, John Bernard. "A Fine Edge—the Paintings of Judith Rothschild." In *Judith Rothschild: Relief Paintings.* London: Annely Juda Fine Art, 1981, n.p.

Nemser, Cindy. "Judith Rothschild." *Arts Magazine* 42, no. 4 (February 1968), p. 62.

Nickerson, Cindy. "'Homeric Themes' at Long Point Gallery." *CapeWeek, Cape Cod Times Magazine*, August 14, 1987.

Penrose, Roland. "Judith Rothschild." In *Judith Rothschild: Relief Paintings.* London: Annely Juda Fine Art, 1981, n.p.

Pennsylvania Academy of the Fine Arts. *Judith Rothschild: Relief Paintings, 1972–1987.* Philadelphia: Pennsylvania Academy of Fine Arts, 1988.

Pomeroy, Ralph. "Judith Rothschild." *Art News* 66, no. 10 (February 1968), p. 16.

Preston, Stuart. "One-Man Shows." *New York Times*, September 27, 1957.

Rothschild, Nannette. "The Reminiscences of Nannette F. Rothschild." In *Encounters with Modern Art*, ed. George H. Marcus. Philadelphia: Philadelphia Museum of Art, 1996, pp. 31–114.

Sawin, Martica. "Judith Rothschild." *Arts Magazine* 32, no. 1 (October 1957), p. 59.

Shirey, David L. "Art That Sparks the Mind." *New York Times*, January 1, 1978.

Sozanski, Edward. "Exhibit Honors Ten-Year Morris Gallery Program." *Philadelphia Inquirer*, July 21, 1988.

State Tretyakov Gallery. *Judith Rothschild.* Exh. brochure. Moscow: Tretyakov Gallery, 1991.

Wolf, Ben. "Jane Street Find." *New York Herald Tribune*, December 30, 1945.

———. "Village Vitality." *Art Digest* 21, no. 3 (November 1, 1946), p. 18.

Christopher Burke, Quesada/Burke: Figures 12, 13, 17–21, 25, 63, 66, 68, 73, 78

Ken Cohen: Figures 57, 74

eeva-inkeri: Figures 60, 61, 64

A. Ficalora: Figures 2, 7

David Heald: Colorplates 1–16, 18–48; Figures 1, 3–6, 8, 10, 11, 16, 27, 29–33, 36–40, 44, 47–53, 55, 58, 59, 62, 65, 69–71, 77

Roger Michaels: Figures 9, 28

Otto E. Nelson: Figures 42, 45, 67

John D. Schiff: Figures 26, 34, 35, 41, 43

Charles Uht: Figures 54, 72, 75, 76

Bill Witt: Figure 15

Graydon Wood: Colorplate 17; Figures 22, 46